TEXTILES FOR THIS WORLD AND BEYOND

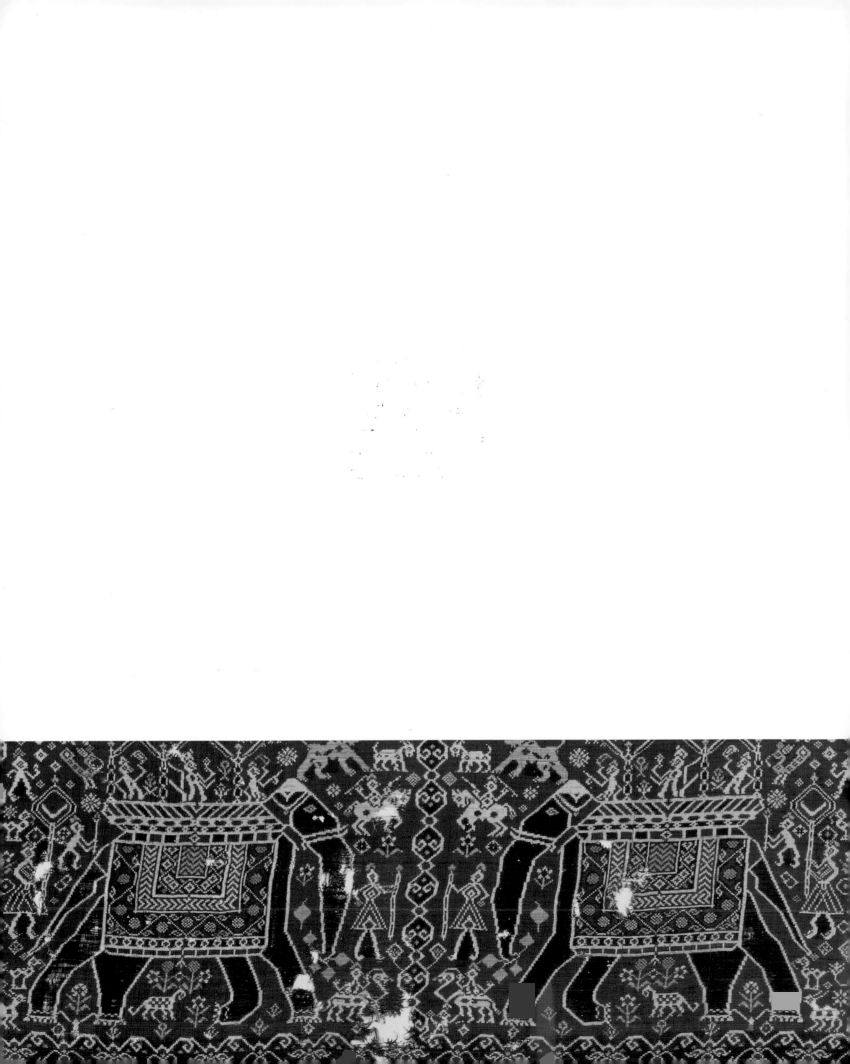

TEXTILES FOR THIS WORLD AND BEYOND :

TREASURES FROM INSULAR SOUTHEAST ASIA

MATTIEBELLE GITTINGER

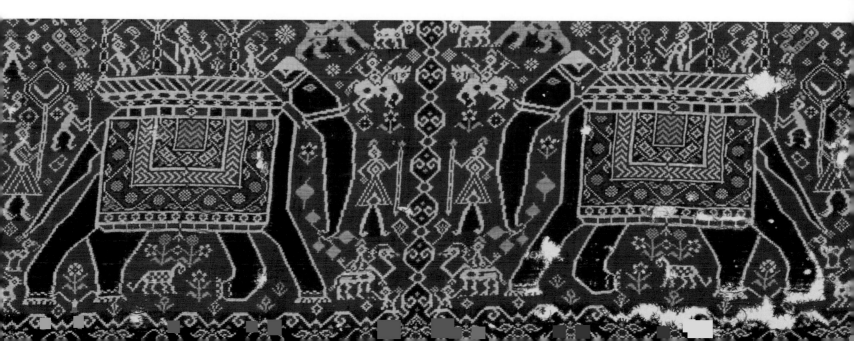

Contributors

This publication was made possible through the generosity
of the following contributors:

The Blakemore Foundation
E. Rhodes and Leona B. Carpenter Foundation
Jeremy and Hannelore Grantham
Furthermore: a program of the J.M. Kaplan Fund
Peter Reed

First published in 2005 by
Scala Publishers
Northburgh House
10 Northburgh Street
London EC1V 0AT

in association with
The Textile Museum
2320 S Street NW Washington
DC 20008-4088

for the exhibition *Textiles for This World and Beyond: Treasures from Insular Southeast Asia*
March 3–August 7, 2005 (Batik) and April 1–September 18, 2005

ISBN 1 85759 376 6

Project Editor: Esme West
Copy Editor: Richard G. Gallin
Design: Andrew Shoolbred
Map: Caesar Chaves
Produced by Scala Publishers
Printed and bound in China

Studio photographs: Jeffrey Crespi, Franko Khoury, and Jennifer Heimbecker
Location photographs: Mattibelle Gittinger (2.1, 3.1–3.5, 5.2, 5.3, 5.6, 5.7); Judith Bird (6.2, 6.3);
Geneviève Duggan (5.1, 5.5); Traude Gavin (7.1); Joan Teer Jacobson (6.1); Cornelia Vogelsanger (7.2);
and E. O. Waples (4.1)

Details: cover (Fig. 4.2), pp. 2–3 (Fig. 6.5), p. 4 (Fig. 7.5), pp. 6–7 (Fig. 6.8), and pp. 8–9 (Fig. 3.8)

Contents

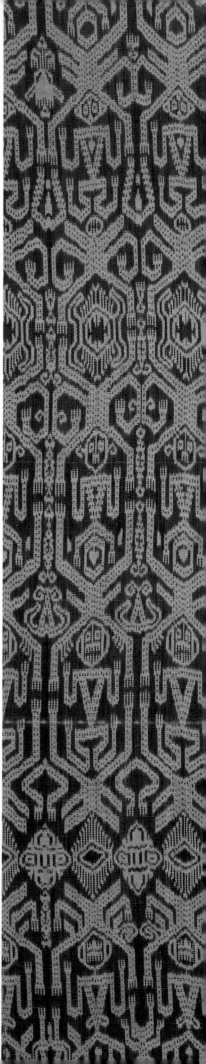

Foreword

The Textile Museum has played a crucial role in bringing to light the diversity, complexity, and resilience of human creativity and cultural expression in the textiles of Southeast Asia.

Starting with *Splendid Symbols: Textiles and Tradition in Indonesia* (1979), The Textile Museum has explored the role of textiles as a symbolic medium functioning on many levels of understanding and communication. Complementing that exhibition was the Irene Emery Roundtable on Museum Textiles (1979), an international forum for discussion of the varied roles textiles play in Indonesia.

The exhibition *Splendid Symbols* was conceived around the holdings of The Textile Museum but quickly grew to draw upon virtually every major Indonesian collection in this country and Europe. Such is the development of The Textile Museum's collection that in 2005, *Textiles for This World and Beyond* is drawn solely from The Textile Museum's own holdings.

On the heels of *Splendid Symbols*, The Textile Museum presented *Master Dyers to the World: Technique and Trade in Early Indian Dyed Cotton Textiles* (1982). Centered on cotton, the exhibition followed the extensive trade in Indian goods worldwide, first as novelties, later as essential materials.

Relatively little attention had been paid to the mainland textiles of Southeast Asia until *Textiles and the Tai Experience in Southeast Asia* (1992) centered on the Thai/Lao tradition. Presented in honor of Her Majesty Queen Sirikit of Thailand on the occasion of her Fifth Cycle Birthday, this Textile Museum exhibition positioned textiles as entry points to Tai culture and the history of the Tai people.

In subsequent years The Textile Museum has continued to display Southeast Asian textiles in thematic exhibitions. Among these were *From the Land of the Thunder Dragon: Textile Arts from Bhutan* (1995) organized by the Peabody Essex Museum, Salem, Massachusetts, and *Fabric of Enchantment: Batik from the North Coast of Java* (1999), organized by the Los Angeles County Museum of Art. An exquisite presentation of piña cloth, *Sweet Yarns: The Story of a Noble Fiber from the Philippines* (1998), drawn from the Museum's collections, complemented *From the Rainbow's Varied Hue: Textiles of the Southern Philippines* (1998), an exhibition organized by the UCLA Fowler Museum of Cultural History.

The Textile Museum has a mission distinctive among the world's museums, even

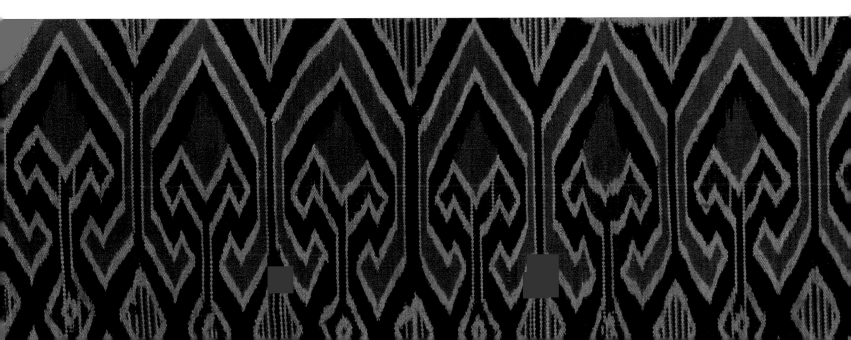

among the limited number of museums devoted solely to textile art. The direction that The Textile Museum has provided in the scholarly examination and presentation of textiles of Southeast Asia has galvanized leadership in these countries to establish their own museums of textiles.

Thanks to Dr. Mattiebelle Gittinger, Research Associate for Southeast Asian Textiles, the importance of these textiles has been made more evident to the world at large. Dr. Gittinger has been the curator of each of The Textile Museum's exhibitions of Southeast Asian textiles, and her books have contributed substantially to our knowledge about them. Her work has also given Southeast Asians themselves impetus to appreciate and to conserve their own material cultures.

The Textile Museum is profoundly grateful to The Christensen Fund, Palo Alto, for a gift made in 2000 of twenty-nine textiles that permitted the Museum to strengthen the collections in particular areas. These included rare nineteenth-century examples from Sarawak thought to be some of the earliest Ibanic material in existence, huge funerary hangings from Sulawesi, and unique textiles from the eastern part of the archipelago. Virtually none of this material has ever before been exhibited by the Museum, and some has never previously been seen in this country. In addition, gifts of batik-patterned cloth from Mary Jane and Sanford Bloom, Kangjeng Raden Tumenggung Hardjonagoro, and Beverly Deffes Labin allow the presentation of a range of examples of cloths favored by ethnic groups such as the Indonesian Chinese, Indonesian Europeans, and Indonesian Arab communities along the north coast of Java and others from the courts of Central Java.

Exhibitions of this scope, significance, and sheer magnitude could not be accomplished without the tireless efforts of the entire staff of The Textile Museum. Particularly instrumental in the development and execution of *Textiles for This World and Beyond* were former Director Ursula Eland McCracken and staff members Doug Anderson, Rachel Bucci, Theresa Esterlund, Anna Grishkova, Mary Mallia, Esther Méthé, Frank Petty, Erin E. Roberts, Crystal Sammons, Richard Timpson, and Sara Trautman-Yeğenoğlu.

Special recognition and thanks are afforded to The Blakemore Foundation, E. Rhodes and Leona B. Carpenter Foundation, Jeremy and Hannelore Grantham, Furthermore: a program of the J.M. Kaplan Fund, and Peter Reed for their contributions, which enabled this exhibition and catalogue to be realized.

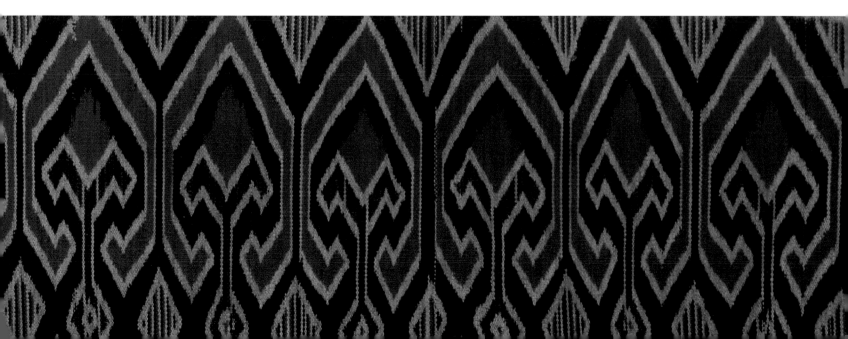

Preface

When The Textile Museum presented its first exhibition of insular Southeast Asian textiles in 1979, the resource material available to place the textiles in social or religious contexts was extremely slender and most of it remarkably old. The Museum's holdings of these textiles were small and had to be augmented with loans from generous individuals and institutions in this country and abroad. Much has changed in the intervening twenty-six years. The Textile Museum has been able to augment this area of the collection—although not as much as hoped for—with the help of friends and foundations. Most importantly, however, extensive data concerning the functioning of cloth in this region of the world based primarily on micro field studies have been gathered and analyzed, and a wealth of information of vibrant traditions has been preserved.

Several institutions have fostered interest in the textiles of this region of the world by devoting staff time and resources to host international symposia that supplied opportunities for new field research and the publication of this material in a timely fashion. The Textile Museum within the context of the Irene Emery Roundtable series was the first of these in 1979. In 1985 the Rautenstrauch-Joest Museum of Ethnology, Cologne, acted as host, and in 1991 the Institute of Ethnology at the University of Basel and the Museum of Ethnography, Basel. Most recently the National Gallery of Australia, Canberra, sponsored a gathering to celebrate recent acquisitions from this region. These papers from 2003 have yet to be published.

In addition to these symposia, insular Southeast Asia textile studies have had an important part in other types of gatherings. The biennial gathering of the Textile Society of America has usually featured one or more panels; Gadjah Mada University in 1997 hosted the Dunia Batik Conference in Yogyakarta, Indonesia. In 1998 the Freer Gallery of Art in Washington, DC, sponsored a symposium on ikat. The Sarawak Museum in Kuching, Indonesia, explored ikat in a six-day conference in 1999 and in a second gathering in 2001. Textiles of Southeast Asia also found a place within more broadly focused forums. The University of Michigan, Ann Arbor, included many speakers who dealt with the textile arts in its Southeast Asian arts gathering in 2000, and the Association for Asian Studies has featured panels on several textile subjects from this region of Asia.

In addition to papers published from such gatherings, special mention should be made of the institutionally organized studies of outstanding importance. Foremost

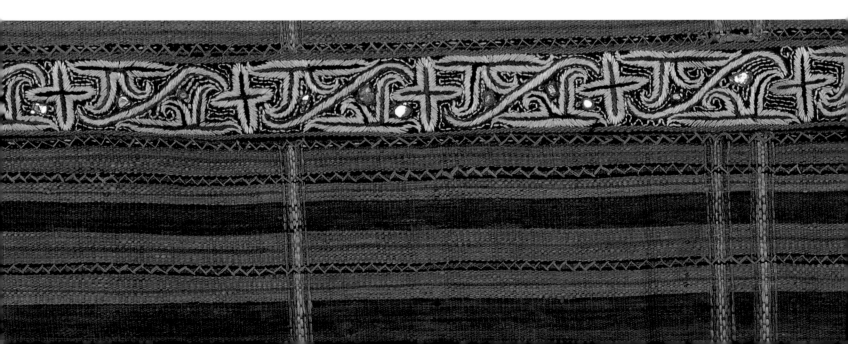

among these is the work on Balinese textiles and culture by the Museum of Ethnography, Basel. While begun in the early twentieth century under the direction of Professor Alfred Bühler, this "Bali tradition" continues in the writings of Brigitta Hauser-Schäublin, Marie-Louise Nabholz-Kartaschoff, and Urs Ramseyer.

Although of a more recent date than the long-standing focus of Basel, the UCLA Fowler Museum of Cultural History under the leadership of Roy W. Hamilton has contributed substantially to an understanding of textiles from Southeast Asia and in particular those of the Indonesian island of Flores and the southern Philippines. In addition to publications the Fowler Museum has made a major commitment to increasing its collections from that region of the world.

Of the major collections created in the past twenty-five years certainly the most striking has been that of the National Gallery of Australia, Canberra, under the curatorship of Robyn Maxwell. Beginning with virtually no Southeast Asian textiles in 1980, this collection has become possibly the world's greatest. Many of its textiles are illustrated in Maxwell's publications.

Outside of the institutional framework the contribution of two scholars in particular should be mentioned for both the quantity and quality of their work: Rens Heringa in the field of batik and Ruth Barnes for the Lesser Sunda Islands and the importance of trade cloths. Batik studies had largely been allowed to repose in the work of early Dutch investigators until Heringa put forward clear new dimensions based on perceptive fieldwork in a few Javanese villages. Barnes has established a pattern for thoroughness and meticulous scholarship in her Lembata studies and her documentation of trade textiles. These women have given us a wealth of information as well as raising the bar for Southeast Asian textile studies.

Mattiebelle Gittinger
Research Associate for Southeast Asian Textiles
The Textile Museum

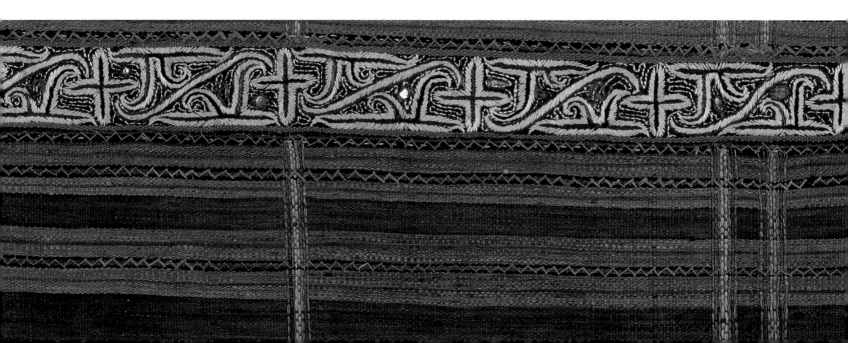

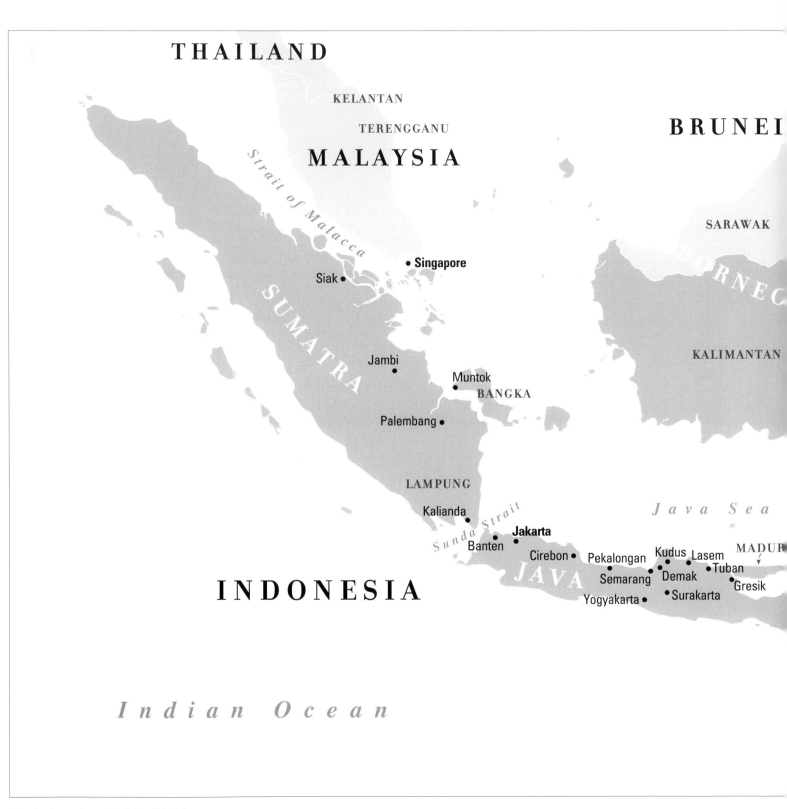

THAILAND

KELANTAN

TERENGGANU

MALAYSIA

BRUNEI

Strait of Malacca

SARAWAK

SUMATRA

BORNEO

• **Singapore**

Siak •

Jambi •

KALIMANTAN

Muntok •

BANGKA

Palembang •

LAMPUNG

Java Sea

Kalianda •

Sunda Strait

Jakarta

MADUR

Banten •

Cirebon • • Pekalongan

Kudus Lasem

INDONESIA

JAVA

Semarang •

Demak • • Tuban

Yogyakarta • • Surakarta

Gresik

Indian Ocean

The Indonesia and Malay World

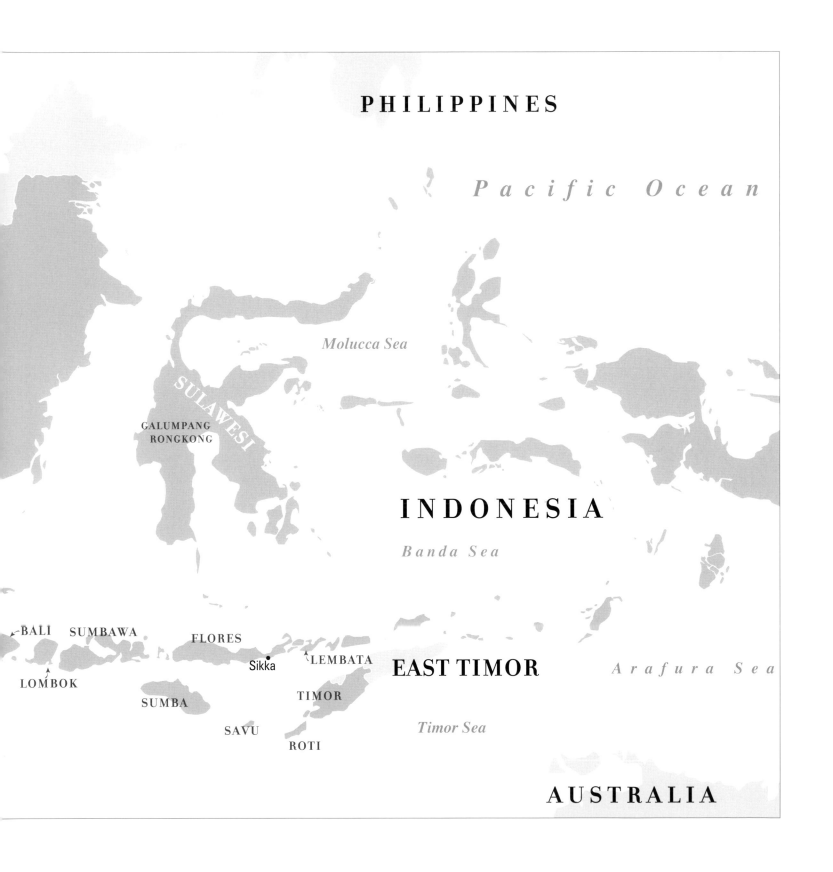

PHILIPPINES

Pacific Ocean

Molucca Sea

SULAWESI

GALUMPANG
RONGKONG

INDONESIA

Banda Sea

BALI SUMBAWA

FLORES

Sikka

LEMBATA

EAST TIMOR

Arafura Sea

LOMBOK

SUMBA

TIMOR

SAVU

Timor Sea

ROTI

AUSTRALIA

Introduction

The people represented in this catalogue are Muslim, Christian, Hindu, and, for want of a better term, animist. They are also Southeast Asians living in Indonesia and Malaysia. Religious and political differences aside, they share a common Austronesian linguistic heritage that seems to have been imbued with an extraordinary sense of the power of cloth. Among these people textiles may be rigorously prescribed gifts, symbols of contractual alliances and obligation, and invitations to gods and spirits as well as items of beauty and conceit.

The Austronesians, ancestors of most Malaysians and Indonesians, are thought to have existed in Taiwan by 3500 BC and to have spread south, then east and west.[1] Ultimately this family contained many languages, extending east as far as Easter Island and west to Madagascar in one of the most extensive and dynamic expansions known to the world prior to the year 1500.[2]

Although this expansion was largely by colonization, there have been diverse trans-formations in these societies. For instance, although no loom is found in Polynesia, in many areas of insular Southeast Asia settled by Austronesians the words for "to weave," "loom," and "shuttle" are similar and may be traced back 4,000 years.[3] This loom was very probably similar to the foot-braced back-tension loom that was used in recent times on Hainan Island and in parts of upland Vietnam and, in a slightly modi-fied form, was once ubiquitous in most of the Southeast Asian region.[4]

In addition to this weaving legacy, the Austronesians of insular Southeast Asia endowed textiles with a worth that seems distinct from virtually all other peoples. This was not a monetary assessment, but a societal investment that gave to textiles a signif-icance that empowered them to enter into all aspects of life and to be viewed on many different levels of interpretation. In some instances the power of cloth extends beyond worldly social structures to relationships with the dead and even to cosmological levels.[5]

The roles textiles enjoy within the varied societies of insular Southeast Asia suggest that the framework of beliefs and customs that control usage must be rooted in a shared far-distant past. Intervening geographical differences and historical happenstance may have brought about the physical differences in textiles seen today, but the continuum of structuring principles that govern how these textiles are used argues for a common heritage.

Foremost within this continuum is the categorization of textile production as women's work. This stands in opposition to men's association with metal and imported goods. These categories provide a conceptual system for ordering social and religious affairs such as gift exchanges between the families of a husband and wife. The bride's family is obliged to give textiles (and other female-classified items such as land) in exchange for male-classified goods such as knives, precious metals, and, now, sewing machines. This pattern of exchange continues through the life of a marriage and beyond the grave and is an enduring expression of alliance.[6]

The metaphorical transparency between women as creators of life and creators of cloth conceptually joins cloth to a range of subjects. Textiles often serve as the nexus in myth, as among some Iban creation stories relating that the first human forms were brought to life after having been covered with a *pua*, the preeminent textile of the Iban (Figs. 7.3–7.5).[7] Women's skirts (Fig. 7.9) also enter into origin stories among the Iban and Malays.[8]

Detail from Figure 5.14

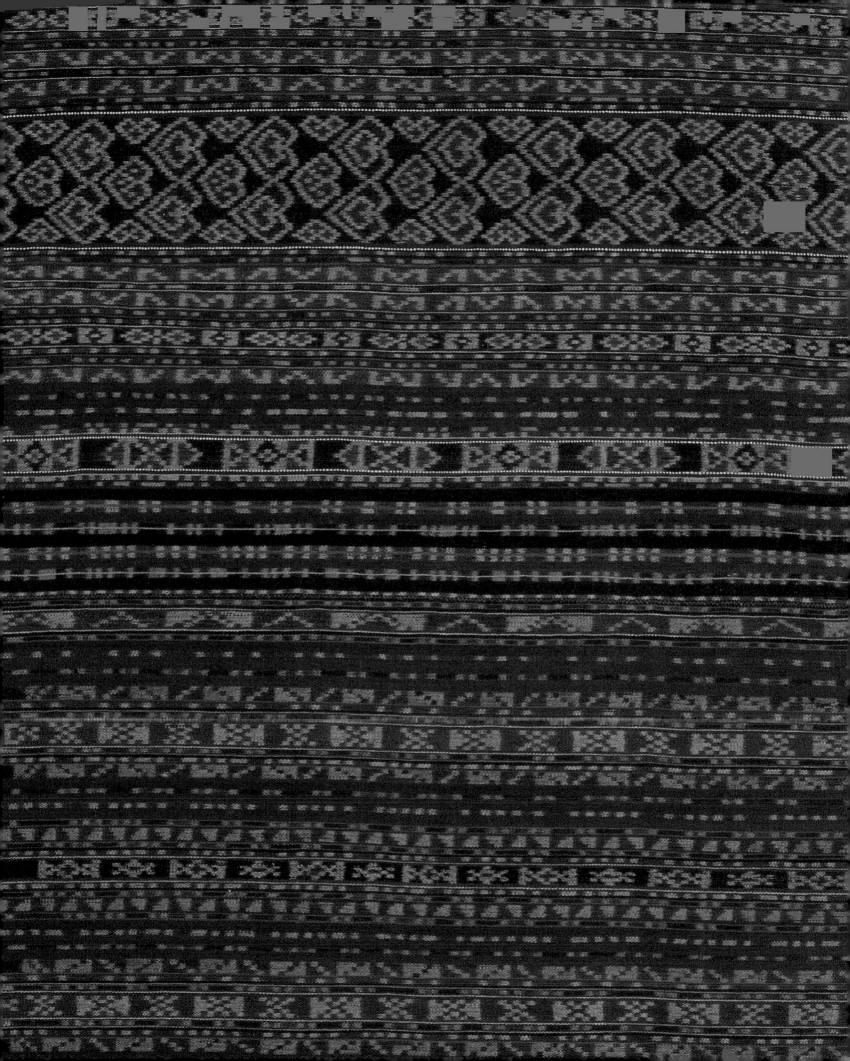

The relationship between textiles and agriculture is another strong conceptual pair. As far back as the ninth century, indigenous Javanese texts reveal that *kain* (cloth pieces) were measured in *blah* (a Javanese word meaning "piece"), which was the term also used to measure *sawah*, or "irrigated fields."[9] Similarly, rice fields on Sulawesi are compared to the sacred textiles known as *mawa'*. On the island of Sumba in the 1960s, according to M.J. Adams, "crop failures were attributed to the failure to carry the sacred textile banner during the opening rites of the planting season."[10]

Rens Heringa's groundbreaking work in a small area of eastern Java explores the connection between cloth and agriculture in great detail. She has shown that in a group of villages near the larger town of Tuban the two principal types of cloth, both hip wrappers, in their terminology and visual properties relate to the land. One is patterned with simple supplementary wefts, and the other is a robust batik worked on locally woven cotton.

Heringa interprets the conceptual ties that inform textile manufacture, agriculture, and fertility.[11] While her interpretation is lengthy and complex, the simplest aspects suggest this relationship between cloth and the land. The symbolism within the batik cloth relates to *sawah*, or "irrigated fields," and that in the woven-patterned cloth to *tegal*, "nonirrigated land."

> The main and most immediate symbolic link is that between the *kain kembangan* [woven cloth] and the *tegal* . . . indicated by the terminology used by the villagers for the separate design sections of the hip wrapper. The center field is called *pelemahan*, cultivated land, a derivation from *lemah* (soil, land). . . . The term for the selvages is *galengan*, also used to denote the low earthen banks edging the field. The dense overlay of flowers covering the central field is related to the flowering crop growing on the land. Near each end, in the so-called *tumpal* sections, the pattern changes into wider spaced floral bands. The weavers view these floral bands as a metaphor for the trees planted at each end of the field.[12]

Batik terminology in these villages includes some of these same terms used for woven cloth, but in place of *galengan*, people use *pinggir*, a term referring to the bank of an irrigated field, and *glontor*, a term applied to a framing design on the cloth and to the ditches of a wet field.[13] Heringa then shows how the processes of textile making and agriculture are closely interlinked.

As creators of textiles, women become the means by which many of their society's structuring principles are revealed or, in some instances, hidden. Among the Sikka of eastern Flores, married women learn motifs from their mothers but arrange them in a sarong format specific to their husband's household.[14] In this manner the cloth clearly relates the alliance of two kin groups. A marriage in this region involves bridewealth and the giving of a cloth and contracts "not so much the marriage of a particular man and woman, but the undertaking of mutual responsibilities between two houses that endure beyond simple lifetime."[15]

Textiles enjoy a role in all life ceremonies in insular Southeast Asia, yet none more so than at funerals. Ritual textiles establish the scene as beyond the ordinary and, as gifts, ensure the benevolence of the dead in the affairs of the living. These broad

themes are manifest in a variety of details in different societies, but all commit a society to focus economic endeavors over a broad period toward rituals surrounding death. So great is this funeral expenditure among certain groups that years of preparation may precede the actual burial (or reburial).

Some of the largest cloths woven in Southeast Asia are those made to honor the dead among the Toraja of Sulawesi (Figs. 6.4a–c). They are used to wrap the dead and enclose graves and were traded to non-weaving groups for these and other uses. So great was the labor involved in these textiles that, contrary to the usual procedure that involved a single woman in the production of a cloth, several women would join to weave these in the Rongkong district.[16] In addition to these ikat-worked cloths, Toraja families treasured groups of sacred cloths known as *sarita* and *mawa'*, and these, too, entered into funerals guaranteeing the efficacy of ritual.[17] *Sarita* (Fig. 6.7) are one of the few Indonesian textiles patterned by a resist process similar to that used to create Javanese batik. Little is known of their actual manufacture in Sulawesi. *Mawa'*, considered sacred family holdings, might consist of imported Javanese batik, trade cloths from India (Fig. 6.5), or other foreign textiles. These were powerful cloths, descended from the ancestors, and were essential to the display at great funerals.

Textile gifts in a funeral context may have slightly different functions. On Sumba some of the textile gifts accompany the dead to the grave, whereas others remain with the family of the deceased and are redistributed at later occasions. In western Sumba each funeral guest brings a textile, and those from relatives are for the deceased to take to relatives and friends in the beyond.[18] The funerals of eastern Sumba nobles, however, have traditionally elicited the greatest number of textiles and astonishing caches of gold ornaments, swords, lances, gongs, buffalo, pigs, horses, and food to feed hundreds of guests for two or more months. Many of these goods are buried after first being displayed in huge piles over the corpse. Eastern Sumbanese see one's rank and status in the beyond as a direct reflection of their status in this world. To maintain their earthly status nobles required suitable offerings to carry to the land of the dead.

Proper costume both in this world and beyond epitomizes an ordered society and universe and is often necessary for the maintenance of this order. One of the strictest examples of this occurs in the traditional village of Tenganan Pegeringsingan on the island of Bali. Here, according to Urs Ramseyer, "[c]lothes . . . are themselves . . . part of the purity that guarantees the survival of the village, its inhabitants and its territory; and owing to their magical powers they also protect the village from the threat of defilement and decay." [19]

While the renowned double ikat textiles of this village immediately come to mind as guardians of the sacred order, the combining of cloth in specific ways is equally essential for effective ritual. Each of the various boys' and girls' associations and married adults' and seniors' groups has specific responsibilities and must be attired in prescribed textiles complemented by required hairstyles and jewelry. These often are plain cotton or simple plaids or stripes constituting inner hip cloth, outer hip cloth, sash, chest cloth, and upper garment.[20] Rules about assembling and wrapping cloth in specific manners are strictly applied to women but less so to men, who, even so, have codes of ritual dress. Punishments for violations of these codes include a three-day exclusion from rituals and social activities for both the offender and spouse.[21]

Both early documents and present custom indicate that cloth and its proper use in

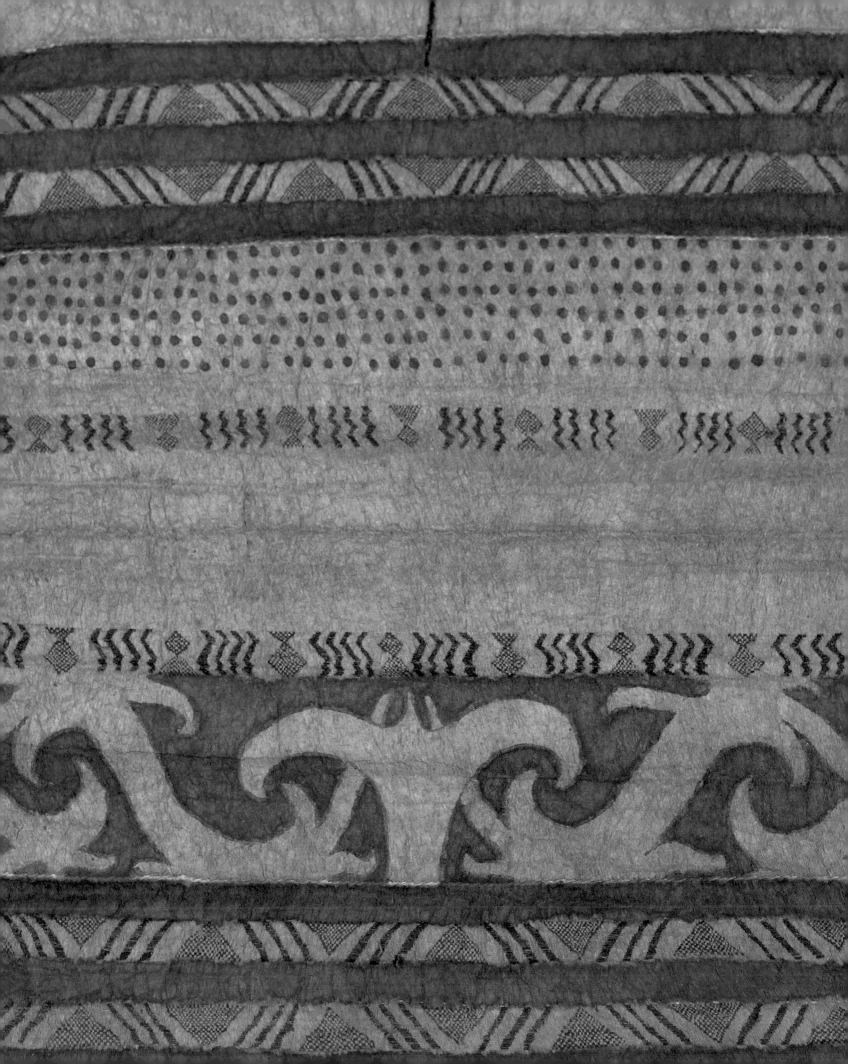

costume has been of significant consequence to the people of Indonesia and Malaysia. Luxuriant costume was considered a sign of the benevolence of the gods and spirits upon a ruler and his realm, and the wealth to afford this costume a sign of morally correct behavior.[22] These beliefs found expression in noble and royal courts in the wearing of brilliant silks embellished with gold metallic yarns. From chronicles as early as the thirteenth century, proper dress may be seen as legitimizing the palladium of state. With prescient foreboding, tradition warned that dressing in a foreign manner would cause the state to fail.[23]

Luxuriant costume reinforced the hierarchical structures that were the matrix of these court societies. Bestowing some of this wealth in the form of ceremonial cloth gifts to loyal subordinates was an established practice particularly noted within installation ceremonies. Melaka Chronicles enumerate the number of trays laden with robes of honor allotted to specific officers and envoys.[24] In the giving and wearing of the gifts there was a reciprocity of allegiance and obligation between ruler and ruled.

Factors of identity and allegiance have also been tightly bound to cloth in insular Southeast Asia. While rooted strongly in the past, this has continued into recent times. Sukarno, the first president of the newly independent Republic of Indonesia, strongly supported the art of batik. He was instrumental in promoting the work of K.R.T. Hardjonagoro (Go Tik Swan), who joined the colorful batik interpretations of the northern coast of Java with the more restrained patterns from the Central Javanese courts. Sukarno saw in this a textile emblematic of a unified country, not just an art of Java. Women in attendance at political functions evinced their support for these ideas by wearing what came to be called "Batik Indonesia" (Fig. 4.16).[25] This style continues to be made today both in inexpensive printed commercial pieces that are marketed throughout Southeast Asia and in artist-worked unique *kain* for the very wealthy.

The constellation of costume, self, and ordered universe repeatedly occurs in daily life in Southeast Asia. At New Year's celebrations even the poorest villager will strive to wear new clothes in the belief that the image of well-being on that day is a forecast for the coming year. As early as the fourteenth century, clothing rules and admonitions were announced on New Year's Day.[26] Men who become Muslim no longer wear ethnic costume, but assume the plaid hip wrapper and cap that show they have "*menjadi melayu*" (become Malay or Muslim). The *dalang*, "the puppet master," in initiating the mythic stories of the theater, establishes the scene and introduces the heroes by describing their costume details.

When the creation of cloth and cloth patterning becomes solely an aspect of a commercial transaction, much of the power of cloth diminishes. The textiles presented here speak of a time before this was true and constitute a small part of a common Austronesian heritage.

Beyond their aesthetic function, design and color—through their absence and presence—convey messages within societies in insular Southeast Asia. In particular instances, these details may speak to what the society forbids to be spoken.

On Savu, each person belongs to a localized male origin group (*udu*, "stack," "cluster," "mound") and a nonlocalized female origin group (*hubi*, "blossom"). The *udu* preside over the agricultural cycle and public affairs, and the *hubi* function in marriage and funerals. Because the *hubi* descend from two founding sisters, the *hubi* are divided into halves known as *hubi ae* (Greater Blossom, associated with red) and *hubi iki* (Lesser Blossom, associated with blue). Membership in a *hubi* may never be spoken, but it is revealed in the textile designs belonging to that group, which are the specific prerogative of the *hubi ae* or *hubi iki* group.

Exclusive *hubi* ownership of particular designs and details of the formatting of a garment is strictly observed. The wearing of such a garment makes a charged statement of possession and membership. Because this type of assertion can lead to friction, women today opt to wear "neutral" patterns that would be permissible to any person. Such a skirt would incorporate both red and blue in the main design band (Fig. 5.18) and would not contain a restricted design detail such as the undulating snake design at the bottom of the skirt in Figure 5.16, which belongs to the Lesser Blossom group repertoire.

Customs governing the making of these Savu textiles also include the inviolate rule that the weaver acknowledges her Blossom group ancestry by including a narrow red or blue stripe in the selvedge that is normally not visible when the two skirt panels are sewn together. This custom, accompanied by symbolic offerings to the appropriate founding ancestress at the beginning of the weaving, ensures the favor and ultimate success of the undertaking.[1]

Beyond the role of clothing, it is startling to observe the finer function of women's weaving in Savu and, as will be pointed out, in some other societies of insular Southeast Asia. Normally a function of oral traditions in preliterate societies, myth and lineage are here recorded in visual form by women.

In Savu, as elsewhere in Southeast Asia, the use of pattern implies maturity on the part of the wearer and, occasionally, the maker. The first sarong a young Savu girl wears carries no patterning, merely simple warp stripes. Only later does she wear Blossom-aligned patterns. In Sarawak among the Iban, when one speaks of the perils of weaving, this does not apply to plain cloth, but only to patterned cloth, especially the large warp ikat *pua* (ritual blanket). In Iban societies the making of certain patterns is inherently dangerous. The mythical tiger pattern in Figure 7.6 is one of these, and only mentally and physically mature women undertake this type. Creating completely new patterns is also only for the strong, socially mature weaver who can withstand the potential ill effect of this creative process. Pattern making is potentially dangerous and avoided at times when a community feels weakened, such as times of death. Weaving ceases during a mourning period and even the making of patterned baskets is not allowed.[2] Patterns may contain multiple layers of meaning realized by only a few observers. Iban weavers who create new patterns on *pua* may endow them with a special name—the so-called praise name—that is orally transmitted when the weaver presents the *pua* to her longhouse community. These named cloths are regarded as particularly powerful, enhanced by the message contained in their title.

Figure 2.1
An indigo dyer at work in Todo, Manggari, Flores, 1965.

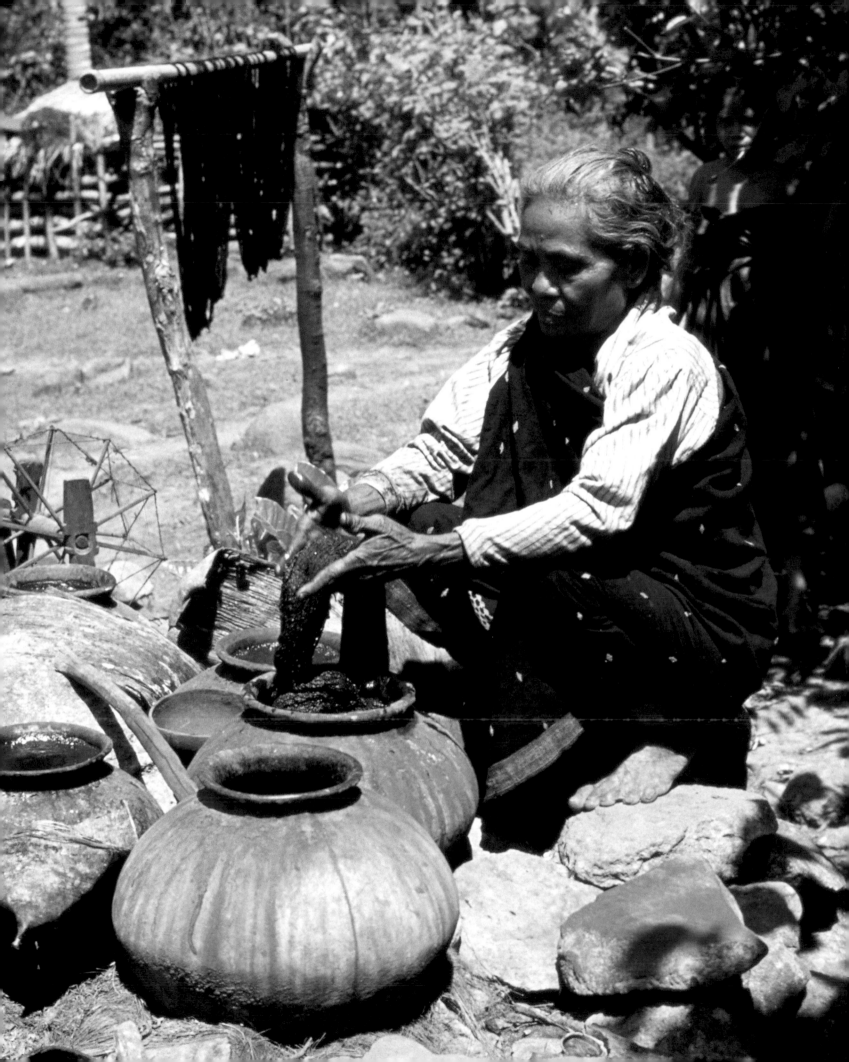

Names are also associated with batik patterns. On one level these are genre names generally used by factories and commercial outlets to classify types of patterns such as *alas-alasan*. These are usually descriptive names. However, formerly batiks produced by experts in the courts of Central Java might carry proper names and be erudite interpretations of abstractions of these names. The resulting patterns would reflect the education and experience of the batik artist as well as her consideration of the characteristics of the person for whom the batik was made. According to Justine Boow, "For this court community, proper names are associated with meaningful batik patterns. It (a name) provides the key to the mystical meaning of the pattern. . . . It thus provides access to religious ideas. Those with proper names are sacred and meaningful and can affect the course of events or the nature of the material world." [3]

Only a very small elite possessed the esoteric knowledge to name batik and confer the power this represented. These named patterns are highly stylized and carry such proper names as *Bondet*: "The Knot"; *Pudak mekar*: "Opening Rose"; and *Peksi Kresna*: "Bird of Krishna." [4] A well-known story from the eighteenth century concerns the naming of a batik pattern that resulted from the return of the sultan's love when he saw his wife making batik. She named it *truntum* meaning "to grow" in the sense of "the budding of love." [5] The very unusual batik in Figure 4.2 would very probably have had a proper name given by the batik artist, although it is no longer known.

Color in batik and in other textiles is extremely important in insular Southeast Asia. The breast wrappers in Figures 4.3 and 4.4 describe to a great extent the women who made them and who would wear them. The pink center field and precise simplified design of the former and the dark colors used on the second wrapper with its complex patterning mirror the ages of the women involved—young and old. While batik pattern descriptions may contain many elements, the most comprehensive description will say if the background is light (*putih*) or dark (*ireng*). To a large extent these color alignments control the appropriateness of a particular batik to a costume. The details of this "suitability" reach back to ancient concepts.

The Javanese identify four colors, and these are aligned with the cardinal directions: white in the east, red in the south, yellow in the west, black in the north, plus a multicolor of these associated with the center. [6] Human life is traced along this circle and becomes associated with the representative colors at life's different stages.

Heringa has explored the intricacies of this system. [7] Her work centers on the roughly patterned but highly structured textiles made in the Tuban area, a remote area of Java. Certain villages in this region continue to produce hand-spun cotton yarns, to weave, and to pattern cloth both by weaving and resist processes. Heringa's work aligns the color of these textiles with color categories and stages in a person's life. White textiles with light blue patterning reflect the lack of color before life's journey and are appropriate in early infancy before being "considered human." Only when a girl enters puberty and is considered marriageable is she able to wear a bright red pattern on a white ground. When married, the young wife will wear a blue cloth. Heringa points out that these early types of cloth each utilize a single dye color. In contrast, when a woman bears a child her cloth will contain red and blue, which in some parts of the design parts commingle to a black. In the final stage of life as a grandmother, she wears completely dark cloth that in reality is achieved by the overdyeing of three layers of dye. [8] Her cloth incorporates all of her life experience.

The color blue has probably been a part of the textile arts of Southeast Asia from the earliest times. While not a simple process, indigo dyeing has readily been accessible to much of Southeast Asia, and much of the basic clothing worn in the region was once dyed with this color. Myth and practice in part of western Sumba show this is not completely true because they did not have indigo-dyeing skills at one time. Here legend records the origin of indigo dyeing goes back to an ancestress who came from Savu and was thought to have been a witch. To this day, the secrets of blue dyeing in this region remain in the hands of her descendants.[9] The early name for west Java was *Tarum* meaning "indigo," and indigo was once the most commonly used coloring agent throughout the archipelago. That term is still used by the Iban; however, the name readily used on Java in historical times is *nila* stemming from Sanskrit terminology. It is thought this reflects the introduction of better indigo varieties from India.

Indigo also became entangled with trade and politics in the archipelago during Dutch control in the seventeenth and eighteenth centuries. Indigo was critical to the production of textiles in India that the Dutch needed to barter for goods in the islands. As the British in India isolated indigo sources, the Dutch turned to leaders on certain islands to produce indigo for their Indian production centers. These special alliances gave rise to traditions and events continued into the present.

The issue of red dyeing is even more problematic. The red-dyeing process is not readily accessible without a tutored background. This is particularly so when dyeing cotton, a fiber notoriously reluctant to absorb coloring agents. Red dyeing requires pretreating the yarns with an oil and a mordant, a substance, usually a metallic salt such as alum, that chemically bonds with the coloring agent in the dye. Javanese charters from the ninth and tenth centuries indicate red and blue were the predominant color of textiles given as gifts.[10] Semiprofessionals and professionals dealt with these dyestuffs as well as plant materials producing other colors.

The inherent complexity of red dyeing invited secrecy and a reserved status. This, in turn, lent the color red special qualities that found expression in textile usage and customs. In eastern Sumba, only noble women once knew the secrets of red dyeing and only the garments of nobles could utilize this color (Fig. 5.8). Nobles could lend their patterned cloths to warriors, dancers, and personal retainers, but they always kept the finest for their burial. Great nobles went to heaven wrapped in ten to twenty garments with abundant additional cloth given by relations.[11] Wrappers of commoners carry designs worked only in blue (Fig. 5.9).

In areas of western Timor, red was similarly reserved for a class of nobles.[12] In certain villages on Lembata, a woman's sarong suitable for marriage exchange (Fig. 5.13) had to contain red.[13]

Probably the most complex associations with red occur among the Iban of Sarawak, who experience a great deal of anxiety associated with red dyeing because it is considered a dangerous task. Women will not undertake this dyeing without a special invitation from the gods or spirits to do so.[14] Once initiated, however, other women will bring their readied yarns to join in the ceremonies and procedures that oil and prepare the fibers. This ceremony, called *ngar,* may be attended only by women and is accompanied by numerous offerings. The women wear their finest skirts and hang beautiful *pua* to invite the gods to join in the work and bless its outcome.[15] Iban society pays the leader of this ceremony the highest regard possible and equates her prestige to that of

war leaders. Just as warriors sport tattoos, women who conduct the *ngar* ceremony declare their status by tattoos on their thumbs.

With the exception of the batik textiles, the cloths discussed above were patterned by warp ikat. This is thought to be possibly one of the oldest patterning processes practiced in Southeast Asia after that of painted bark cloth.[16] The earliest extant example comes from an archaeological site in the Philippines dating to the fifteenth century. Words written in Javanese charters of the tenth century indicate that taxes were applied to tiers, a category of semiprofessional craftsmen, normally paired with dyer. This suggests ikat yarns were actively being made and sold at that time.[17] These were probably cotton yarns used in warp patterning, and not silk, which is not reported in Java or Bali until the eleventh century. Although sericulture was reported on these islands by Chinese records of that time, it was probably limited in distribution. Even in historical times silk weaving and the closely associated weft ikat patterning have been limited to certain coastal enclaves and court-supported enterprises. Adjustments to existing loom technology as well as the expense of the fiber itself curbed its unlimited expansion. When silk was used, Southeast Asian weavers were able to produce some of the most stunning textiles known (Figs. 3.12, 3.13).

The origin and advent of batik in Java is quite murky. Records referring to "written cloth" in the twelfth century probably represent the beginnings of this type of patterning on Java.[18] There is no clear sequence of development because the oldest examples can be traced only to the nineteenth century. Sir Thomas Stamford Raffles built a small collection of models and puppets during his time as lieutenant governor of Java (1811–16) that recorded some costume patterns. Those remaining in the British Museum show that such honored patterns as *alas-alasan*, *ceplok*, *kawung*, *parang*, and *poleng* were well developed.[19] From the published evidence one hundred years later it seems many patterns, particularly ones of a geometric character, either developed in that interval or were not recorded in Raffles's admittedly small sample.[20]

Outside of Java, simple resist patterning like batik was worked on cotton cloth by the Toraja of Sulawesi to create some of their most treasured ceremonial textiles (Fig. 6.7). It is not clear what stage in the historical development of resist patterning these quite primitive renderings represent. At a relative late time, batik textiles were also made in the Jambi region of Sumatra. These are thought to originate from Javanese influences.

These resist means of patterning, ikat and batik, share renown with patterning worked on the loom. Principally this is patterning with supplementary wefts either worked continuously or discontinuously across the weft dimension. Cotton, silk, and metallic yarns all appear in this technique, often in mixed combinations (Figs. 3.11, 3.14). This technique is so widely spread through insular Southeast Asia that it defies a historical or geographical association.

Supplementary warp patterning does not present such a ubiquitous distribution. This patterning has been relatively restricted in insular Southeast Asia in historical times. It has been known in eastern Timor where it was used for skirts and belts and in narrow bands.[21] In eastern Sumba it was the patterning structure of choice for women's wrappers (Fig. 5.11). Also, on Savu the structure appears in three narrow bands on women's wrappers belonging to the Greater Blossom group. Termed *raja*, the bands give the tube skirt its name, *ei raja*. At one time this may have been associated

only with nobles of the Greater Blossom group, being found also on men's belts of that group.[22] Among the Ngadha of Flores, men also used supplementary warp-patterned belts.[23] A remarkable holding of supplementary warp-patterned long narrow panels exists in the British Museum. They are thought to come from Borneo where they were sewn into jackets. The problems inherent to supplementary warp patterning involve maintaining sufficient tension on the supplementary yarns, which by their very function must be slightly longer than the foundation warp.[24] These difficulties are more easily solved on narrow widths, and one supposes this to be a very old patterning structure in Southeast Asia when the simplest of back-tension looms were used.

The same suspicion applies to structures such as weft twining. This structure appears on warrior's garments and items associated with perilous times, both spiritual and physical. Among the Iban it appears in the lower decorative border on the back of the jacket (Fig. 7.13), and in Timor it is joined with twined tapestry on headhunter costumes.[25] On Sumatra, twining was used to finish the ends of fine mantles in decorative cross borders and once was the structure of finely patterned men's bags. In western Sumba the men's mantles are not considered complete if the warp ends of the cloth are not finished by a twined or woven border.[26]

Within the Southeast Asian context, the fine details of textile construction and usage encode a historical record of the societies that made them. The following textiles help to reveal some of those messages.

Sumatran geography aided by the caprice of history has resulted in an island of diverse cultures. Contacts with India, the Arab world, Europe, and China have all in various ways influenced the peoples of this, the sixth largest island in the world. This is mirrored in the textile arts, which are distinctly different among these groups. The present exhibition looks at only two distinct textile types, but these are diverse in subject matter, including some of the most complex images of Southeast Asia and some of the most luxurious patterning in Asia.

Ceremonial Textiles in South Sumatra

The Lampung, the southernmost region of the island of Sumatra has been neighbor to some of the most important kingdoms in the region. To the north, in the area of Palembang, in the first millennium was the kingdom of Srivijaya with its important Buddhist center, which attracted students from much of Asia. To the south were the kingdoms of Java and a powerful trade center just across the Sunda Strait. These undoubtedly influenced the Lampung cultures we know today and to a great degree the textiles of this region. Of equal interest is the close relationship many of the South Sumatran textiles have in design details and social functions with those of mainland Southeast Asia, especially textiles made by the Tai linguistic groups.[1] In looking at the textiles from this region, we are probably seeing evidence of very early close contacts within Southeast Asia and possible suggestions of customs dating to the last half of the first millennium.

Three groups of people live in the Lampung area. Along the south and parts of the west coast and in the interior near Lake Ranau are the Paminggir. Further inland, to the east, are Abung, and between these two live the Pubian. In historical times, the Paminggir and the Abung have been highly stratified societies with graded systems of ranks accompanied by privileges. Among the Abung this included the right to ride in a special bird carriage at festivities (Fig. 3.1), to erect a gate of honor, and to use special umbrellas and seats of honor. Among the Paminggir, rank was associated with privileges including the right to carry special objects in ceremonial processions but, most importantly, with the right to use certain textiles.

Originally only the heads of lineage groups known as *marga* and *suku* had the right to use one of the long textiles known as *palepai* (Fig. 3.6). This was hung behind the principal person of a transition rite such as boy's circumcision, marriage, advancement in rank, or death. This was a jealously guarded prerogative that weakened only in the 1970s when others could ask to borrow a cloth for a ceremony. This type of ceremonial cloth, approximately 300 by 65 centimeters, was patterned by cotton supplementary wefts on a plain-weave cotton foundation.

The *palepai* compositions may be organized into five types based on color and design elements. One of these may be interpreted as representing an upper world with images of ancestors, ancestor shrines, birds, and the color red. A second seems to be associated more with this world with images of earthly dwellings, animals, and the color blue. Two other *palepai* have completely different images, one has rows of human figures and another is composed of different design panels showing stylized trees.[2] A single red ship characterizes still another type.

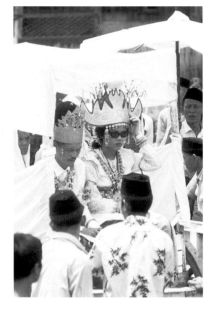

Figure 3.1
Among the Abung the bride and groom of aristocratic families have the right to use a special conveyance modeled in the form of a bird when traveling to the central stage at the traditional part of the ceremony. Gunung Sugih, Lampung, 1971.

Detail from Figure 3.12

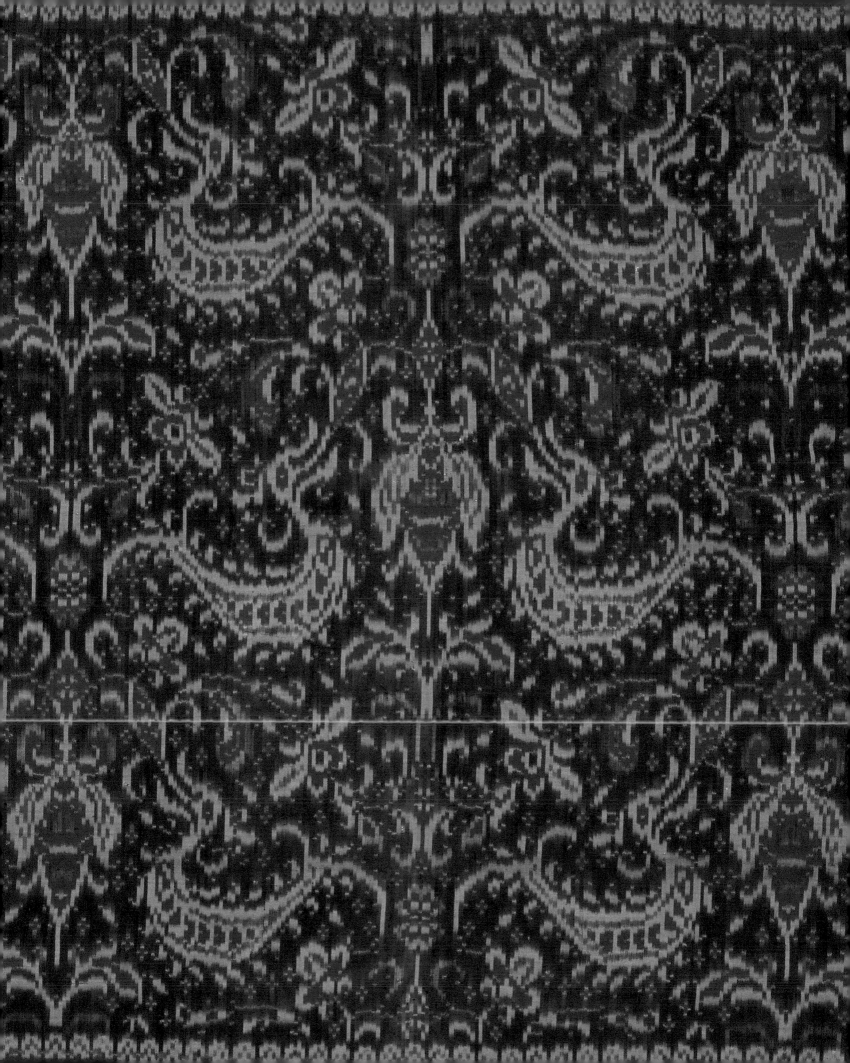

Figure 3.2
In elaborate weddings among the Abung, eligible unmarried women from the bride's family have their ears symbolically pierced by the members of the groom's family using sacred kris. Gunung Sugih, Lampung, 1971.

Figure 3.3
An ancestor shrine near Gunung Menung, Lampung. These umbrella-shaped forms may be seen depicted in textiles from the area, 1970.

While we do not have the evidence to organize each of these types into a recognizable system, these textiles seem to have represented concepts of a social structuring that operated among the Paminggir living along the south coast. The *suku* were highly stratified, being considered strong or weak and positioned in relationships designated as to the right and to the left. When several *palepai* were hung, as at a *marga* event, they reflected this alignment. At one time the design elements of the several types probably abetted such an organizational scheme.

These textiles have been called ship cloths in the Western world after the dominant use of ships in the design vocabulary. The inventory also includes many other forms of conveyance: birds, horses, elephants, and many imaginary forms, all of which could enter into concepts of transition from one stage of existence to another.

While *palepai* usage was limited to people of rank, another form of ship cloth, the *tampan*, seemingly operated through much of the society. These are small rectangles ranging in size from 30 to 100 centimeters on a side and, like the *palepai* are patterned with cotton or silk supplementary wefts on a plain-weave cotton foundation. The compositions range from simple geometric forms to complex narrative scenes (Figs. 3.7a–d).

These textiles were essential to virtually all social interactions. They wrapped ceremonial foods at engagement and marriage transactions when they established paths of gift exchange that endured through all of a marriage and even after death. Together with a woven mat the *tampan* was a part of a gift of allegiance to a superior. When combined with other objects (Figs. 3.4, 3.5), the cloths help to create symbols critical to proper ritual. [3]

The weaving of these textiles in the Lampung area seems to have ceased about the turn of the twentieth century. In the 1980s they became the focus of intense collecting on the part of art dealers and are now virtually all in private or museum holdings around the world.

Both the Abung and the Paminggir are known for elaborate women's skirts known as *tapis*. The Paminggir of the interior knew a style with elaborately embroidered panels showing ships carrying figures (Figs. 3.8, 3.9). Often these skirts contain bands of warp ikat patterning that may show additional ship forms or patterns copied from the Indian-made patola. The *tapis* of the Abung are heavy with couched metallic yarns on a locally woven cotton base. While initially this embroidery may have replicated simple forms (Fig. 3.10), over time the gold yarns covered the entire surface. These skirts were the costume of flamboyant ceremonies, most often associated with marriage. They singled out the important participants and were essential in the multiple changes of costume that marked various stages in the ritual.

Textiles in Eastern Sumatra and the Malay Peninsula

The internal evidence in design and technology of the textiles of Palembang, Muntok, Siak, and the Malaysian centers of Terengganu and Kelantan argue for a similar origin. Historians are just not able to prove what that similar origin was. The textiles are patterned by weft ikat and a supplementary weft structure known as *songket,* using primarily metallic yarns on a silk foundation. Both types of cloth were brought to

aesthetic and technical perfection on the east coast of Sumatra, and the gold cloth of Terengganu (Fig. 3.14) was perfected in court ateliers supported by state rulers. People in Terengganu say *songket* technology came to them from India via Palembang and Jambi, whereas those in Kelantan point to Cambodia and Thailand by way of Pattani in southern Thailand as their source.[4]

Weaving in Kelantan can be traced to back to 1610 and in Terengganu from the early eighteenth century.[5] Production of weft ikat seems to have largely stopped in most of Malaysia early in the twentieth century. Interest on the part of some state sultans in the 1930s kept the arts of *songket* alive, and it may now be found in Kelantan and Terengganu as well as in smaller centers in Pahang, Johor, and Selangor.[6]

Originally *songket* was limited to royalty. These textiles were the visual evidence of the prosperity of the Malay courts. They were essential evidence of both material and moral well-being. The textiles also entered the fray of competition between the courts for splendor and extravagance in ceremony and in gift giving. Visiting royalty and foreign dignitaries normally received *songket* gifts, a product of the court workshops. The practice of bestowing gifts of cloth continues today.[7]

The weft ikat patterned silks from these centers are some of the most beautiful and luxuriant textiles made in Southeast Asia. The orchestration of red, blue, and yellow produces a spectrum of colors used to enhance lyrical forms of birds, snakes, and flowers (Figs. 3.11–3.14).

These cloths also present textile scholars with the problems associated with weft ikat. This technique is paired with silk weaving in insular Southeast Asia in contrast to warp ikat, which largely appears on cotton.[8] No reliable evidence suggests the origins of weft ikat in this region, but its manufacture is associated with coastal enclaves, many of which had participated in international commerce since the first millennium. The problem is also compounded by the fact that we do not know the advent or the source of silk weaving in this part of the world. Weaving silk requires a device to keep the fine filaments from tangling. On back-tension looms this meant the introduction of the reed or comb and the wrapping of longer warp yarns on a board rather than letting them circle back toward the weaver. This directly encouraged the weaver to favor weft patterning. With the patterns carried in the weft, the weaver could adjust the patterns that had been dyed on the weft with each insertion. This, as well as the finer silk yarn, allowed for extremely fine pattern definition.

In historical times weft ikat on silk has been associated with the Khmer, Cham, and Tai weavers of Cambodia and parts of Thailand. Some of the tools used on the mainland also appear in reports from Sumatra. There is surely some link among these areas, possibly even the exchange of weavers. Such an initial introduction may have been overlain by subsequent changes in both areas.

Figure 3.4
A Serawai groom carries a ceremonial spear adorned with a *tampan* to the area of the ritual killing of a buffalo. Kampung Pudding, 1970.

Figure 3.5
The *tampan* is removed from the spear and placed in the gift of ritual foods sent to the bride's family. Kampung Pudding, 1970.

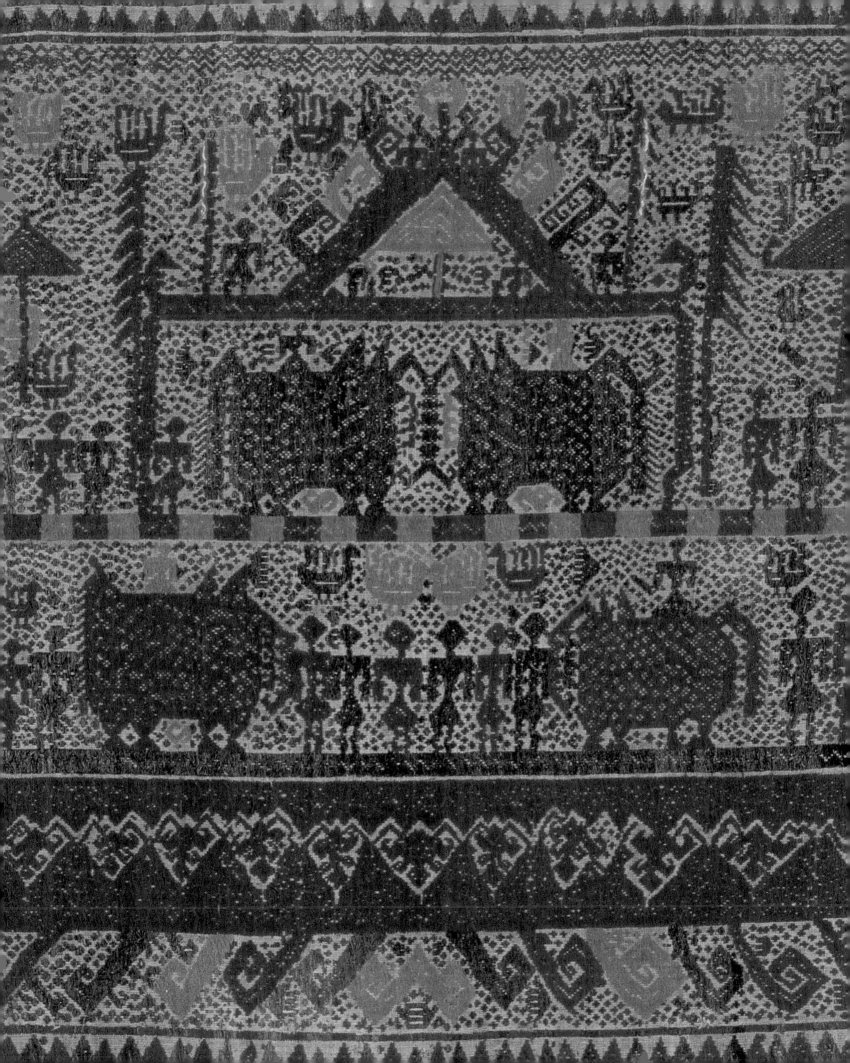

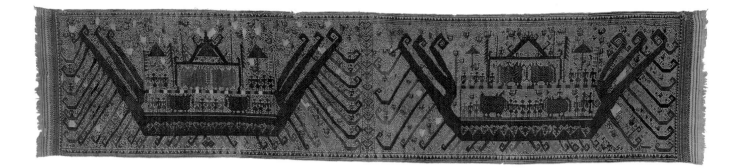

3.6
CEREMONIAL HANGING
(*palepai*)

Indonesia, Sumatra, Lampung, possibly the
Kalianda Peninsula
Paminggir people
Cotton, continuous and discontinuous
supplementary wefts
Warp 315 cm x weft 71 cm
The Textile Museum 1962.41.1
Museum purchase

Images of people, elephants, birds, and
banners crowd the two large ships that fill
this cloth. The umbrella-shaped forms
refer to ancestor shrines once known in
the region. Such cloths were hung within a
house during life transition rites, and it is
appropriate that ancestors would be called
to witness such a celebration.

 Palepai of several distinct formats
were known in this region of South
Sumatra. It is thought their different
design features and colors once partook
of a complementary system representing
this world and an upper world. The cloths
have not been woven since the early part
of the twentieth century. Although they
continued in use into the 1970s, an under-
standing of the finer details concerning
their iconography was lost. This region of
Sumatra was largely devastated in the
eruption of Krakatoa in 1883. Many of the
cloths were destroyed at that time, and it
is possible that the details informing the
design system were lost in the period
before weaving resumed.

3.7a–d
CEREMONIAL CLOTHS (*tampan*)

Indonesia, Sumatra, Lampung
Paminggir and Serawai people
Cotton, supplementary wefts

a. Warp 38 cm x weft 38 cm
The Textile Museum 1984.23.2
Gift of Mr. and Mrs. G. Reginald van Raalte

b. Warp 51 cm x weft 46 cm
The Textile Museum 1984.23.5
Gift of Mr. and Mrs. G. Reginald van Raalte

c. Warp 46 cm x weft 41 cm
The Textile Museum 1983.42.22
Gift of Mr. and Mrs. Edward H. Smith, Jr.

d. Warp 91 cm x weft 79 cm
The Textile Museum 1980.2
Gift of John Maveety

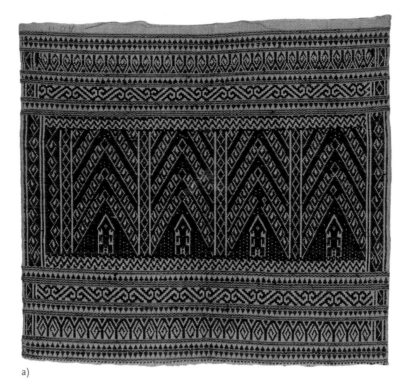
a)

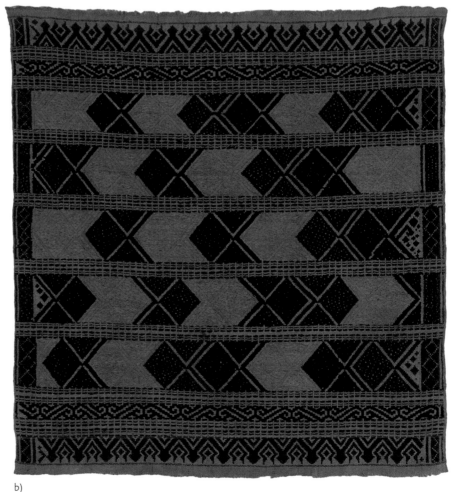
b)

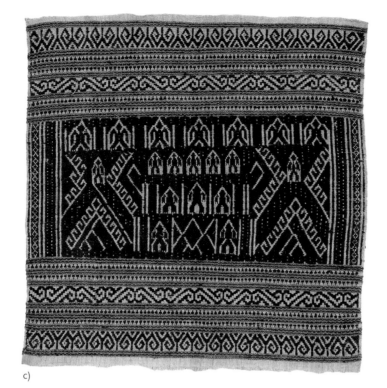

c)

These four *tampan* are representative of this type of cloth, showing a typical range of sizes, colors, and patterning from simple to complex. At one time they were essential wrappings for ceremonial foods exchanged in large numbers at weddings, namings of new children, circumcision, and funerals. The largest cloth, with its complex imagery similar to the adjoining *palepai*, would have covered many smaller packets carried on a large litter in a ceremonial procession. While the families of both a husband and a wife were obliged to contribute such packets at various times in the ritual life of a family, the wife's family always contributed the larger number.

The cloths when joined with other objects helped to create ritual symbols. Among the Serawai one of the *tampan* is tied to a ceremonial spear that attends all stages of a wedding. In this role the cloth helps to form a tree of life that is destroyed at the end of the ceremony when the *tampan* is removed and sent to the bride's family with ritual food.

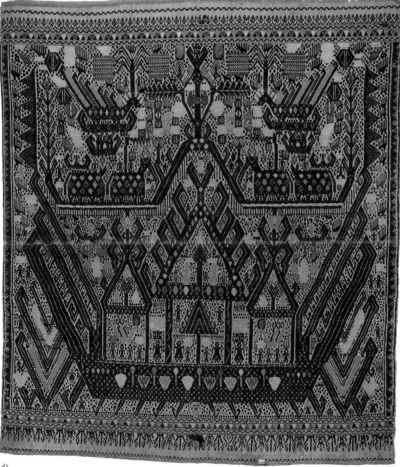

d)

3.8
SKIRT (*tapis*)

Indonesia, Sumatra, Lampung
Paminggir people
Cotton, silk embroidery yarns, mirrored glass
Embroidery (satin, running, herringbone
stitches)
Warp 127 cm x weft 104 cm
The Textile Museum 2000.23.1
Gift of David and Isabel Taylor

Although skirts continue to be woven in
the Lampung region, none of this style
seems to have been made since early in the
twentieth century. The finely embroidered
bands with their integrated scenes of ships
peopled by strange forms employ a style
rare in Southeast Asia. The only compa-
rable images, as was pointed out long
ago, exist among the Ngaju of South Kali-
mantan. Thus the subjects of ships, spirit
figures, musical instruments, and trees—
all associated with life transition rites—
probably originate in a very distant past.

 Seven separate bands sewn together
in the warp direction make up the skirt. As
is customary, the embroidery is worked on
an indigo ground.

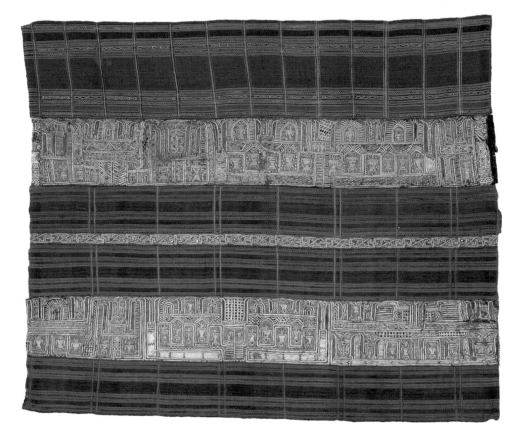

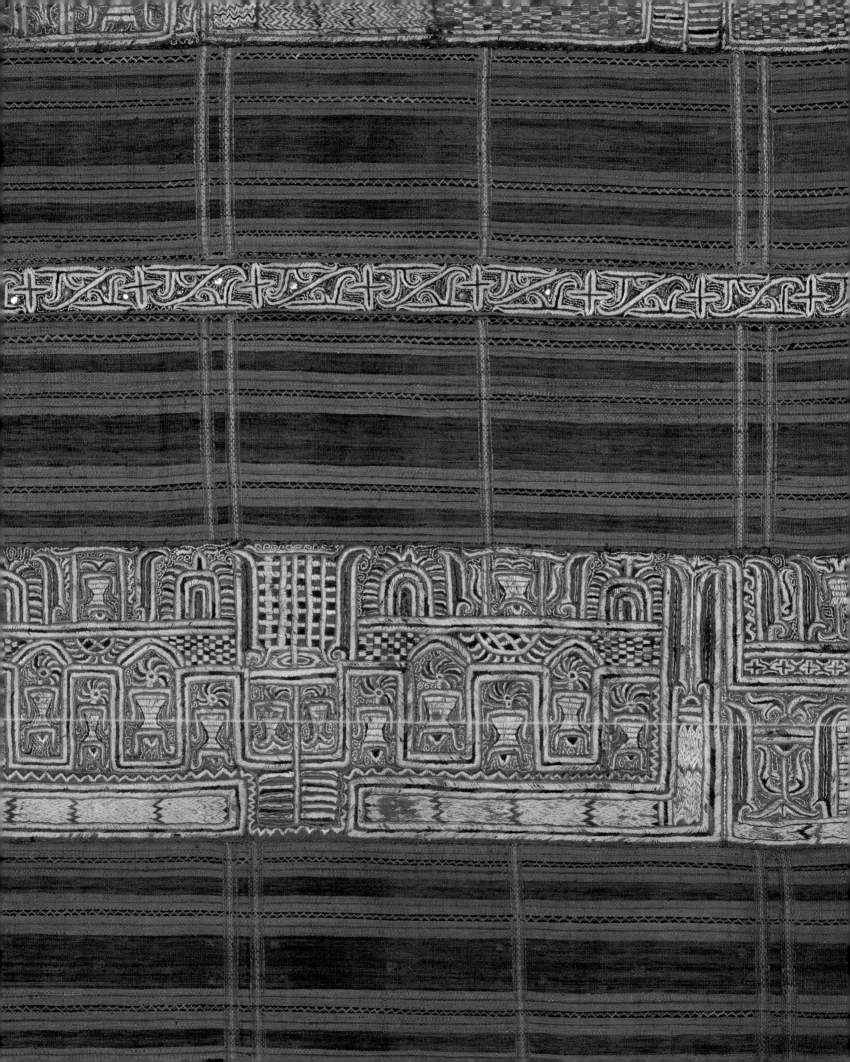

3.9
SKIRT (*tapis*)

Indonesia, Sumatra, Lampung
Paminggir people
Cotton, silk embroidery yarns
Warp ikat, embroidery (satin and running stitches)
Warp 127 cm x weft 119 cm
The Textile Museum 1982.37.2
Ruth Lincoln Fisher Memorial Fund

In addition to the fine embroidery depicting ships filled with images, this skirt is also patterned with warp ikat. Here the designs are not distinct, but in some examples images of ships appear in the ikat as well as in the fine embroidery. The prevailing imagery of such ceremonial skirts of this region, just as in the *palepai* and *tampan*, involved ship forms as signs of transition.

 This skirt, composed of five separate pieces, was probably assembled from two older skirts. The broad embroidered bands are worked on differently dyed cotton grounds and vary slightly in stylistic details from one another. Such recycling implies the skirt components retained value over time, and the benevolence of previous owners, probably ancestors, would have contributed to their worth. This style of embroidery was done in the interior region of the Lampung early in the twentieth century. Recent examples replicate the style, but it is not clear where these more recent skirts are made.

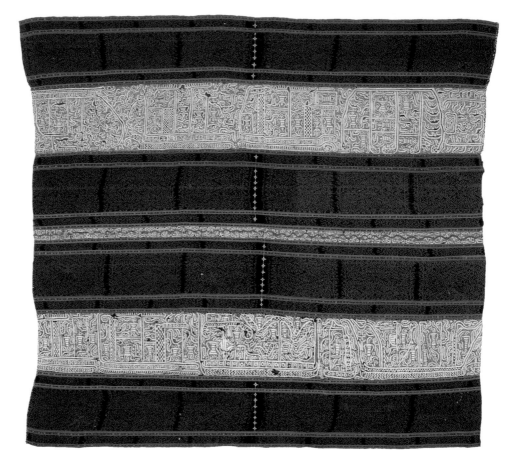

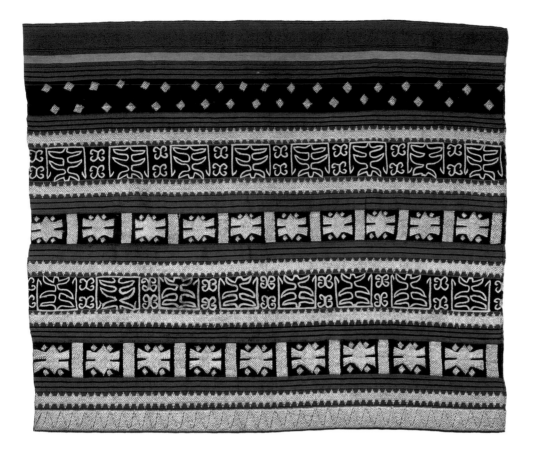

3.10
SKIRT (*tapis*)

Indonesia, Sumatra, Lampung
Abung people
Cotton, metallic yarns
Embroidery (couching)
Warp 131 cm x weft 110 cm
The Textile Museum 1962.1.10
Museum purchase

This skirt was made for ceremonial use by
an Abung woman working in the Lampung
region of South Sumatra. This area pros-
pered from the trade in its black pepper.
The resulting wealth stimulated a system
of social ranking recognized in special
prerogatives such as seats of honor, use of
special conveyances in ceremonies,
umbrellas, and honorific gates. Elaborate
ceremonies and extravagant costume were
part of the cultural scene.

The wealth also brought imported
metallic yarns, which increasingly
displaced other decorative media. The
designs on this skirt are created by
couching metallic yarns to the surface of a
handwoven cotton ground. In some exam-
ples virtually none of the ground cloth
remains visible.

3.11
HIP WRAPPER (*kain songket*)

Indonesia, Sumatra, Siak
Indonesian or Malay people
Silk, metallic yarns
Weft ikat, continuous and discontinuous
supplementary wefts
Warp 249 cm x weft 97 cm
The Textile Museum 1977.16
Gift of Mrs. Blake Middleton

This cloth with its sumptuous use of gold
yarns and fine patterning would have been
suitable only on ceremonial occasions.
As Islam increasingly influenced social
patterns in the Malay-styled courts of
Southeast Asia, cloth of such ostentation
gave way to more subdued expressions.
At one time, however, it represented
divine benevolence and the moral
correctness of the wearer.

Subtle changes in color in both the
warp and weft create a plaid grid that
orders the gold patterns in the body of the
cloth. Such fine details, particularly in the
plaid, were characteristic of the work from
Siak, located on the east coast of Sumatra.

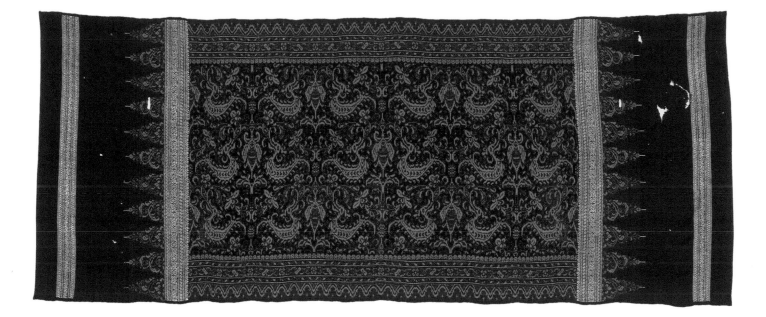

3.12
SHOULDER CLOTH (*slendang*)

Indonesia, Bangka, Muntok
Indonesian or Malay people
Silk, metallic yarns
Weft ikat, continuous supplementary wefts
Warp 205 cm x weft 89 cm
The Textile Museum 1986.13.2
Gift of Mary Jane and Sanford Bloom

The naga, or snake, motif rendered on this shoulder cloth is found throughout Southeast Asia where it is commonly associated with water and concepts of fertility. It appears in almost all artistic media and enters into myth and legend.

The abundant use of yellow in this weft ikat suggests it was made in Muntok on Bangka, a small island off the southeast coast of Sumatra. Other details align the cloth with a broad array of influences. The side borders are framed by narrow bands of white warps. This is a feature of some Indian silks that were traded to this region. Each triangle in the end borders, known as *pucuk rebung* (bamboo shoot), has a fine white line at its tip created by white threads wrapped around a narrow group of warps. This is more commonly a feature of textiles made in and for Thailand. Textiles were an important element in trade in this region from as early as the sixteenth century so cross-cultural borrowing would not be surprising.

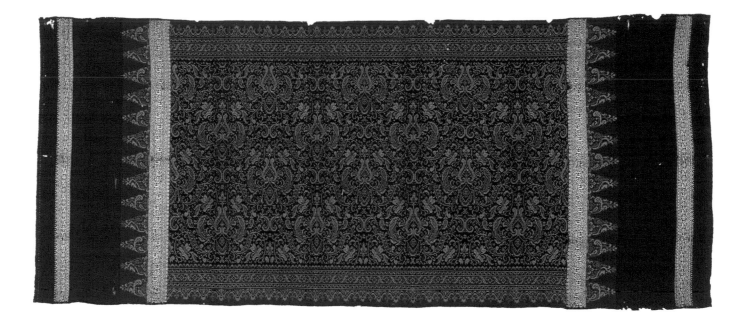

3.13
SHOULDER CLOTH (*slendang*)

Indonesia, Bangka, Muntok
Indonesian and Malay people
Silk, metallic yarns
Weft ikat, continuous supplementary wefts
Warp 205 cm x weft 89 cm
The Textile Museum 1986.13.1
Gift of Mary Jane and Sanford Bloom

The principal design in this weft ikat is the Garuda, the mount of Vishnu in Hindu mythology. However, bird symbolism preexisted Hindu influences in this region of Asia, so a blending of forms was not difficult. The bird is now a symbol of the Ruler and carries connotations of harmonious balance between Ruler and the Cosmos. The name is also that applied to the national airline, Garuda Airways.

This shoulder cloth should be compared with a similar cloth in Figure 3.12. They were very probably made by the same weaver and share many technical details. The latter cloth features a naga, a symbol associated with water and the underworld. It is interesting that these two counterbalancing elements, bird-upper-world and snake-underworld, do not share a single cloth.

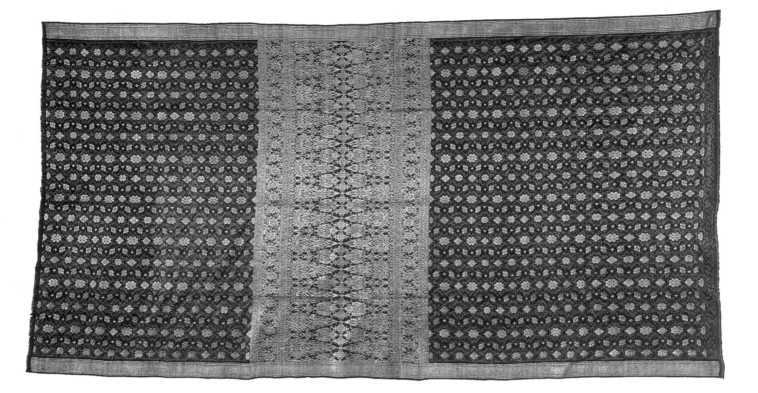

3.14
SARONG (*kain lemar songket bertabur*)

Malaysia, Terengganu
Malaysian people
Silk, metallic yarns
Continuous and discontinuous supplementary wefts, weft ikat, calendared surface
Warp 206 cm x weft 104 cm
The Textile Museum 1982.25.1
Gift of Cici Brown

Such luxurious sarong were made in the nineteenth century in court ateliers specifically for noble families of the Malay sultanates. The splendor of the court clothing reflected on the prestige of the ruler and was a sign of his power and, ultimately, the well-being of his domain.

Textiles of this quality were also important gifts bestowed upon deserving followers and, when worn, were symbols of allegiance. They were also gifts of honor to foreign visitors, as this example proves. This cloth was given to the donor's father while in Malaya and was subsequently displayed at the World's Columbian Exposition (the Chicago World's Fair) in 1893.

The broad patterned area in the center of the sarong, known as the *kepala*, or "head," carries the design known as *lawi ayam,* meaning "cockerel's tail feathers." *Lemar* (also spelled *limau*) in the Malay name denotes weft ikat, and *songket* refers to the supplementary weft patterning.

No other country is as closely aligned to a textile tradition as is Indonesia to batik. It constitutes the national dress and is deemed worthy as a state gift. It is the cloth of a "fabled" land and has represented this island nation in world exhibitions for two centuries. Yet outside this Eastern archipelago, few people know of the intricacies invested in this textile form within its own environment.

Although it has come to stand for a nation, Indonesian batik, at least as we think of it, was originally made only on Java and was primarily women's work.[1] While most people throughout the island wear commercially produced cloth, often in imitation of the earlier handwork, the customs surrounding this cloth on Java from as early as the seventeenth century have influenced its usage.[2]

To a great degree, the history of Java has defined the cloth. In the interior, a few agrarian-based courts claimed the rights to special patterns and eventually developed an etiquette of usage and interpretation of pattern that ennobled the cloth. In turn, the refined qualities and spiritual strength of the court batik artists imbued great cloth with worth beyond aesthetic enjoyment alone. Along the north coast of Java a more diverse clientele gave rise to different batik patterns and methods of production. Set astride major trade routes, this region became home to Chinese, Indians, Islamic traders, and Europeans as well as Javanese and traders from the archipelago. Designs suitable for each of these groups began to be produced in small factory-like establishments that employed local women. Access to different natural dyes and varying water qualities contributed further to regional differences. Over time, many of these cloths became so associated with particular ethnic groups that they were largely inappropriate for others to wear.

Some of the textiles presented here illustrate the diversity of textiles that were previously only suitable for limited audiences within the earlier Javanese context. Others exemplify the creativity this art form is capable of expressing and the precision by which it was practiced in the courts.

The origin of resist patterning on Java remains very much in question. Batik is not rare elsewhere in the world, but none of these places is an obvious source and no area perfected this type of patterning to the same degree as the Javanese. The word *batik* grows from the Malay-based *tik*, meaning "drop" or "drip." It enters into other combinations such as *nitik*, the name for a staccato batik rendering of woven patterns. Perhaps the earliest record of its use is on a bill of lading from 1641 designating cloth being shipped from Jakarta. Until recently, however, the word did not have such currency on Java as now; instead one spoke of *kain tulis* or *kain cap* in reference to textiles patterned with hand-drawn wax (written or painted cloth) or stamped wax. It is *tulis* that appears in reference to cloth types in twelfth-century Javanese texts that may suggest older roots.[3]

Tulis is a just term to apply to the hand-drawn batik we know today because the batik maker uses a spouted cup, much like a pen, to apply the wax to the cloth. Various forms of spouts allow flexibility in how the wax is applied (Fig. 4.1). This instrument, known as a *canting,* permits control and precision that bamboo nibs, metal points, and brushes used elsewhere do not. The batik process first requires the cloth to be soaked and beaten to assure the smoothest surface possible on which to draw. Even when commercial cotton was used, as in all of the examples here, the cloth was processed to insure a suitable surface. A smooth cloth surface is essential to precision batik.

Detail from Figure 4.15

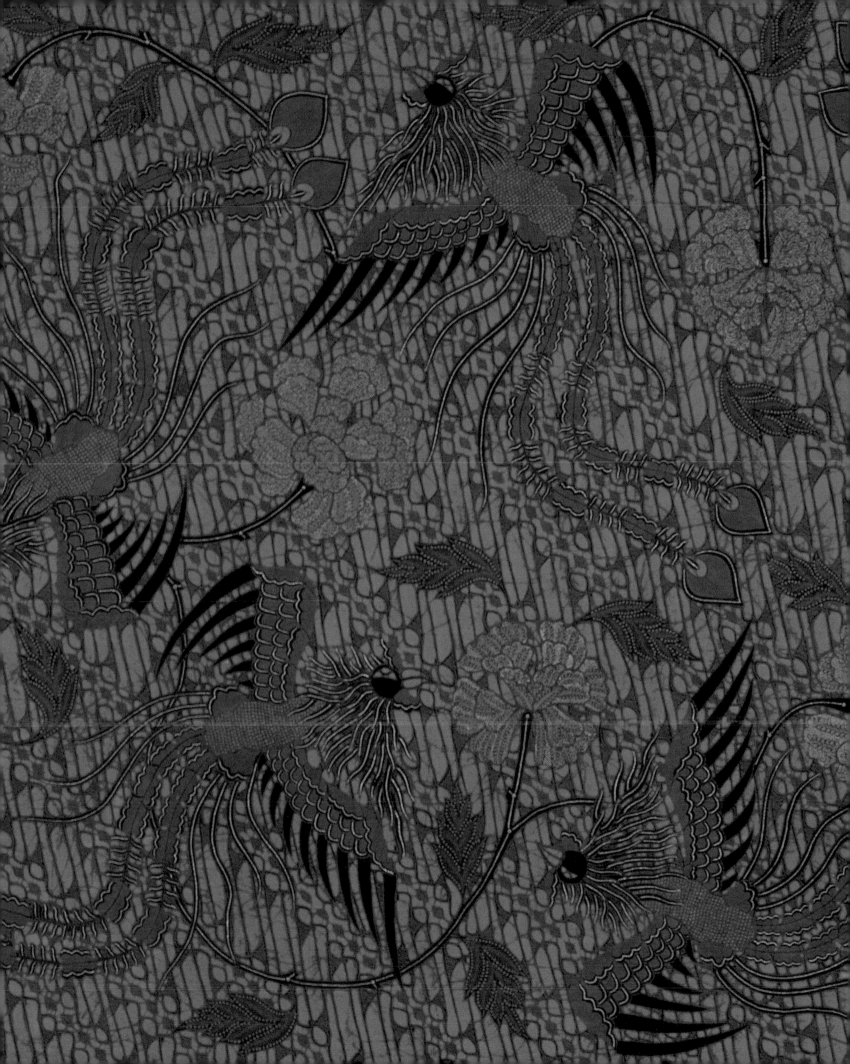

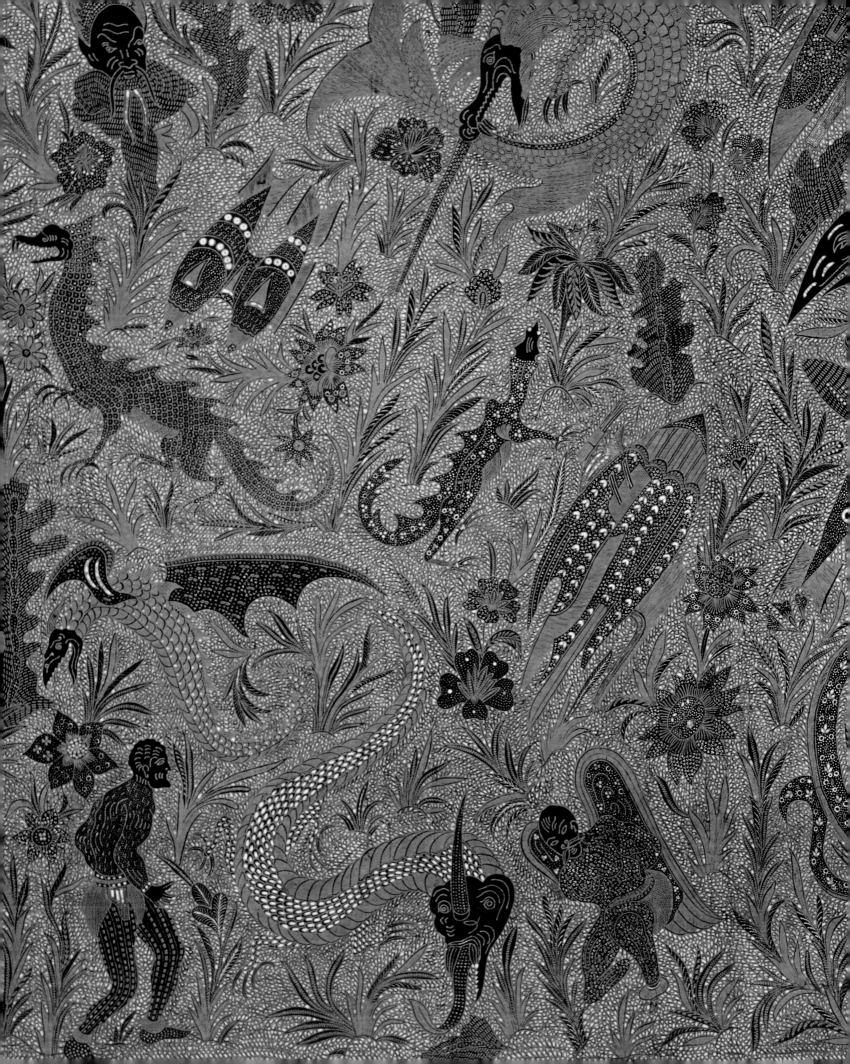

Coarsely woven cotton cannot accept a fine wax line nor the tiny dots and filling elements that articulate the finest patterns. The advent of machine-spun and woven cottons facilitated the evolution of the Javanese batik we know today. The Javanese further distinguished their production by waxing the pattern on both sides of the cloth, thus adding a sharper image. (Beginning makers of batik apprentice by waxing the reverse face of the cloth, following the designs set down on the face by an experienced worker.) Copper stamps to apply the wax came into use in the mid-nineteenth century. This was the first step in the broader distribution of batik. [4]

The role of Indian trade textiles also enters into any discussion of batik origins. Undoubtedly there is an overlap in batik patterning and the silk patola patterns.

Figure 4.1
A Javanese woman waxes a batik cloth, 1973. She uses the penlike applicator, the *canting*.

These Indian double ikat textiles were probably the most influential import in all of the textile arts of Southeast Asia. However, the hundreds of Indian-patterned cotton textiles that remain to us from trade to Sumatra and Java are specific to those markets and may represent local demand, not an imposed commodity. The direction for the inspiration of this trade is not clear. Also, it should be mentioned that fundamentally the patterned cottons of India depend primarily on an orchestration of mordants for their excellence and only secondarily on resist patterning. [5] In contrast, Javanese batik is based on resists to control all patterning. Heringa, who discusses this, also points out that Chinese along the north coast of Java were instrumental in the evolution of batik. She suggests early immigrants may have brought resist patterning skills from southern China that subsequently evolved into the patterning we know today. [6]

An aspect of batik usage that argues for its antiquity on Java concerns the function of batik cloth within a larger context. At least in the Central Javanese courts where other types of patterned cloth are known and used—namely, *tritik*, plangi, and *lurik*—the entrance of these textiles into ceremony is at stages of ritual incompleteness; in comparison, as Danielle C. Geirnaert has stated, "[B]atik is always worn at a ceremonial stage when the protagonist reaches the highest and most sacred status. In contrast to all other cloths, batik represents a situation of wholeness and equilibrium." [7]

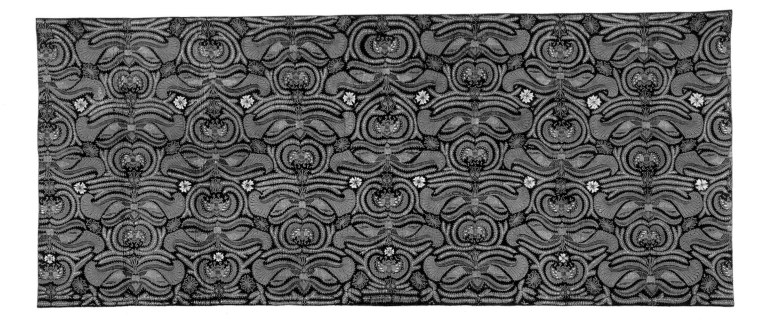

4.2
HIP WRAPPER (*kain panjang*)

Indonesia, Java, Surakarta
Cotton
Wax resist, dyed
Warp 252 cm x weft 104 cm
The Textile Museum 1985.51.2
Gift of Katharine Z. Creane

This extraordinary batik was probably
made about seventy years ago in one of
the courts in Surakarta. The designs have
the finesse of court workmanship, and
only a person of high social and financial
stature would have dared to make and
wear this cloth.

 The lyrical patterning centers on a
winged motif known as *lar,* which ultimately
refers to Garuda (the mount of the god
Vishnu). Below the *lar* is a large form of an
inverted butterfly. However, the enveloping
tendrils that surround these forms put the
patterning into a *semen rante* classification.
Semen patterns, particularly those with a
dark ground, are created and worn by
older people who possess great spiritual
maturity. These patterns often conceal
deep meanings known only to the woman
who waxed the cloth.

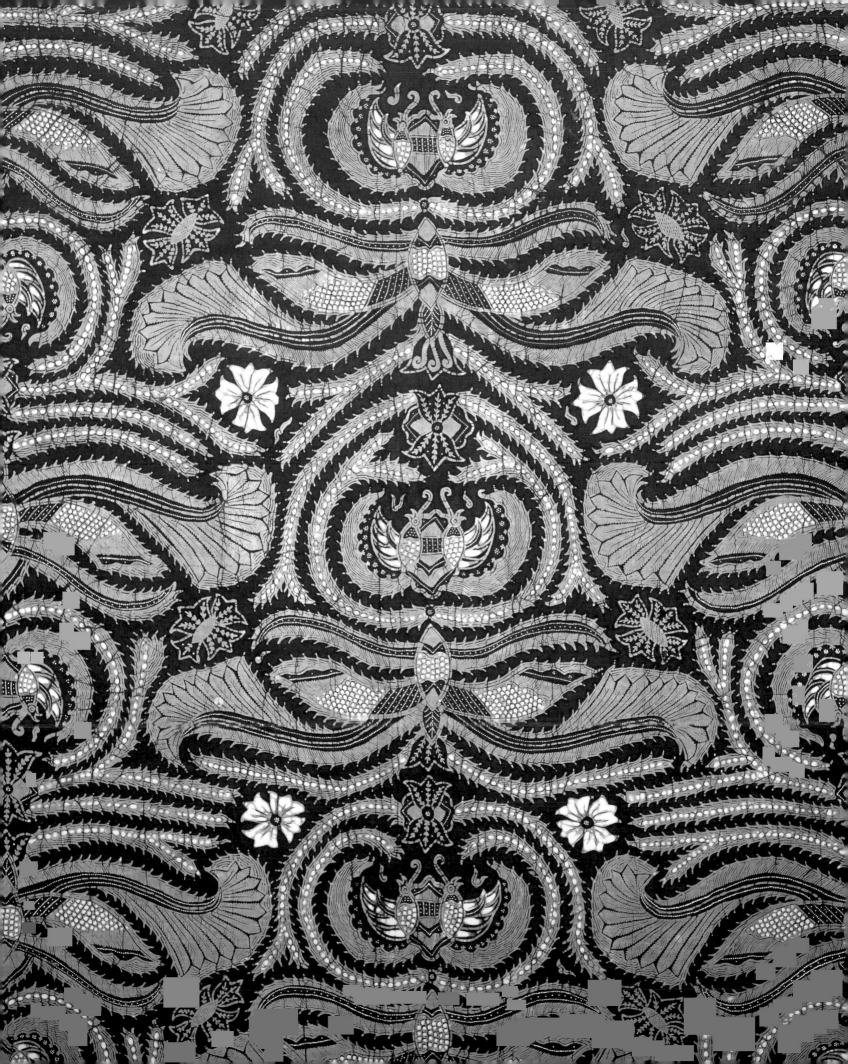

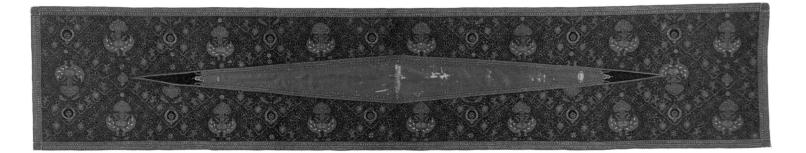

4.3
BREAST CLOTH (*kemben*)

Indonesia, Java, Surakarta
Central Javanese court women
Cotton, silk
Wax resist, dyed, appliqué
Warp 254 cm x weft 52 cm
The Textile Museum 1979.6.5
Gift of K. R. T. Hardjonagoro

This breast cloth was made in approximately 1917 by a fifteen-year-old girl who would become the queen of the sunan of Surakarta, Pakubuwono XI. It epitomizes court style in the precise drawing and flawless execution. Also, the appliqué center was the prerogative of royal ladies, the appropriate color darkening with the age of the wearer.

The batik pattern is commonly referred to as *semen*, which may be interpreted as "to grow up." Here the reference is to fertility as represented in the rice grains (brown dots), mist (white dots), and water (undulating parallel lines). The donor of the cloth interprets the circular design in the midst of the water symbols as the coat of arms of the palace of Surakarta. Others say it refers to an inverted tree commonly found in *semen* patterns.

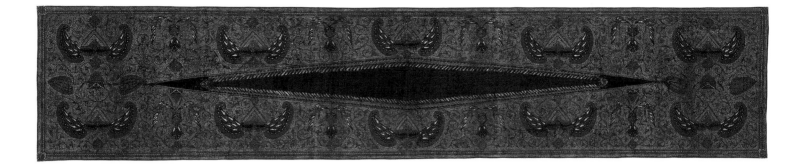

4.4
BREAST CLOTH (*kemben*)

Indonesia, Java, Surakarta
Central Javanese court women
Cotton, silk
Wax resist, dyed, appliqué
Warp 249 cm x weft 52 cm
The Textile Museum 1979.6.6
Gift of K. R. T. Hardjonagoro

The darker silk appliqué and complex patterning of this breast cloth make it appropriate for married, older royal women. Those of slightly lesser rank wore breast cloths with a plain central diamond shape without the added silk, and commoners did without the central diamond form entirely.

The batik pattern is known as *semen Rama*, showing wings, or *lar* motifs, set in a ground of curling tendrils and floral elements. The wings here refer to the protective function of the ruler. The other design details of this cloth differ from the usual Surakarta style, which may suggest the batik maker came from a region other than Surakarta, even though she was a member of the court.

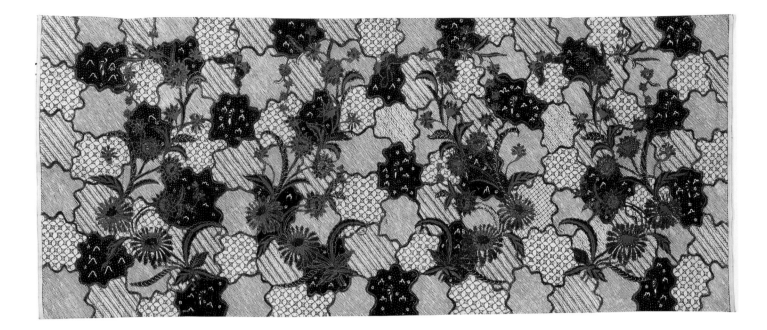

4.5
HIP WRAPPER (*kain panjang*)

Indonesia, Java, Yogyakarta area
Javanese people
Cotton/synthetic
Wax resist, dyed
Warp 246 cm x weft 107 cm
The Textile Museum 1987.25.2
Gift of Mr. and Mrs. Edward H. Smith, Jr.

The fine batik textiles usually seen in exhibitions derive from the arts of the courts of Central Java or commercial workshops such as those found on Java's north coast. Outside of these there once flourished a tradition of village batiks, which employed a more robust style of patterning, even when replicating similar motifs. This is one of those, probably made in a village near Yogyakarta in the mid-1960s. The mosaic ground contains many classical designs, while superimposed on these are large flowering forms, which together give the cloth its name—Flowers of the Universe.

Even within village society, patterns, their size, and their selection communicated a great deal about the maker. The woman who wore this example must have been wealthy and a relatively large woman to carry off this bold patterning. Factory production often utilizing silk-screening techniques has largely replaced this type of village wrapper.

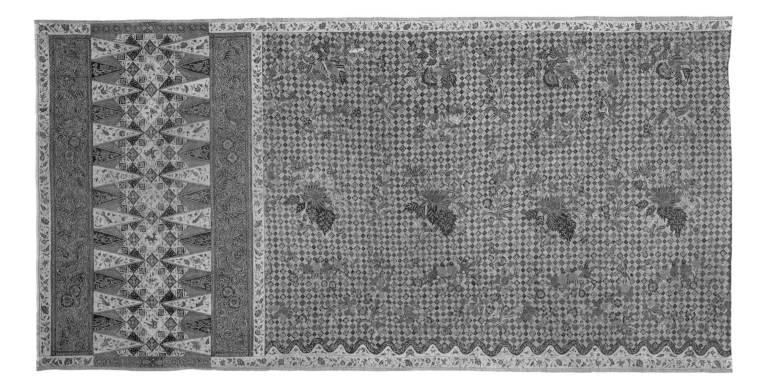

4.6
SARONG

Indonesia, Java, Pekalongan or Semarang
Indonesian Chinese (Peranakan) people
Cotton
Wax resist, dyed
Warp 206 cm x weft 107 cm
The Textile Museum 1991.32.2
Gift of Mary Jane and Sanford Bloom

This sarong known as *bang biru hijau*, meaning, "red, blue, and green," would have been the bridal garment of an Indonesian Chinese (Peranakan) woman. Images of lovebirds with progeny are appropriate for the occasion. The wearer would have worn the undulating edge down while young and inverted the cloth at a later date.

The patterning is built from multiple layers, creating a complex design system.

This is true of both the body and the *kepala*. Between the triangles of the *kepala*, many shapes and forms fill the ground. This was a stylistic detail of this community, which evolved at a very early date. Some experts date this cloth as early as 1860. This complex patterning reemerged as the principal patterning plan during the World War II era.

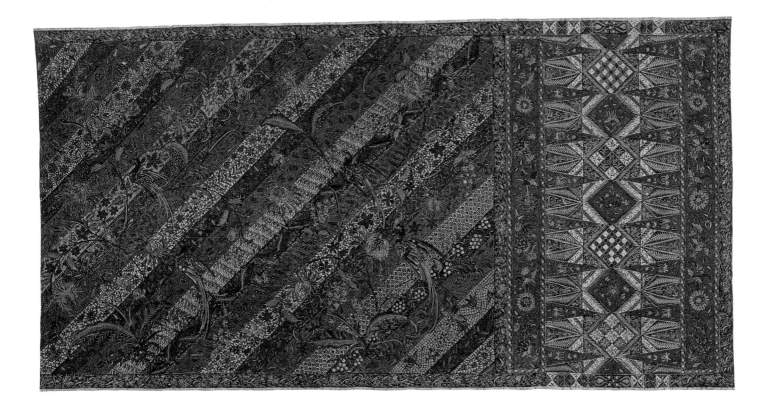

4.7
SARONG (*sarung tiga negeri*)

Indonesia, Java, Pekalongan, Lasem, Demak
Indonesian Chinese (Peranakan) people
Cotton
Wax resist, dyed
Warp 198 cm x weft 107 cm
The Textile Museum 1985.12.1
Gift of Mary Jane and Sanford Bloom

Before synthetic dyes were available, specific regions of Java were notable for a particular color or shade that became a signature when appearing on a cloth. Expensive batiks such as this were carried to different areas to be patterned and dyed in the specialty of the region. The title, *tiga negeri*, refers to three areas in which this cloth was worked.

This cloth probably originated in Lasem, noted for its red color and large filler patterns (*isen*). The blue would have been added in Demak or Pekalongan, and the brown possibly in Lasem or Kudus. These were some of the most expensive batiks made and served the Indonesian Chinese community along Java's north coast.

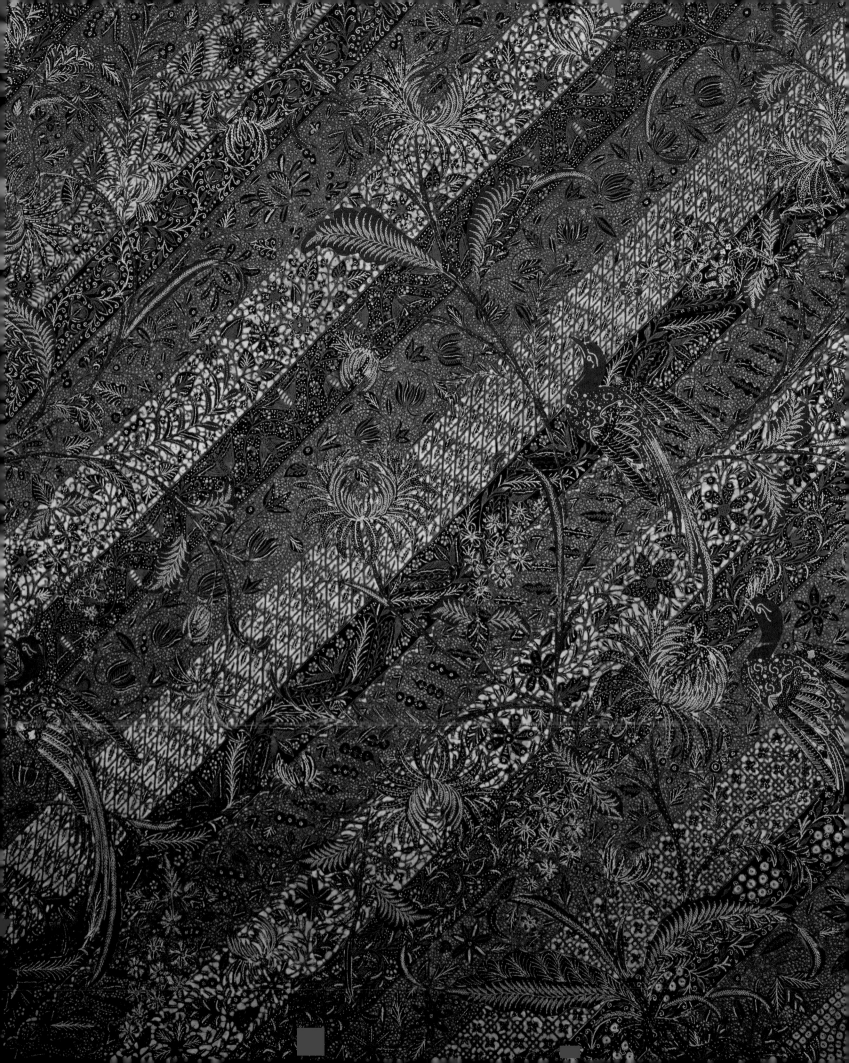

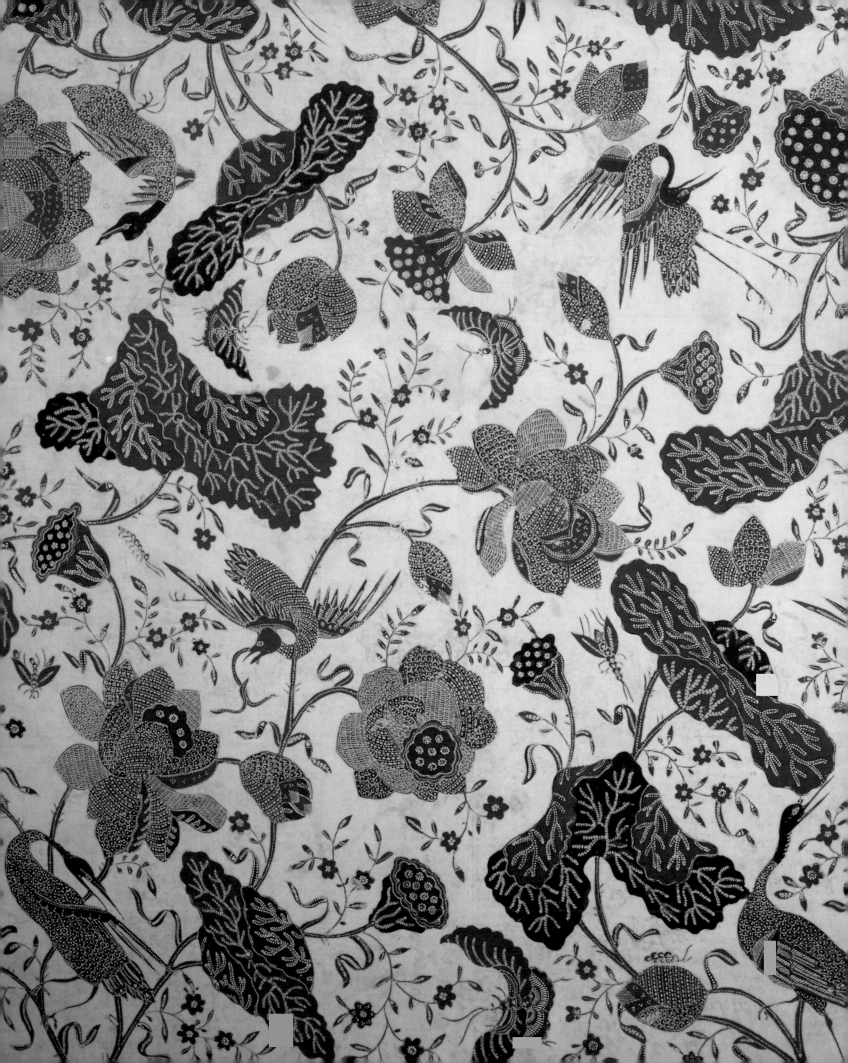

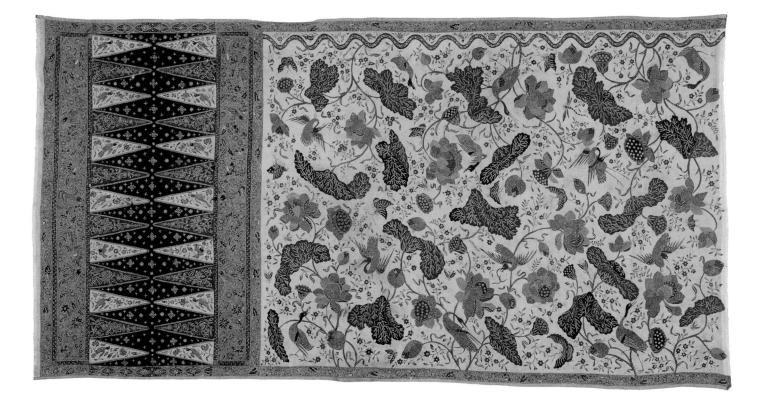

4.8
SARONG

Indonesia, Java, Pekalongan or Semarang
Indonesian Chinese (Peranakan) or Indone-
sian European people
Cotton
Wax resist, dyed
Warp 204 cm x weft 107 cm
The Textile Museum 1985.12.5
Gift of Mary Jane and Sanford Bloom

Made about 1880, this cloth shows a
remarkable three-dimensional quality in
its large lotus flowers and leaves. The
subject matter of ducks, cranes, and lotus
speaks to Chinese tastes, but the styling
of the designs is more Western. The
design elements of trees growing from
both margins are cleverly arranged so the
cloth may be worn with either margin
down. The dark *kepala* makes this cloth
suitable for an older Indonesian Chinese
woman, but the playful use of animals and
smaller filling elements speak to a wider
audience.

The large blossoms are constructed
of variously patterned petals, a style
commonly used in textiles patterned in
India destined for the European market.
Collections of these trade cloths
remaining in Southeast Asia occasionally
contain this type of cloth, indicating
market-specific cloths often found an unac-
customed home.

4.9
SARONG

Indonesia, Java, Pekalongan
Indonesian European people
Cotton
Wax resist, dyed
Warp 188 cm x weft 107cm
The Textile Museum 1998.11.4
Gift of Beverly Deffes Labin Collection

Named *kain porselen* for its blue and white colors replicating fine tableware, this garment would have been worn in the Indonesian European community, particularly by those living along Java's north coast. It would have served as a bridal garment and would have been saved throughout the life of the woman to be used at her burial.

The flowers, here accompanied by swallows and butterflies, would have grown more successfully in a temperate garden. They probably came to tropical Java on Dutch greeting cards or books. The central portion of the sarong, the *kepala*, or "head," is patterned with vertical bands of flowers, which indicate the cloth was made about 1900. After this time, the vertical bands were replaced by a large bouquet similar to those in the body.

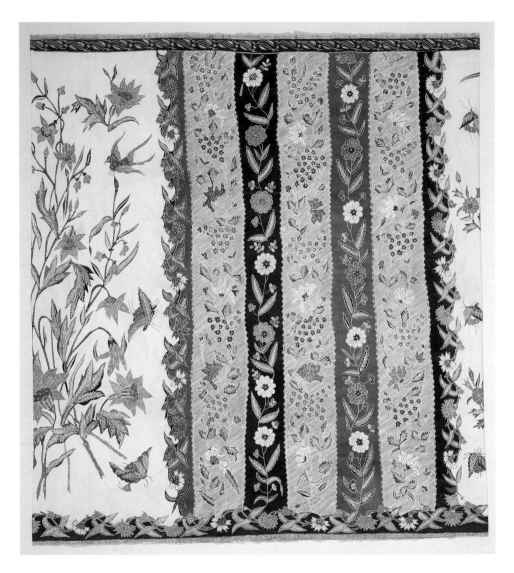

4.10
SARONG

Indonesia, Java, Pekalongan
Indonesian Arab people
Cotton
Wax resist, dyed
Warp 192 cm x weft 106 cm
The Textile Museum 1985.12.4
Gift of Mary Jane and Sanford Bloom

The design elements in this cloth are formed by short strokes of wax placed individually upon the cloth. Termed *nitik*, this style imitates the visual effects of woven patterns. It is an extremely laborious technique that, while practiced by other batik workers, was a specialty of Indonesians of Arab descent. This particular cloth would have been an appropriate bridal costume in this community.

The pattern derives from traditions of a much broader cast. They replicate the elements found on the widely traded double ikats from western India known as patola. These silks were one of the most highly regarded trade items from as early as the sixteenth century. Throughout the archipelago, they exerted a profound influence on textile patterning and were worked in many textile techniques.

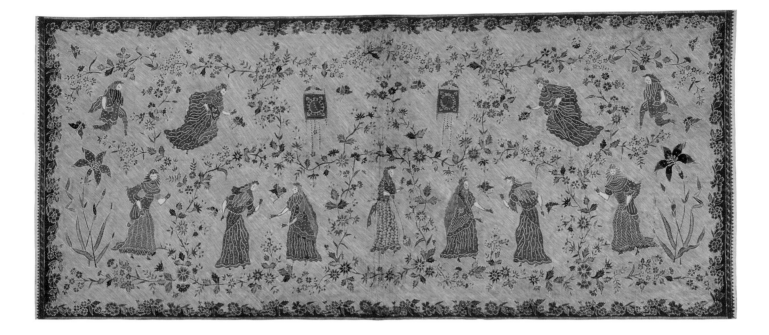

4.11
HIP WRAPPER (*kain panjang*)

Indonesia, Java, Pekalongan
Indonesian European people
Cotton
Wax resist, dyed
Warp 240 cm x weft 105 cm
The Textile Museum 1984.45.2
Ruth Lincoln Fisher Memorial Fund

At the turn of the twentieth century many new types of subject matter entered the batik repertoire. This was due to the increased Dutch colonial presence along the north coast of Java and new sources of inspiration that accompanied this population. These included Western books, magazines, greeting cards, and traveling opera groups. This batik depicting the legend of Cinderella arises from that time. It would have been suitable for the Indonesian European market and an appropriate gift to a young woman.

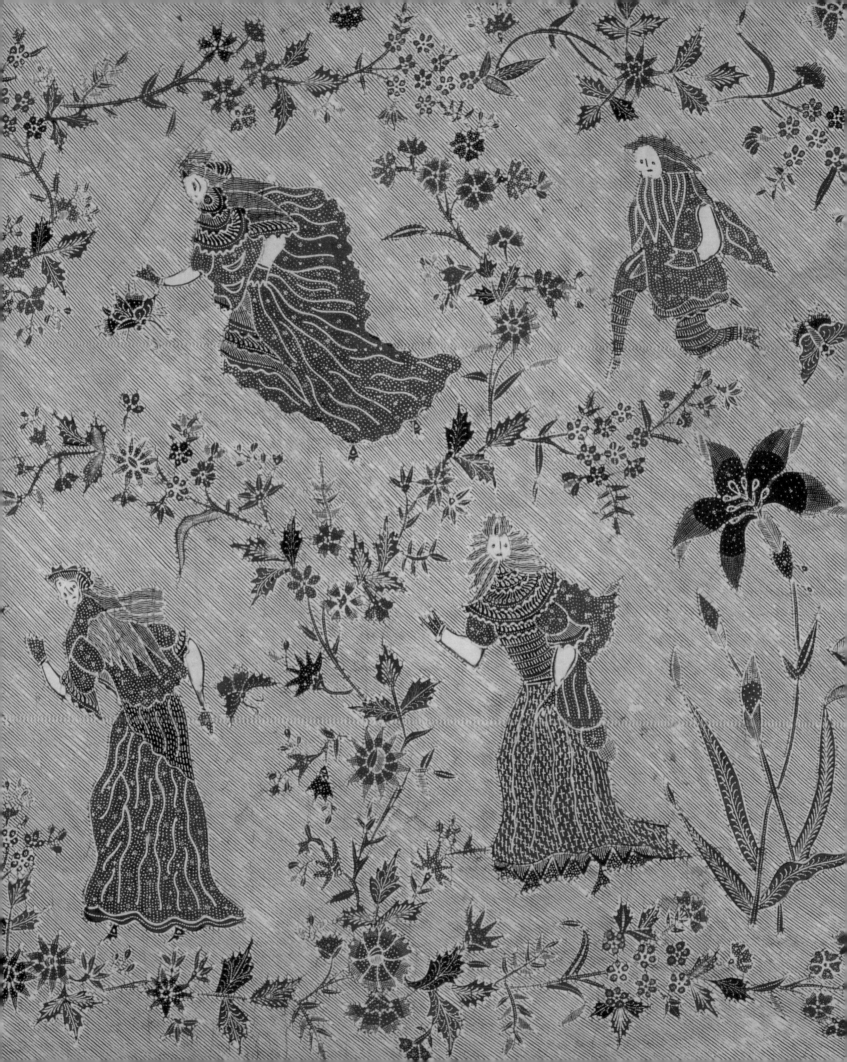

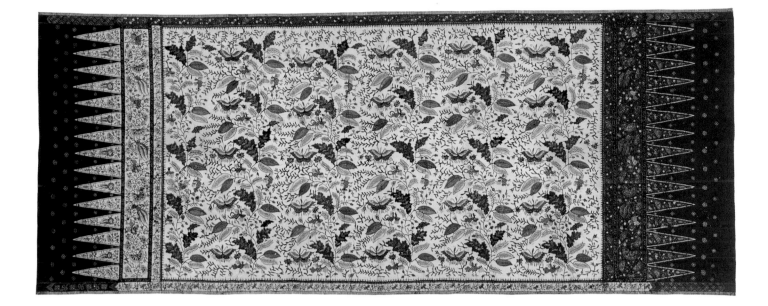

4.12
HIP WRAPPER (*kain panjang, kepala tumpal*)

Indonesia, Java, Lasem
Sumatran people
Cotton
Wax resist, dyed
Warp 262 cm x weft 107 cm
The Textile Museum 2003.25.3
Ruth Lincoln Fisher Memorial Fund

This cloth was probably made in an Indonesian Chinese (Peranakan) workshop in Lasem on the north coast of Java to be traded to an Islamic community in Sumatra. This format of a longcloth with rows of triangles at the ends was used in both of these areas, but the unhemmed edges were a Sumatran idiosyncracy. Another name for this batik is *kain sisihan*, meaning "dissimilar halves." This is in reference to the red and black ground colors of the end borders. As worn, one of the rows of triangles would have fallen over the left thigh. The body of the cloth carries sinuous trees that pattern the whole.

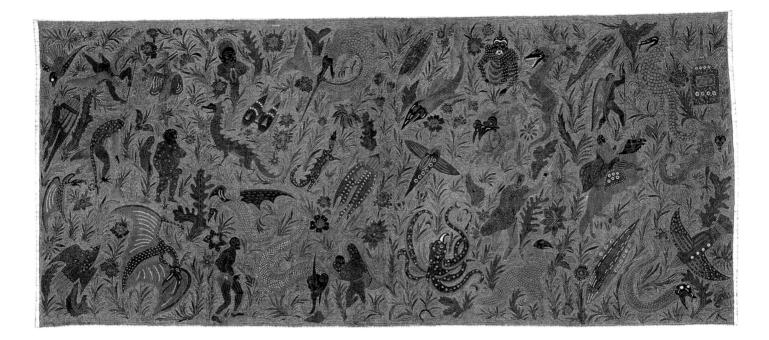

4.13
HIP WRAPPER (*kain panjang*)

Indonesia, Java, central region
Javanese people
Cotton
Wax resist, dyed
Warp 239 cm x weft 106 cm
The Textile Museum 1985.51.3
Gift of Katharine Z. Creane

The workmanship of this batik is of the highest level with minute filling of the background with small curls (*ukel*) and the central forms with a multitude of small patterns (*isen-isen*). The dyes, except for a commercial black, are well-known to the batik art in Central Java. Only the subject matter is a surprising intrusion.

The batik artist has drawn inspiration from the *Flash Gordon* comic strip, which originated in 1934. This was a completely new type of comic strip based on the wealth of exotic themes inherent to science fiction. It was immediately successful, and the strips were translated into numerous languages.

The winged bird-men, spined lizard-men, and horned villains—all set within the threatening jungles and seas of the planet Mongo—are at the source of this cloth. Here the Javanese artist tames these environments into a benign floral landscape more familiar to the batik world. She has not reproduced the violent confrontations so graphically rendered on paper nor included the alluring women presented in the strip. She has even clothed the muscular Flash Gordon with a veil of batik patterning.

The themes of *Flash Gordon* turned on the conflict of good versus evil and the tenacious persistence of evil. Indonesians with their legends and theater founded on similar motifs would have particularly relished this contemporary interpretation.

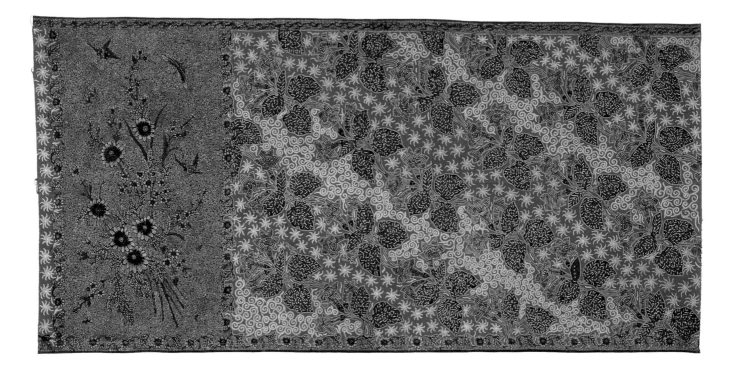

4.14
SARONG

Indonesia, Java, Pekalongan or Madura
Madurese people
Cotton
Wax resist, dyed
Warp 206 cm x weft 104 cm
The Textile Museum 1998.11.12
Gift of Beverly Deffes Labin Collection

The vigorous floral forms, small stars, trailing waterweed, and diagonal arrangement of this cloth indicate it was made on the island of Madura, just off the north coast of Java, or in Pekalongan on Java for trade to Madura.

Rens Heringa, a Dutch batik expert, reports Madurese batik patterns became fashionable in the early 1970s in parts of Java. The Pekalongan workshops seized on the style and supplied both the Madurese and Javanese markets at that time. Madura was renowned for its shades of red, which the Pekalongan workshop tries to replicate here with chemical dyes.

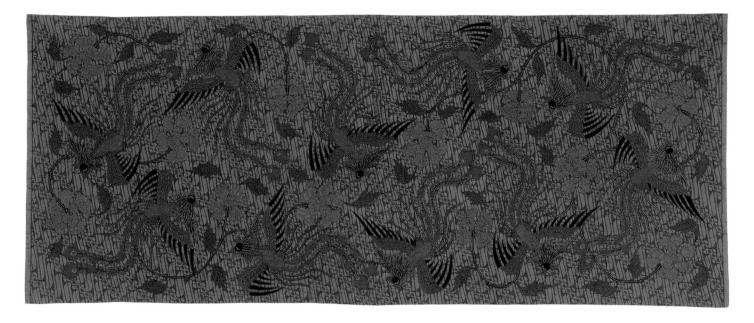

4.15
HIP WRAPPER (*kain panjang*)

Indonesia, Java, Surakarta
Javanese people
Cotton
Wax resist, dyed
Warp 258 cm x weft 107 cm
The Textile Museum 1979.6.14
Gift of K. R. T. Hardjonagoro

The style of this batik, known as "Batik Indonesia," represents the blending of the bolder forms and brighter colors from Java's north coast with the more muted tastes and conservative forms of Central Java. This joining was initiated by K. R. T. Hardjonagoro in the 1960s and 1970s in response to President Sukarno's admonition that he do something for the new, recently independent country. President Sukarno promoted the new style as a cloth for the whole of the new nation, not just Java.

The main pattern is *kukila peksowani gendala giri* arranged on a *parang rusak* ground. The first name refers to a mythological bird, a motif also found in Balinese art. The background pattern was once a motif reserved to the courts of Central Java. Here it is rendered in three sizes, lending a tension to the ground that enhances the bird's motion.

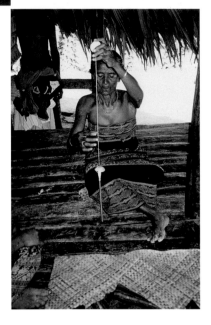

Figure 5.1
A Savunese weaver uses a drop-spindle to spin cotton.

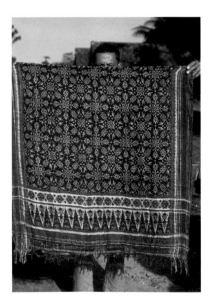

Figure 5.2
Indian patola were one of the most prized trade items throughout insular Southeast Asia. While of several different patterns, this particular design had a great impact on locally made textiles.

The chain of smaller islands that stretches east of Java harbors such a diversity of the textile arts that a simple summary is difficult.[1] It is not clear how ancient the roots of weaving in this region are. Roy W. Hamilton has pointed out that while we know the Austronesian expansion included weaving, it may not have been carried forward along these islands.[2] He also suggests that earlier textiles may have had a far different physical appearance than that we know today, a feature suggested earlier by Alfred Bühler.[3] The latter scholar thought simple warp stripes probably predominated before the overwhelming influence of imported Indian textiles introduced new concepts that basically inform today's textiles.

Because most of the patterning in this area centers on warp ikat, the advent of this technique in the region also enters the equation. We cannot, with any certainty, say warp ikat patterning on cotton or any other fiber is a very ancient art in this eastern area. The earliest empirical evidence for ikat in the island world of Southeast Asia is a fragment found in association with a fifteenth-century grave in the Philippines. Epigraphic evidence from Java strongly suggests ikat was known on that island as early as the tenth century, and we can assume early interisland trade could have spread this technique.[4] Even so, experts think this area remained beyond the sphere of greater Asian contact until after the fourteenth century.[5] By the fifteenth century, Sumba and Timor were connected to a wider sphere through the Malacca trade.

Yet in surveying merely the few textiles presented here, their fundamental importance in identifying contractual relationships and in the ordering of most aspects of life both in this world and beyond speaks to very old traditions. There is no one convincing answer to this dilemma. It may be that earlier cloth forms such as beaten bark cloth or cloth created from narrow strips earlier harbored these customs now vested in more substantial cloth forms. Traders, initially from Java and later of a more international cast, in search of local sandalwood, beeswax, honey, and slaves would have carried trade textiles that offered models for change.

Whenever these skills became available, the cloths that ultimately evolved came to distinguish people from one another by hierarchical alignment, affinal relationships, or ethnic identity. However, an image of ageless social patterns and enduring cloth patterns and traditions is not sustained when one is able to apply historical coordinates to a defined locale. James J. Fox has convincingly presented evidence for the early evolution of Rotinese and Ndao textile traditions in the seventeenth and eighteenth centuries and their maturation in the nineteenth century.[6]

Fox's evidence, even as briefly summarized here, presents an intriguing picture of evolution. In the seventeenth century the United Dutch East India Company (V.O.C.) established a presence on the island of Roti, a small island off the southern tip of Timor, to further their trading interests in the area. The V.O.C. representatives dealt with local rulers of the largest domain on the island and in return for allegiance gave gifts of textiles including Indian patola (Figure 5.2). The source of these and other Indian trade textiles was dependent on production centers in India. In the eighteenth century those Indian areas accessible to the Dutch came to be cut off from a source of indigo. The V.O.C. then began to enforce indigo planting in several islands of the archipelago to supply its Indian centers. Roti and Ndao, while never commercially profitable centers, were the most affected by this until recent times; according to Fox, "the use of indigo is considered of paramount importance by the Rotinese and is surrounded with

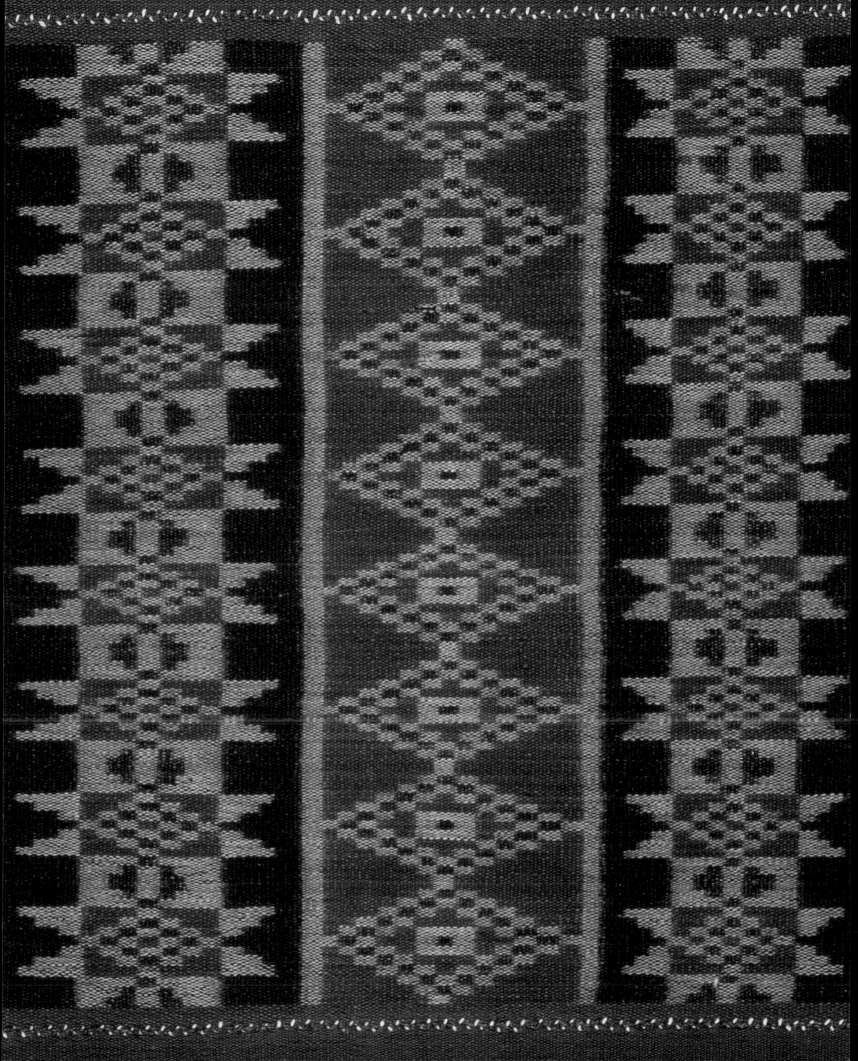

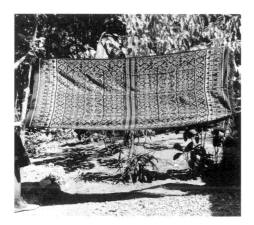

Figure 5.3
This Rotinese cloth illustrates the impact of imported patola on local textile design. Textiles in this area are distinguished by their close adherence to the original patola format and by the use of indigo. 1965

Figure 5.4
Men in the vicinity of Kupang, on the neighboring island of Timor, wear hip wrappers with a white central panel. The Rotinese, to establish a separate identity, use indigo. 1965

a number of prohibitions and restrictions. The secrets of indigo dyeing are jealously guarded, especially among high nobles and the most valued cloths of these nobles are distinguished by their use of indigo."[7] Men's cloth involves a solid black band, in contrast to neighboring Timor groups, which use white bands. Noble families claimed for themselves motifs borrowed from patola and tended to copy the entire patola format (Fig. 5.3).

Rotinese myths account for the color and pattern of their cloths, but history shows that local rulers, ennobled by the Dutch attention, expressed allegiance and concordance with their "benefactors" by their use of indigo in their locally woven cloth to distinguish themselves from their neighbors on Timor (Fig. 5.4), and from one another, by the proscription of certain motifs. Thus patterned textiles came to distinguish the wearer by locality, class, and status. In varying degrees this was true of textiles through much of the Lesser Sunda Islands.

Few groups have utilized distinctions in patterned cloth to the same degree as the people of Savu. As discussed earlier, specific motifs identify membership in one of two female origin groups known as *hubi* (blossom). While these are clearly delineated in women's sarong (Figs. 5.16, 5.17), they are not strictly aligned in the men's wrappers known as *hi'i*. Nor are any motifs associated with male origin groups. Rather, men's textiles, wrappers, belts, and head wrappers reflect social status. Thus, if all the fringes on a wrapper are plied and twisted, the owner is a nobleman, a war leader, or a priest. In a similar manner, the color green was once reserved for the ruling classes.[8] The greater the number of stripes on a man's wrapper, the higher his social status. Savu men also know a completely white wrapper, and this, too, was associated with members of the ruling class.

Savunese seriously observe the *adat* (religious and social custom or tradition) surrounding their textiles. To honor the founding weaving ancestress, offerings are made at various stages in the weaving and six chickens are raised in honor of the ancestor who will then protect the weaving process

On other islands women of rank found various means to monopolize certain patterns. In one Lio village on Flores only postmenopausal women were allowed to tie certain designs, particularly the noble women of certain high-ranking patrilineages. By tabooing these patterns for younger women they essentially monopolized them for their own use. They were known for working in concealed areas and effectively hiding their work processes from others.[9]

In many areas of the Lesser Sunda Islands color is an important consideration. Red dyeing was traditionally the secret of eastern Sumbanese noble women and textiles with red dyes were restricted to the ruling class (Fig. 5.8). In Lamaholot on Lembata, red is the required color of the prestigious bridewealth sarong, and even today natural dyes are essential to validate the exchange cloth (Fig. 5.13). On the same island, in the northeast area of Kedang only indigo-dyed sarong may fill a similar role.

With a few exceptions, the textiles of this region were overwhelmingly influenced by the designs carried on the Indian silk patola. These cloths must never have been excessively numerous, given the complexity of their manufacture and comparative value in their home market. The less expensive mordant-drawn or stamped cotton cloths traded from India were surely more common. One bill of lading on an early Dutch ship listed forty-three textile types coming from the Coromandel Coast and thirty

types in a single ship sailing from western India to Java in 1619.[10] The vast majority of these have left no discernible impact on local cloth of the archipelago.

The very rarity of patola textiles and their use as gifts often conveying contractual alliance elevated the motifs they carried into a special category. The repetition of those motifs through generations was a continuing affirmation of a privileged history. Now, as new religions vie with older beliefs, many of the rules that governed usage of motifs and particular textile forms are set aside. Almost all of the skirts made on Savu now are of the *ei worapi* type (Fig. 5.18) that can be worn on any occasion and doesn't require the propitiation of the founding ancestress. Commercial red dyes have deprived Sumba noble women of their advantage, and new cloths to be sold to tourists include red. One can envision a not-too-distant time when through much of the archipelago color and design prerogatives will mostly be forgotten.

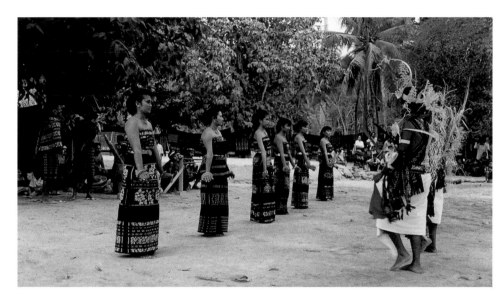

Figure 5.5
Savunese men and women dance in traditional costumes. The women wear tube skirts that are folded down under the arms. When the skirt is belted, a slight flounce graces the hipline. The woman on the far left wears the *ei worapi* that does not align her with any Blossom group. The woman second from the left wears a pattern that aligns her with the Lesser Blossom group. The men wear commercially made white hip wrappers and locally woven shoulder cloths. The beach on which they perform is that visited by Captain James Cook in September 1770.

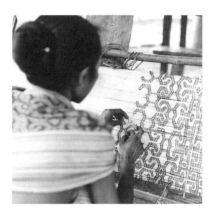

Figure 5.6
Sumbanese men tie their *hinggi* hip wrappers in this shortened manner for riding horseback. 1965

Figure 5.7
For warp ikat, the warp yarns are stretched on a tying frame where the designs are bound off with a dye-resistant fiber. After dyeing and cutting away the resists, the patterns will be in the color of the ground. Additional resists may be tied for subsequent dye baths. 1965

5.8
WRAPPER (*hinggi kombu*)

Indonesia, Sumba
Sumbanese people
Cotton
Warp ikat,
Warp 290 cm x weft 142 cm (2 panels)
The Textile Museum 68.1
Acquired by George Hewitt Myers in 1953

The closely interlocked design elements
and rhythmic cadence of the renderings
in this textile characterize the very best of
the men's wrappers from eastern Sumba.
They were made by women of the noble
class who retained the secrets of dyeing
the red color, *kombu,* and only this class
had the right to the cloths or to loan them
to another to wear. Just as the colored
cloths were the prerogative of the nobility,
so the referents of the design elements
were a part of their world.

 The large male figures alternate with
images of skull trees in the broad upper
and lower bands. These figures probably
refer to the slaves who formerly served the
nobility and who at times of funerals were
killed to serve the dead in the beyond.
These alternate with skull trees, known as
andung, set before important houses.
Made of wood stakes, the trees were hung
with skulls after war hunts. The birds in
the flanking bands are probably chickens
critical to sacrifice and augury and,
possibly, fighting cocks. The deer with
their ornate antlers have reference to the
nobility's hunting parties, which
continued as sport in recent times. The
complex netting of the center band origi-
nates in the imported Indian silk textiles
known as patola. Just as the cloth, this
design element, too, was reserved for
nobles in certain parts of Sumba.

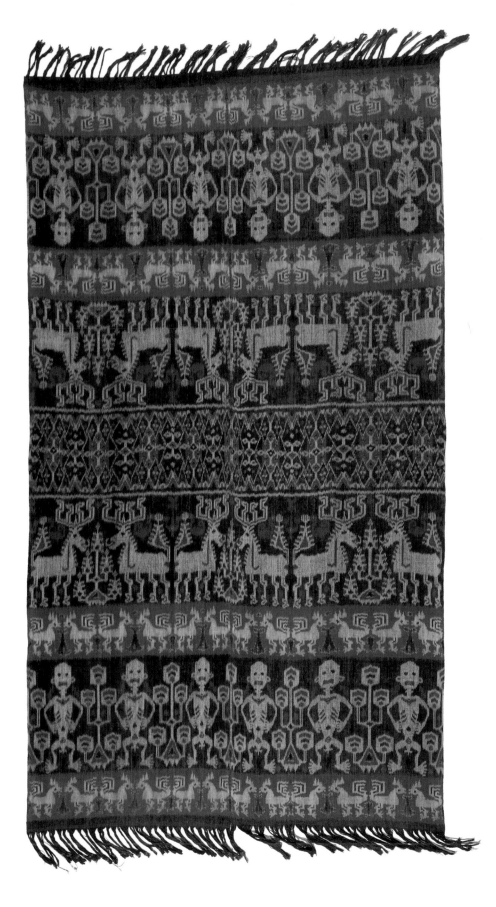

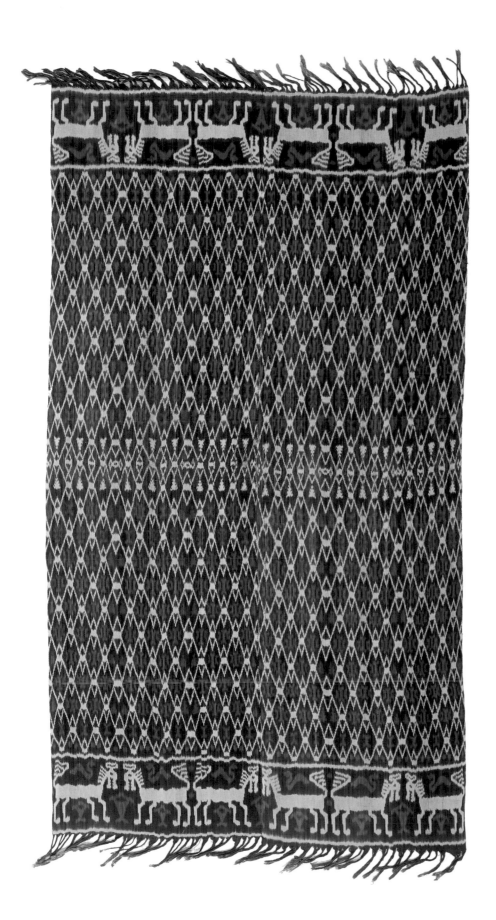

5.9
WRAPPER (*hinggi*)

Indonesia, Sumba
Sumbanese people
Cotton
Warp ikat
Warp 278 cm x weft 136 cm (2 panels)
The Textile Museum 1985.18.2
Gift of Mrs. Gertrude W. Corwin

Because this textile contains no red dye, normally reserved for Sumba nobility, we can assume the cloth was made for a commoner in eastern Sumba. However, the striking net pattern of the center field derives from imported Indian textiles, and these patterns tend to be reserved as well as the color red. While we cannot explain this, we can certainly admire the virtuosity of the cloth patterning.

The vibrancy of the white netting is accentuated by an undercurrent of two shades of blue, investing the cloth with multiple visual layers. Similar visual devices encompass the stark white horses of the end bands. Here echoes of images, such as the squid and snake forms, appear in the dark bands. Men wore these cloths in pairs as a wrapper about the hips and as a mantle over the shoulder.

Horses are important in many aspects of Sumbanese life. They were the pride of their owners and supplied young men with the means of derring-do in hunts and tournaments. Horses were part of the bride-price wealth, and one of the favorite mounts of a noble was sacrificed at his grave. Horses were also an important economic factor in the trade of Sumba with other islands and the Dutch in colonial times.

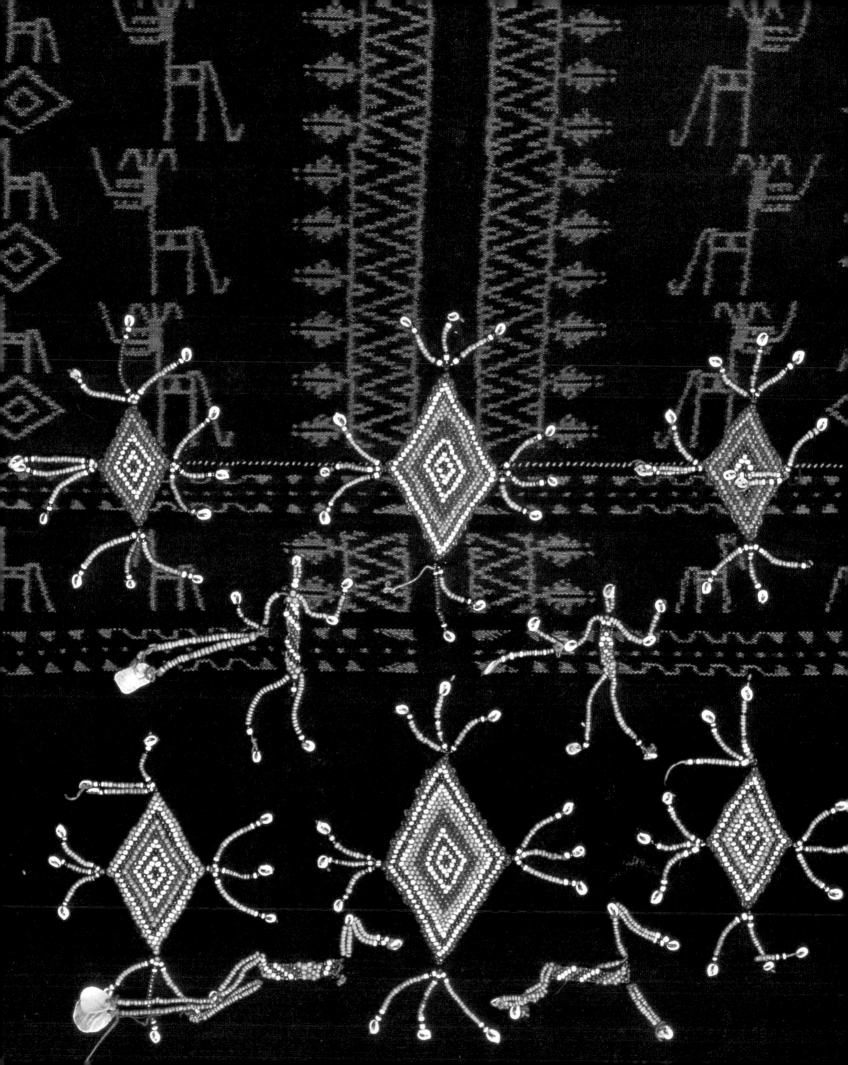

5.10
CEREMONIAL TUBE SKIRT (*lawo butu*)

Indonesia, Flores, Ngada Regency
Ngadha people
Cotton, beads, shells
Warp ikat, embroidery
Warp 156 cm x weft 177 cm (3 panels)
The Textile Museum 1986.26.1
Gift of Mary Jane and Sanford Bloom in honor of Patricia L. Fiske, Director of The Textile Museum 1982–86

Worn only on sacred occasions, beaded skirts such as this were originally created to be heirlooms. A clan leader might commission such a skirt, and after his death the garment was known by his name.

In a rare divergence from custom, which allots textile work to women, the beads on the *lawo butu* were applied by men. In Ngadha beliefs beads have a supernatural origin and are equated with gold.

The warp ikat figures on the skirt may represent a dragonlike figure such as the naga and also a horse. The ovoid shapes arranged down the center represent metal ear ornaments that were an emblem of wealth, entering into bridewealth exchanges and other economic transactions.

5.11
TUBE SKIRT (*lau pahudu*)

Indonesia, Sumba, eastern region
Sumbanese people
Cotton
Warp ikat, supplementary warp
Warp 133 cm x weft 160 cm (2 panels)
The Textile Museum 68.4
Acquired by George Hewitt Myers in 1953

On Sumba, women's skirts were an essential element in the exchange of goods between the families of the bride and the groom both before and throughout the life of a marriage. One reads of numbers of skirts as high as forty in a single exchange. The wife's position within her new home was directly proportional to the value of skirts and other gifts given to the husband's family.

The subtle qualities of women's garments in eastern Sumba are frequently overshadowed by the more flamboyant man's wrappers, the *hinggi*. The skirts, however, are a creative statement showing expert understanding of color, line, and texture. This may be seen in the colored warp stripes forming the ground beneath the white supplementary warps in this skirt. They lend a muted color intonation. In the lower panel, a yellow-brown dye has been daubed on the white patterning, giving it added complexity.

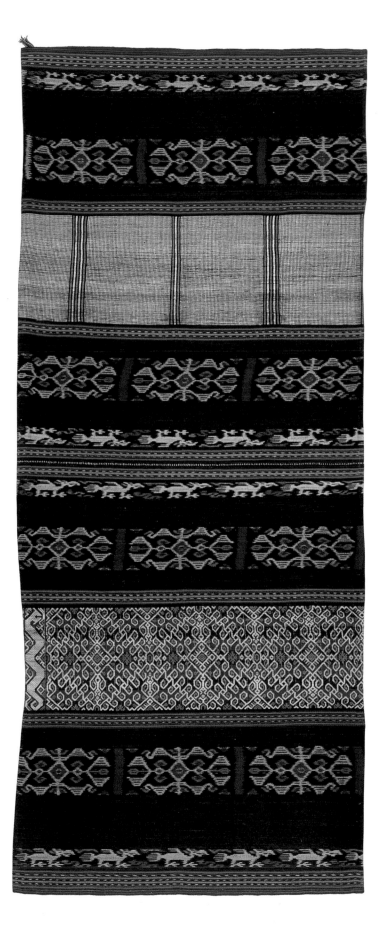

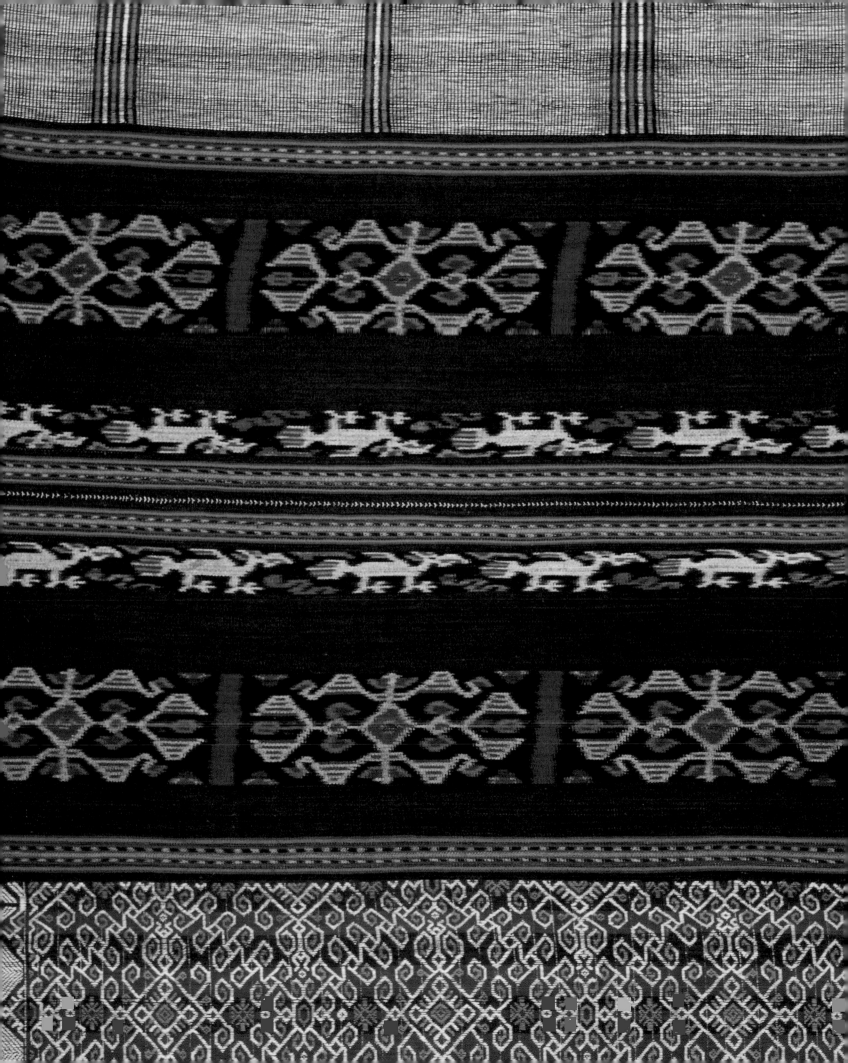

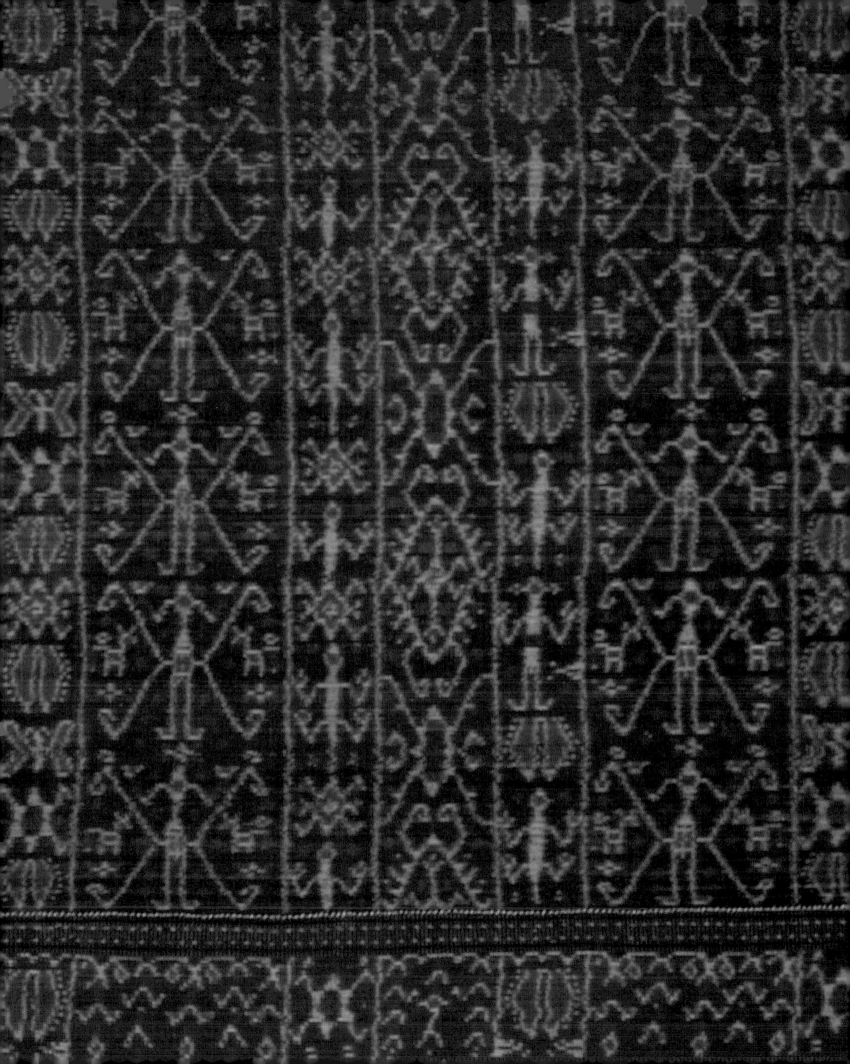

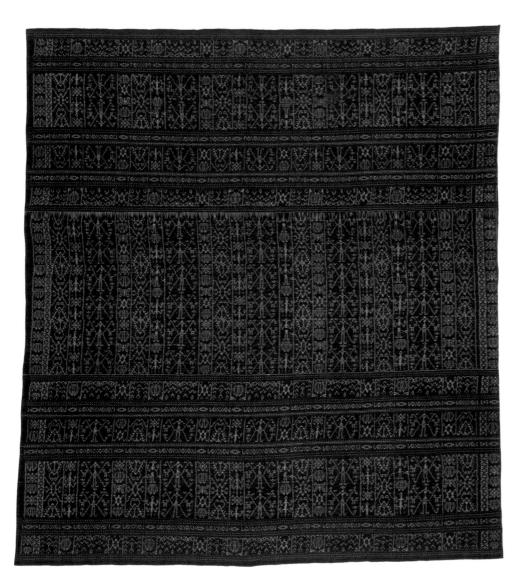

5.12
TUBE SKIRT (*lawo pundi*)

Indonesia, Flores, Ende Regency, Nggela
Lio people
Cotton
Warp ikat
Warp 162 cm x weft 156 cm
The Textile Museum 1977.4
Gift of Gilbert H. Kinney and P. J. Maveety

This is one of at least thirty-three types of cloth woven in one coastal village by the Lio people of Flores. The stylized human figures, animals, and traditional jewelry make this an extremely rare textile. Ikat designs such as these are markers of women's sarong, whereas men's feature only stripes. The cloths are ranked by their designs and enter into ceremonies and gifts by specific categories. Formerly the twelve agricultural rituals that marked the year's calendar brought forth the most prestigious cloths.

5.13
TUBE SKIRT (*kewatek nai telo*)

Indonesia, Lembata, Lamalera
Lamaholot people
Cotton, warp ikat
Warp 137 cm x weft 142 cm (3 panels)
The Textile Museum 68.19
Acquired by George Hewitt Myers in 1957

Although three-panel tubular skirts such as this continue to be made today in Lamalera, they are seldom worn. They remain, however, as an essential component in marriage presentation from the bride's family in exchange for ritual items such as ivory tusks and bracelets. Requirements still demand the use of hand-spun cotton yarns and natural dyes that endow the cloth with its rich subtle qualities. In addition, skirts suitable for exchange may not have had their circular warp yarns cut. Rather these unwoven yarns are hidden within the side seam and cut only after the skirt is given.

Ritually acceptable skirts from this area always have two shades of blue—a light blue and a virtual blue-black. This is achieved by binding certain of the warp patterns after the initial indigo dyeing. Subsequent immersion in a red-morinda dye turns the unprotected areas blue-black while those protected retain the lighter shade. All bridewealth cloths must have these colors as well as the white of the undyed cotton.

The designs in the central panel of this type of skirt are commonly inspired by design details found on Indian patola cloths once traded within the archipelago. Some designs on the patola, such as these, became specific clan property in Lamalera.

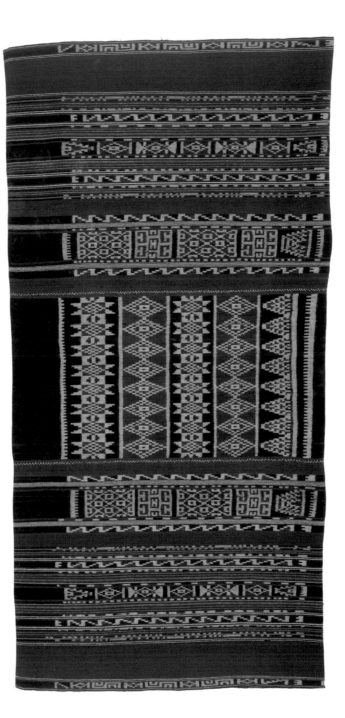

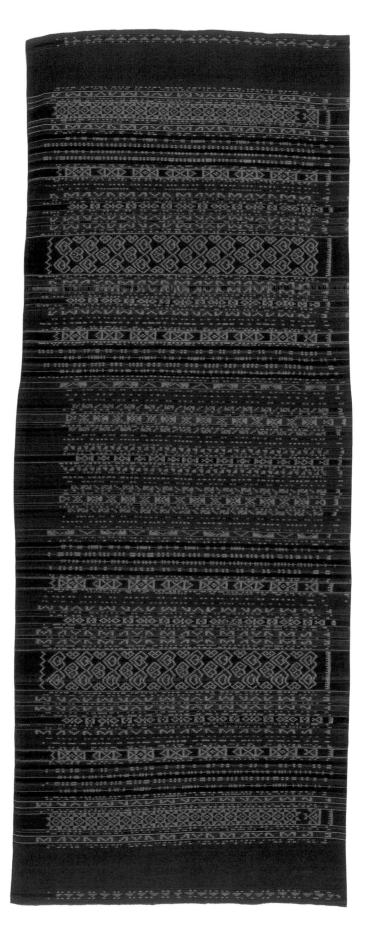

5.14
TUBE SKIRT

Indonesia, Lembata, Ili Api region
Lamaholot people
Cotton, warp ikat
Warp 140 cm x weft 188 cm (3 panels)
The Textile Museum 68.18
Acquired by George Hewitt Myers in 1957

Normally skirts made in this far northern
area of Lembata have only two cloth
panels; this three-panel example is
extremely rare. Characteristic of this
region are the parallel horizontal bands
worked in warp ikat that cover the skirt.
This is in contrast to the arrangement in
the adjoining skirt (Fig. 5.13) in which the
patterning of the central panel interrupts
this horizontality. The heart-shaped
elements in the larger ikat bands were
derived from the Indian-made patola
textiles traded to much of Southeast Asia.
 The ikat-patterned textiles of the Ili
Api area were famous and were exported
to eastern and interior parts of the island.
In these regions, as well as locally, the skirts
were critical to marriage presentations.

5.15
TUBE SKIRT (*ei*)

Indonesia, Savu
Savunese people
Cotton
Warp ikat
Warp 116 cm x weft 152 cm (2 panels)
The Textile Museum 1985.58.1
Gift of Mrs. G. Reginald van Raalte

Among the Savunese, indigo, thought to
cool the body, is the main color of tube
skirts and loincloths worn in life. While
certain cloths imbued with power are red,
that color is thought to be hot and is more
commonly associated with funerary
cloths, which return energy to the body.

Another distinction between textiles
for the living and those for the dead
concerns the weft yarns. These are
thought to carry life fluids and for protec-
tion are tightly concealed by the warp to
hold in life in the textiles for this world.
The dead, having lost life's forces, are
wrapped in cloth that clearly reveals the
weft yarns, the powers of which are no
longer needed.

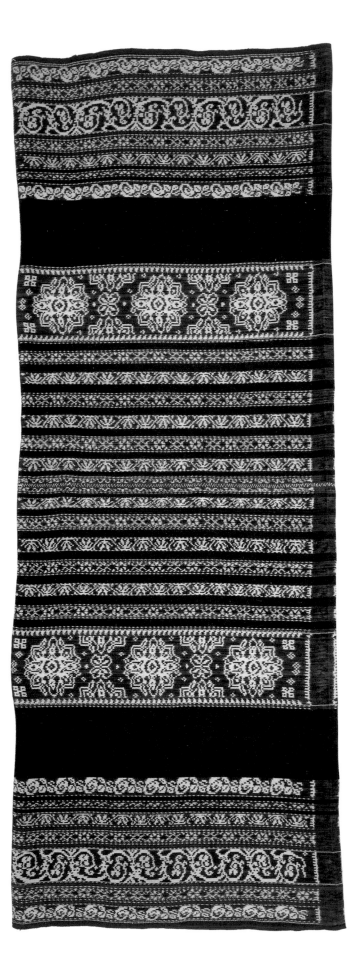

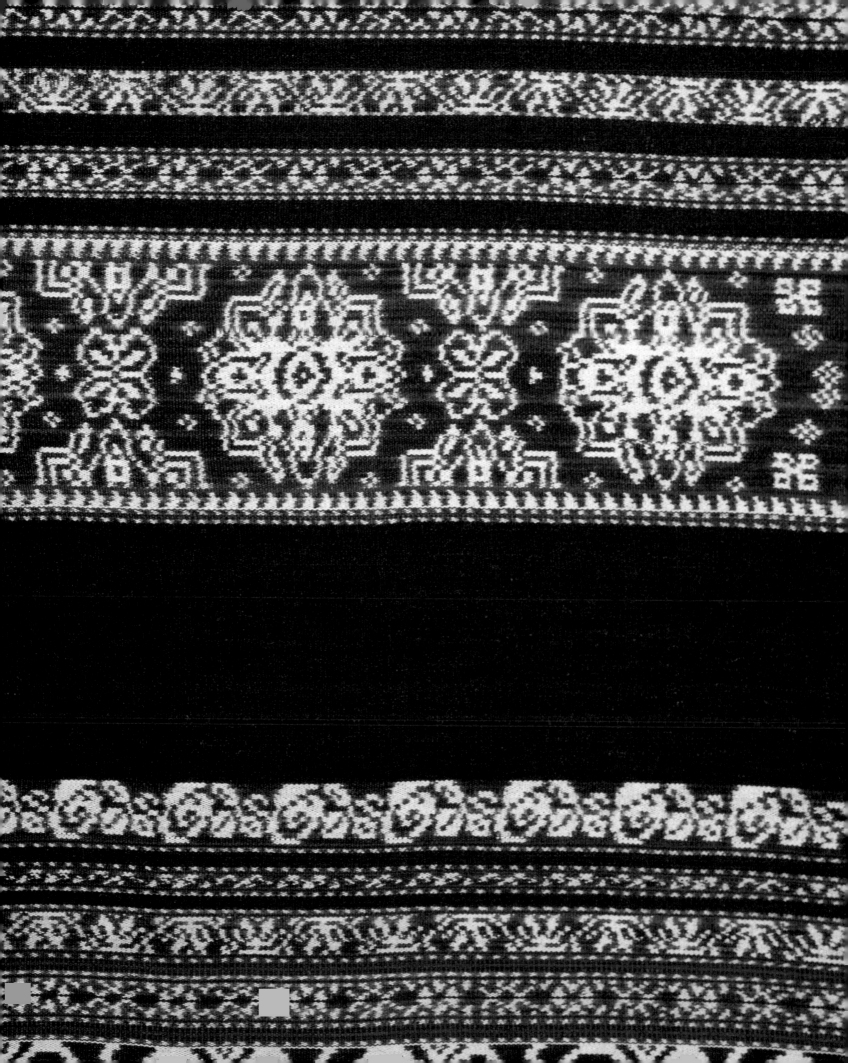

5.16
TUBE SKIRT (*ei ledo*)

Indonesia, Savu
Savunese People
Cotton
Warp ikat
Warp 115 cm x weft 168 cm (2 panels)
The Textile Museum 1969.2.3
Museum purchase

Ledo in the name of this tube skirt refers
to the wavy lines in the lower border.
According to various informants these
represent a snake, a centipede, or light-
ning. The motif is common to the skirts of
the Lesser Blossom group. Also associ-
ated with this group are the four wide
black bands in each of the top and bottom
half. This is in contrast to seven black
bands, which are normally associated with
the skirts of the Greater Blossom group.

Two lengths of cloth joined together
along the selvedge and, subsequently,
sewn into a tube, create the skirt. The
joined selvedges usually not visible when
worn, will be either red (for the Greater
Blossom) or blue (for the Lesser
Blossom). This is an inviolate rule based
on myth concerning the original division
of the two female groups. As stored in the
house in special baskets, the skirts are
folded to reveal the color of this seam,
and only those of one color may exist in a
single pile.

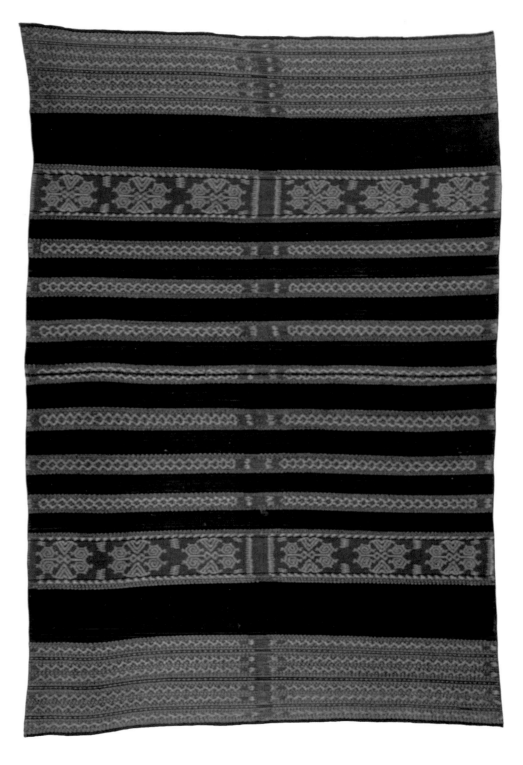

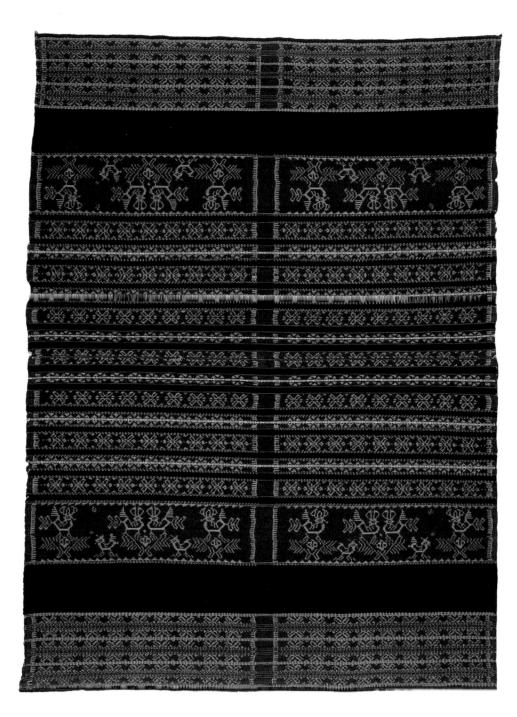

5.17
TUBE SKIRT (*ei raja*)

Indonesia, Savu
Savunese People
Cotton
Warp ikat
Warp 119 cm x weft 167 cm (2 panels)
The Textile Museum 1976.13.1
Gift of Gladys O. Visel

This skirt is known by the name *ei raja* after the narrow bands of white supplementary warp patterning appearing in the middle of some ikat-patterned bands. Formerly these white bands were the privilege of nobles, and the number of yarns in each allowed local identification. In this example, five pairs of white yarns suggest the cloth was made in Mesara. The main ikat design depicts birds, possibly seabirds. A mourner would wear this motif if both parents were dead.

The seven narrow black bands in each skirt half are associated with the Greater Blossom group. This is confirmed, additionally, by a narrow red stripe in the selvedge where the two panels are joined. Even if a weaver wove for a different Blossom group, she would have to carry the requisite red or blue warp stripe, according to her Blossom group, in this seam area.

5.18
TUBE SKIRT (*ei worapi*)

Indonesia, Savu
Savunese People
Cotton
Warp ikat
Warp 122 cm x weft 163 cm (2 panels)
The Textile Museum 1993.7.3
Gift of Mrs. Robert L. Maher

This skirt is a third type of skirt known as *ei worapi*. It does not proclaim membership in either of the two female descent groups—the Greater or the Lesser Blossom. Those groups will have either red and white or blue and white in the major design bands. Here, designs in the major band are rendered in white, red, and blue. Also, the patterns carried in the lower part of the skirt are neutral, not claimed by either Blossom group.

Weaving this skirt does not involve the ritual that surrounds the more restricted Savunese skirt forms. It is the most popular skirt woven today because it may be worn in broader secular and religious contexts.

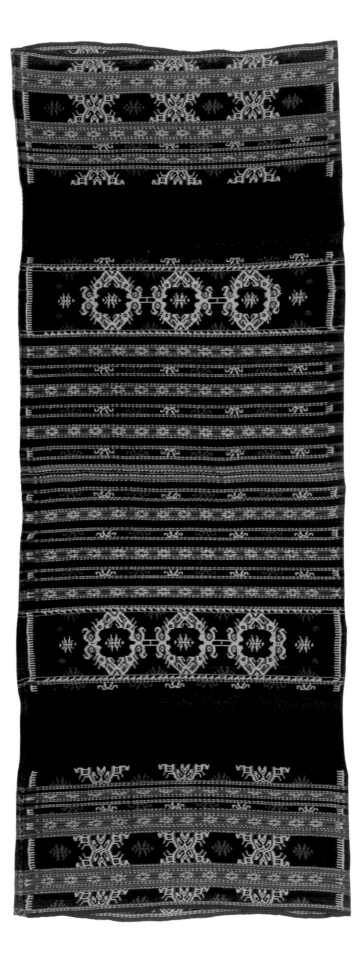

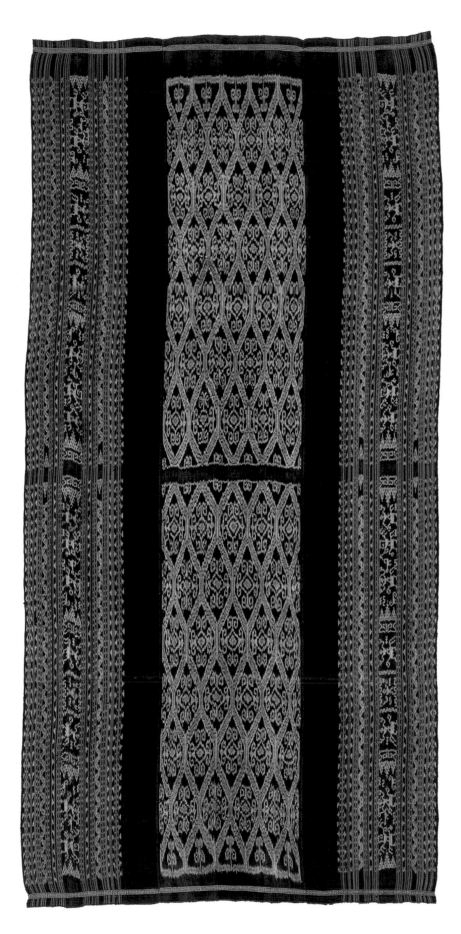

5.19
WRAPPER (*selimut*)

Indonesia, Southern Moluccas, Kisar or
Luang
Proto-Malay people
Cotton
Warp ikat, weft twining
Warp 218 cm x weft 104 cm (3 panels)
The Textile Museum 2000.25.15
Gift of The Christensen Fund

Kisar and Luang are small islands off the
northeast coast of Timor, and although
they are not strictly a part of Lesser Sunda,
their textiles align more easily here than
elsewhere. Kisar and Luang once
produced an array of women's and men's
skirts, loincloths, and wrappers such as
this *selimut,* featuring patterns worked in
one- and two-color warp ikat. The patterns
were geometric, renderings of birds, or
orant human forms frequently represented
on horseback. Weavers here exported
cloths to Alor, Timor, Babar, and islands
farther east.
 The latticework framing device in the
center field of this cloth is unusual in the
archipelago and an extremely effective
patterning device for this long narrow cloth.
It is reminiscent of patterning schemes
explored in parts of neighboring Timor.

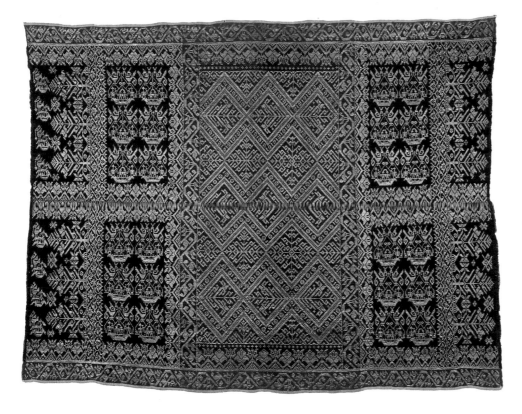

5.20
SKIRT CLOTH (*kré alang*)

Indonesia, Sumbawa
Semawa people
Cotton, metallic yarns
Supplementary weft (continuous in the
center area, discontinuous in the black side
areas)
Warp 155 cm x weft 120 cm (2 panels)
The Textile Museum 2000.25.16
Gift of The Christensen Fund

This luxuriously patterned skirt was
undoubtedly worn in the courts of the
highly stratified society of western
Sumbawa. The use of imported metallic
yarns reflects the wealth of this island
largely derived from the sale of horses and
buffalo that were known to the interisland
trade as early as the fourteenth century.
Yet the motifs used here may speak to
even earlier times. Ships bearing frontal
figures and birds in the rigging hearken to
themes of transition developed in many
areas of Southeast Asia. For instance, the
ship cloths from Sumatra express similar
themes in varying degrees of complexity.

The appearance of several colors is
cleverly achieved in this cloth, even
though it has a simple plain-weave struc-
ture. The warp yarns in the margins are
red, whereas in the center of the cloth they
are black. Paired red wefts in the center
enhance the red of the margins and make
the black appear maroon.

Some Toraja groups of Sulawesi have no weaving traditions. Others have modest skills, producing utilitarian cloth. That does not mean, however, that they have no cloth traditions. In fact, Toraja groups of this island employ an extremely rich repertoire of cloths in celebrations for the living and the dead.

Some cloths were thought to have divine origin, and myth has enhanced this status. Origin stories relate that the supreme god, Puang Matua, gave rise to the first humans from his forge bellows. One of these was Laungku, the ancestor of cotton. Laungku married the earth and commanded that her body be spun into thread, and this was to be woven into *sarita* cloths bearing the motif of swimming men and into *mawa'* cloths decorated with crosses.[1] Other myths relate that the Toraja ancestors first resided in heaven, and when they descended to earth, they brought with them sacred *mawa'* and *sarita*. Certain other *mawa'* were given to man by supernaturals. The groups that know these textiles include the people of Mangki, Rongkong, and the Bare' speakers, as well as the closely related Sa'dan and Mamasa Toraja.[2]

When one looks with more focused eyes at these sacred cloths one sees that many of the *mawa'* were made in India, some being mordant-drawn or printed cloths that were actively traded for spices, aromatic woods, and slaves. Others are the silk double ikat cloths from Gujarat, India, so highly prized throughout the entire archipelago (Fig. 6.5). Many others are batiks once made on Java. Some *sarita* (Fig. 6.7) were made by the Sa'dan in a process akin to batik, others were printed with wood stamps and hand-painted, whereas still others were made in Holland between 1880 to 1930 to be exported to Sulawesi, probably in imitation of Sa'dan prototypes.[3]

These textiles were essential to the efficacy of rituals that were classified into Eastern and Western spheres. The West is called the Realm of the Setting (dying) Sun and the East that of the Rising Sun. Each of these has its own rituals; those concerning death are considered rituals of the West, and those with fertility, renewal, and well-being, with the East.

Within the funeral context of high-ranking people a *sarita* is placed on the chest of the dead and later a *mawa'* covers the wrapped body. Other *mawa'* and *sarita* are hung in the house at critical periods of the funeral, and one of the cloths acts as a saddle on the back of the most important buffalo to be sacrificed to carry the dead to the beyond.[4] *Sarita* were head wrappers for the officiant at the funeral and for the effigy of the dead. *Mawa'* also served as shoulder cloths for participants at funerals and other ceremonies.

The *maro*, a ritual (aligned with the East) whose purpose is to expel illness or evil influences, also utilizes these cloths. These ceremonies (as well as the *bua'* feasts, originally a harvest festival, now a total celebration of society) tend to center on the large family house, which symbolizes the extended kinship group (Fig. 6.2). *Sarita* bind the house to a constructed tree of life, and among some groups *mawa'* form an enclosure to hide the ritual guardians of the ceremony in the limbs of a sacred tree.[5]

These highly orchestrated ceremonies are just one feature of the structured orientation that brings order to the Toraja world. According to Jane C. Wellenkamp, "There are, moreover, numerous traditional rules regulating the proper orientation of objects, plants, people, activities and so forth, in space and time. There are rules, for example, regulating the location and orientation of houses and rice barns and of certain plants and trees in the village, as well as the time of year during which specific foods can be

Detail from Figure 6.9

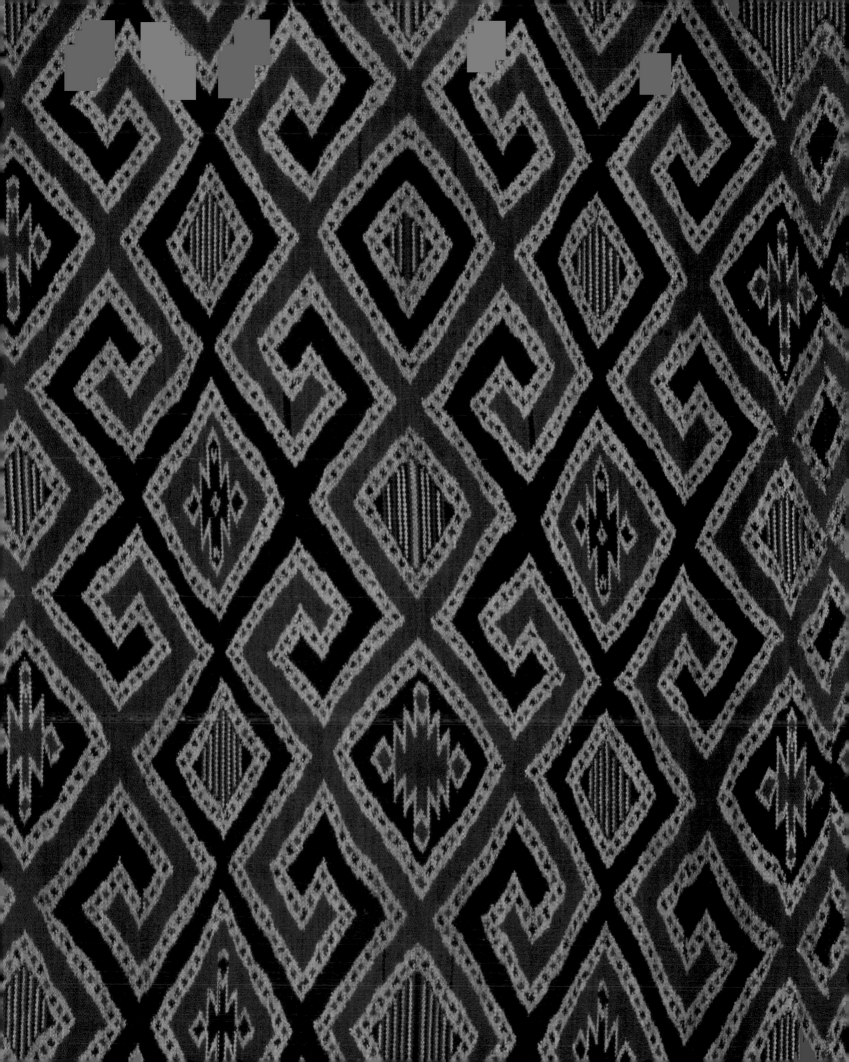

Figure 6.1
A Toraja wedding shows the use of traditional textiles to frame the dias. In the foreground is a *porilonjong* and, possibly, a *porisitutu*. Behind the bride and groom and surrounding still another sacred cloth is a *sarita*. 1987

consumed, rituals can be performed, and certain children's games can be played." [6]

The orientation of the great family house, itself seen as a cosmic symbol, and the ritual textiles within that space invest the cloths with even more complexity. The house faces north, and the most sacred room is the *sumbung* located on the south, the realm of the ancestors. The room is for honored guests and marriage ceremonies. In the building of the house, the root ends of the timbers are laid to the south. Sacred cloths and swords are stored in the *sumbung* to promote fertilization. [7] Thus the cloths nourish the house and its earthly members. When called into ritual use, the cloths are hung from a gable in the northern part associated with the gods.

Sarita and *mawa'* seem to have been the most revered textiles among the Toraja. However, they are only a part of a larger repertoire of cloth known to the Toraja that is imperfectly understood today.

At one time the richest Toraja weaving centers seem to have been in the interior area between Rongkong and Galumpang. Here large warp ikat-worked cotton cloths were hung at ceremonies, used to wrap the dead, and traded to many neighboring groups to serve in similar ways or to be used in bridewealth exchanges or as clothing (Figs. 6.4, 6.6, 6.8, 6.9). These interior groups were largely displaced before studies could record finer distinctions surrounding these textiles.

The sheer physical dimension of these cloths suggests their societal worth. The investment in materials, time, and labor that these would have entailed is empirical evidence of their value. These are some of the largest textiles made in Southeast Asia. When one considers they were executed on back-tension looms with hand-spun fibers, the accomplishment is impressive, if not astonishing.

In the Rongkong area these locally woven ikat cloths shared a ceremonial context with *mawa'*. Reports from the early part of the twentieth century say the dead were wrapped in a white cotton cloth, a *mawa'* (described as a cloth imported by the elders), and a *porisitutu* (described as a type of ikatted Rongkong cloth, probably similar to Figure 6.6). The report continues by saying that, of these, the *porisitutu* can never be missing. [8]

These cloths also enter into the secular world. Certain villages specialized in making caskets, and one ikat cloth could purchase two of these. An ikat cloth could purchase ten stone beaters. [9] A person accused of a lethal crime who could reach the sanctuary of his family great house could atone for the crime by paying a fine of one *mawa'*. Among the gifts a man gives to the family of the bride is a *mawa'*. [10]

The rich variety of Toraja textiles is suggested not just by those already presented here but by still additional types for which even less information is available. Among the Sa'dan, long banners patterned by a tie-dye technique known as plangi were equally sacred and were flown from tall poles on ceremonial occasions. In certain areas particular female mourners wore a long black-fringed hood known as *pote*. This was plain except for a border of imported beads and card-woven bands. Other objects that were created by card weaving included belts and slings. The Sa'dan also valued conical

beaded ornaments known as *kandaure*. Made from imported beads, they were used as ceremonial ornaments and elements of costume. These, like other sacred cloths, often had personal names and belonged to ancestral houses where it was believed they helped to prevent misfortune and to guarantee prosperity. The most extraordinary was a cloth known as *mbesa tali to batu* thought to have come from the Rongkong area (Fig. 6.10). These are narrow textiles first woven as a slit tapestry. The critically placed slits served as binding points for dye-resistant ties applied to the cloth before dyeing red and blue-black. The careful orchestration of the slits, ties, and dyeing left a surface patterned with large integrated hooked lozenge and other geometric figures. Believed to be unique to the Rongkong area, this type of cloth was used as a headdress at funerals by the closest relative of the dead. The cloth's name, which means "ceremonial headscarf for a stone person," may refer to the immobile posture required of those who attend the body of the deceased.[11] Others have termed these *pewo*, meaning "loincloth."

The textiles of the Toraja suggest a story of change influenced by external contacts. The people of Rongkong area in the interior say they emigrated from the Sa'dan area and took ikat-weaving skills with them. Their textiles show they were experts in this art and had extraordinary color sensitivity. In contrast, the Sa'dan subsequently abandoned this patterning technique, probably in response to the flood of prestigious textiles and materials that became available from foreign contacts. The Sa'dan also seemed to have moved from patterning on the loom to surface patterning such as plangi, batik, and stamped and painted cloth—all techniques that could be applied to imported cloth or a simple, locally woven plain-weave cotton. The virtually insatiable need for ritual cloths became more easily fulfilled once surface patterning techniques, probably enhanced by their foreign origin, were available.

Another field of consideration is opened by imported beads and their use in the creation of ritual forms such as the *kandaure*. While textiles are traditionally the work of women, these sacred objects are made by men. Presumably, beads from abroad transcend the usual classification. This transgression occurs again in gift exchanges, which normally dictate that cloth passes from the family of the bride to that of the groom. *Mawa'* are frequently listed as a gift from the groom's family to that of the bride's. Again, because of this textile's association with its foreign origin, the usual path of customary law seems to have been superseded. All of these details are witness to a once-traditional society accommodating change in its world of material culture.

Before the coming of Christianity to the Toraja throughout the twentieth century, these textiles were an essential element in the well-being of a family. They were held to be sacred and were invested with the prosperity of the family, its animals, crops, and future wealth. Each family held a store of these cloths as insurance of good fortune. Some of the most sacred cloths had personal names and were believed to bring special favors on their owners.

Many changes have brought about the devaluation of these textiles in the religious sphere of the Toraja. Concomitantly, their beauty and exotic qualities attracted the international art market, which seems to have absorbed the majority of finer old textiles.

Figure 6.2
The Toraja family house, the *tongkonan*, is central to many ceremonies when sacred textiles are displayed on the facade. 1967

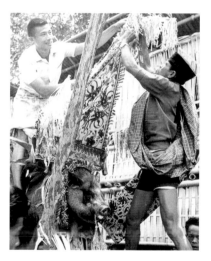

Figure 6.3
Pigs destined for sacrifice at elaborate funerals are carried in decorated litters festooned with sacred cloths. 1967

6.4a–c
CEREMONIAL HANGINGS OR SHROUDS (*porilonjong*)

Toraja peoples
Cotton
Warp ikat
a. Warp 549 cm x weft 160 cm (2 panels)
The Textile Museum 2000.20.1
Gift of The Christensen Fund
b. Warp 417 cm x weft 168 cm (2 panels)
The Textile Museum 66.4
Acquired by George Hewitt Myers in 1955
c. Warp 488 cm x weft 149 cm (2 panels)
The Textile Museum 1961.8.7
Museum purchase

These *porilonjong* are some of the largest textiles found in Southeast Asia. The very name, *pori* (referring to ikat) and *lonjong* (long) articulates this dynamic aspect. Other Sulawesi groups purchased these textiles from Rongkong weavers and used them in a variety of ways. In Rongkong they were hung on fences to demarcate a sacred area. Once they wrapped the wooden death house of the Sa'dan or were hung on walls at the time of ceremonies. Toraja are renowned for their elaborate death rituals, which involve the slaughter and distribution of meat and display of sacred textiles such as these.

 The two panels that make up each cloth are each approximately 76 centimeters wide. Traditionally several women worked together to tie the patterns on hand-spun cotton. Joint work on a woven cloth is an unusual feature in insular Southeast Asia; normally a single woman handles all aspects of a cloth's manufacture. The dyes on such early examples as these appear to be natural, and even the simple border stripes show a gentle nuance in coloration.

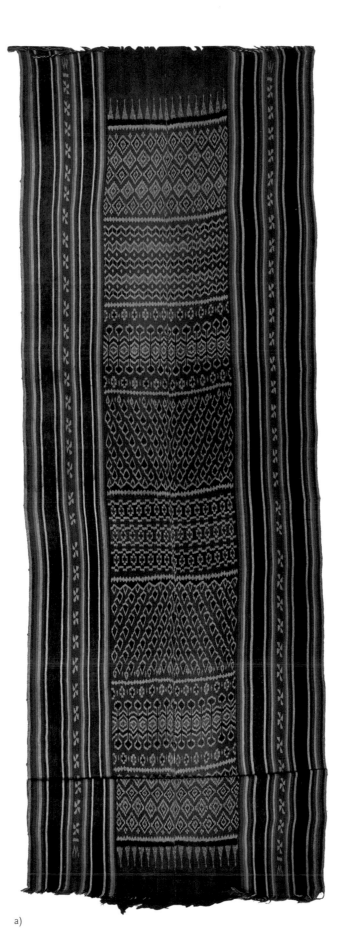

a)

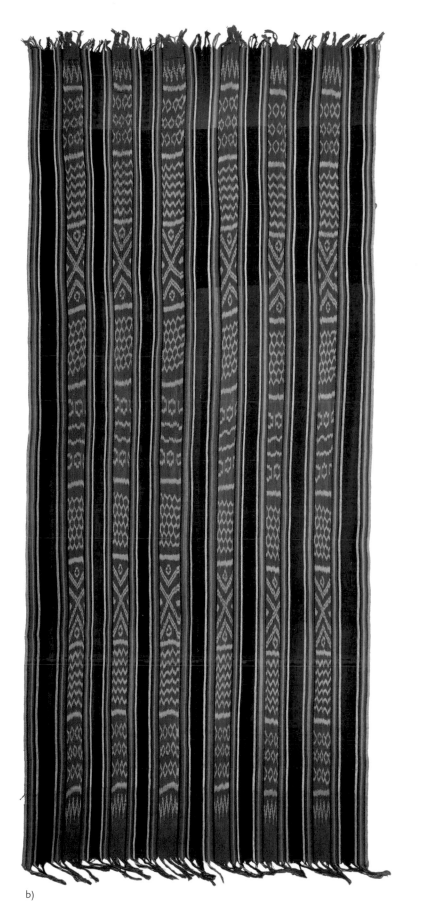

b)

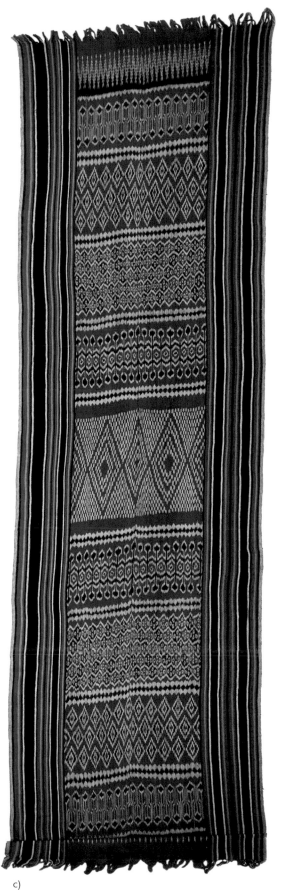

c)

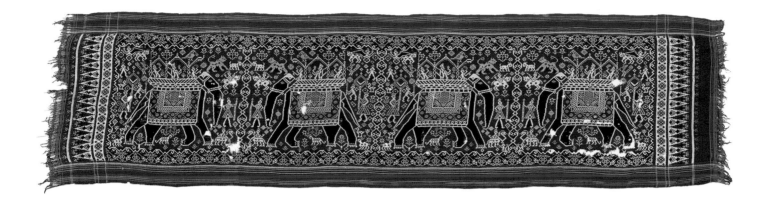

6.5
SACRED CLOTH (*mawa'*)

India, Gujarat
Toraja of Sulawesi
Silk
Double ikat
Warp 411 cm x weft 107 cm
The Textile Museum 1985.7.1
Ruth Lincoln Fisher Memorial Fund

There are numerous types of *mawa'*, the general term for a class of sacred textile known to the Toraja. Batiks from Java, cloth from China, and many sorts of cloth made in India were considered sacred and thought to have been descended from the ancestors or gifts from supernaturals. They had the power to ensure the well-being of people, their crops, and their animals.

The double ikats from India were some of the most prized, and those depicting the procession of large elephants such as this were the most highly valued. From her fieldwork in 1970, Nooy-Palm reported one of the cloths was valued at approximately twenty buffalo or $2,000 (Nooy-Palm 1989, 168). (In today's purchasing power, this would equate to about $9,500, a sizable sum within communities earning a fraction of that per capita.) Cloths attributed with special powers might carry personal names, and this further increased their value. Families may trace some of these back thirty generations.

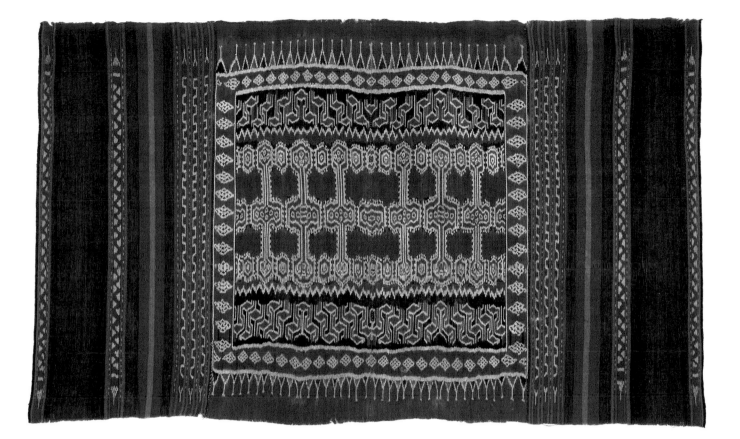

6.6
SHROUD OR HANGING
(*porisitutu*)

Indonesia, Sulawesi, Rongkong area
Toraja people
Cotton
Warp ikat
Warp 152 cm x weft 274 cm (4 panels)
The Textile Museum 1986.26.2
Gift of Mary Jane and Sanford Bloom in
honor of Patricia L. Fiske, Director of The
Textile Museum 1982–86

This motif is unusual in the Toraja repertoire, but the deeply saturated dyes and technical details place this cloth within the Sulawesi traditions. Hundreds of foreign textiles were traded to this area in exchange for coffee, slaves, and rice. One or more of these textiles may have provided the inspiration for this example. Another textile similar to this exists in the Australian National Gallery, Canberra. It was acquired at approximately the same time as this and both probably represent the work of a single house.

A visitor to this region early in the twentieth century reported that among the several textiles selected to wrap the dead a *porisitutu* would never be missing (Kruyt 1920, 394).

Even within the outstanding cloth traditions of the Toraja, this is a remarkable, vibrant cloth. At times the pattern has been termed a "backbone." Whatever its original significance, it appeals to the kinetic senses today.

6.7
SACRED CLOTH (*sarita*)

Indonesia, Sulawesi
Sa'dan Toraja people
Cotton
Resist patterned
Warp 223 cm x weft 27 cm
The Textile Museum 1976.43
Gift of Ernest H. Roberts and Near Eastern
Art Research Center

Old *sarita* carry some of the most intriguing images of all Toraja textiles. Men are depicted leading buffalo or in some instances plowing fields with teams of buffalo. Or, as in this example, men are shown in front of the family houses, the *tongkonan*. These scenes are carefully zoned in rectangular panels that are interspersed with other panels showing geometric patterning. The latter recall the heavily carved boards that decorate the house facades, which, in turn, are a partial record of imported Indian textile patterns.

These sacred cloths were essential in ceremonies for the living and the dead. One of the cloths bound a large constructed tree of life to the family great house in rituals of renewal. At funerals a *sarita* is placed on the chest of the dead, and another is used as a head wrapper by the ceremonial leader. These and other sacred textiles were saved in the family great house where they guaranteed the well-being and prosperity of the extended family.

The oldest of these textiles seems to have been made by a resist process similar to batik. Other obviously old textiles show painted and stamped figures. Other, probably more recent examples were printed in Holland for export to the Toraja.

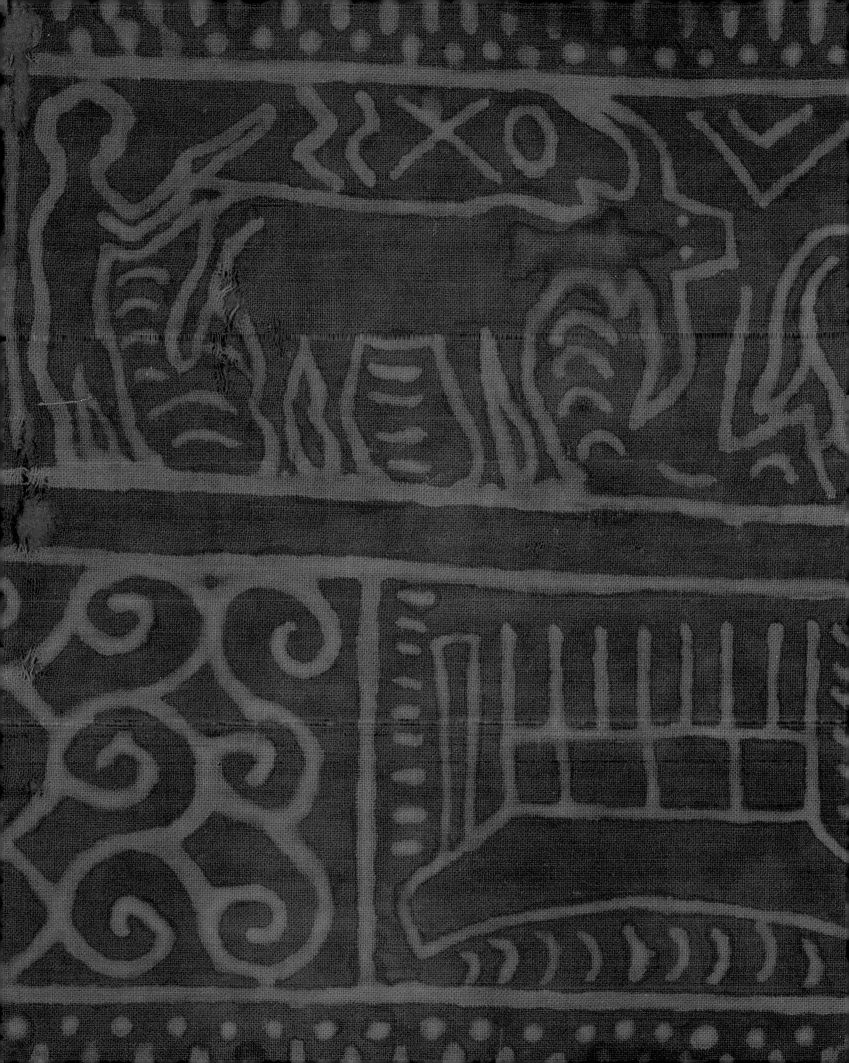

6.8
SHROUD (sekomandi)

Indonesia, Sulawesi, Galumpang area
Toraja people
Cotton
Warp ikat
Warp 154 cm x weft 140 cm (2 panels)
The Textile Museum 66.2
Acquired by George Hewitt Myers in 1955

Within their remote mountainous terrain, the Toraja developed a complex of ceremonies centered on honoring the dead. These invoked customs that called for the use of large, spectacular textiles once considered sacred, having originated from divine sources. This example would have been used to wrap the dead or as a hanging at funeral ceremonies. When traded elsewhere, the cloth could have been worn as a skirt or used as a backdrop to the principal participants of a ceremony, not necessarily just at funerals.

This cloth, made from two cotton panels sewn together, was collected in Indonesia in 1900. It originally may have had striped panels on the lateral margins similar to those in Figure 6.9.

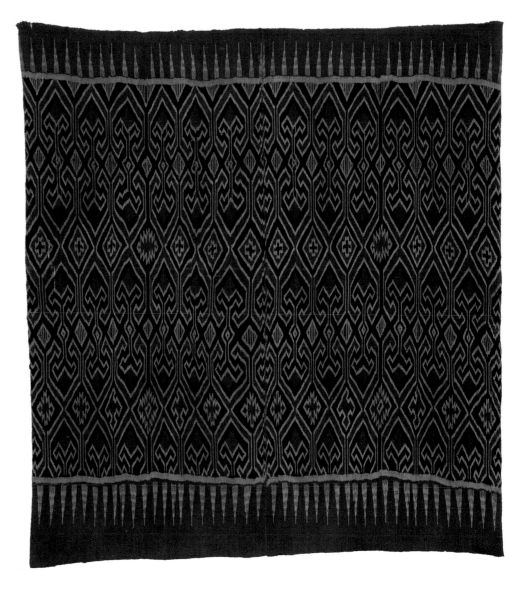

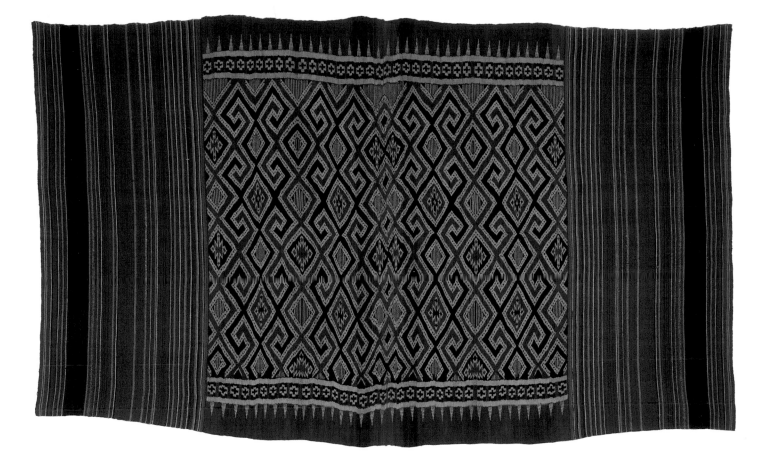

6.9
SHROUD

Indonesia, Sulawesi, Galumpang area
Toraja people
Cotton
Warp ikat
Warp 178 cm x weft 295 cm (4 panels)
The Textile Museum 66.1
Acquired by George Hewitt Myers in 1955

Ceremonies surrounding the death of an honored person often required months or even years of preparation. In the initial stages the body was kept in the house of the deceased wrapped in many layers of cloth. This textile would have been appropriate for such use. At other times this type of cloth would have been a wall hanging for various ceremonies.

This motif has been interpreted as a "genealogical pattern," with the hooked arms and legs of the stylized human forms representing generations of ongoing social groups. Four cotton panels joined at the selvedges make up the cloth.

6.10
SACRED CLOTH (*mbesa tali to batu* or *pewo*)

Indonesia, Sulawesi, Rongkong area
Toraja people
Cotton
Tapestry, resist patterned by ties
Warp 273 cm x weft 48 cm
The Textile Museum 1982.37.1
Ruth Lincoln Memorial Fund

These long narrow cloths were used in the Rongkong area as a headdress by the closest relative of the dead during mourning rituals. Its alternative name, *pewo*, meaning "loincloth," suggests it may have had an earlier function.

Whatever its original function, the cloth patterning is unique to the weaving genre. The complete patterning was conceived before the cloth was woven. When woven, certain wefts were worked back and forth over only a few warps, leaving a slit between this weft and an adjoining weft being worked in a similarly limited manner. After completing the cloth these slits served as binding points for ties that resisted the penetration of the dye. After tying and dyeing in red and dark indigo these bindings were cut away, leaving designs in red, blue-black, and the natural beige of the cotton foundation. There is no name for this form of resist patterning; it falls somewhere between ikat and plangi and seems to be an original creation of the interior Toraja.

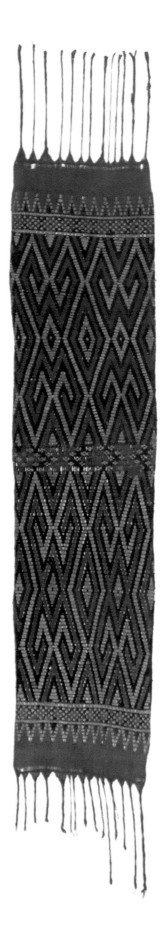

a)

6.11
TUBE SKIRTS (*sora langi'*)

Indonesia, Sulawesi, Rongkong area
Toraja people
Cotton
Warp ikat
a. Warp 174 cm x weft 206 cm (3 panels)
The Textile Museum 2000.22.10
b. Warp 137 cm x weft 176 cm (3 panels)
The Textile Museum 2000.22.9
Gifts of The Christensen Fund

We know very little about these tube skirts
and few exist in collections. One museum
records they were made in Galumpang
and traded to the Palu region farther
north in Sulawesi. Others attribute them
to the Rongkong area. While there are
many ceremonial cloths known from the
Toraja, costume in historical times has
been largely created from imported cloth
or, among some groups, has been made
from bark cloth. An early visitor to the
Rongkong area reported that they were
expert weavers of ikat, but they did not
wear this patterned cloth (Kruyt 1920,
374). The skirts have the technical
virtuosity characteristic of the
Rongkong area.

 These tubular skirts are each
created from three panels joined along
the selvedges. As worn, the warp is hori-
zontal. In the ikat-patterned areas two
finely spun warps are paired to make the
design more pronounced. This is a detail
found in some other Sulawesi cloths and
some from Sarawak, but few others from
this part of Indonesia.

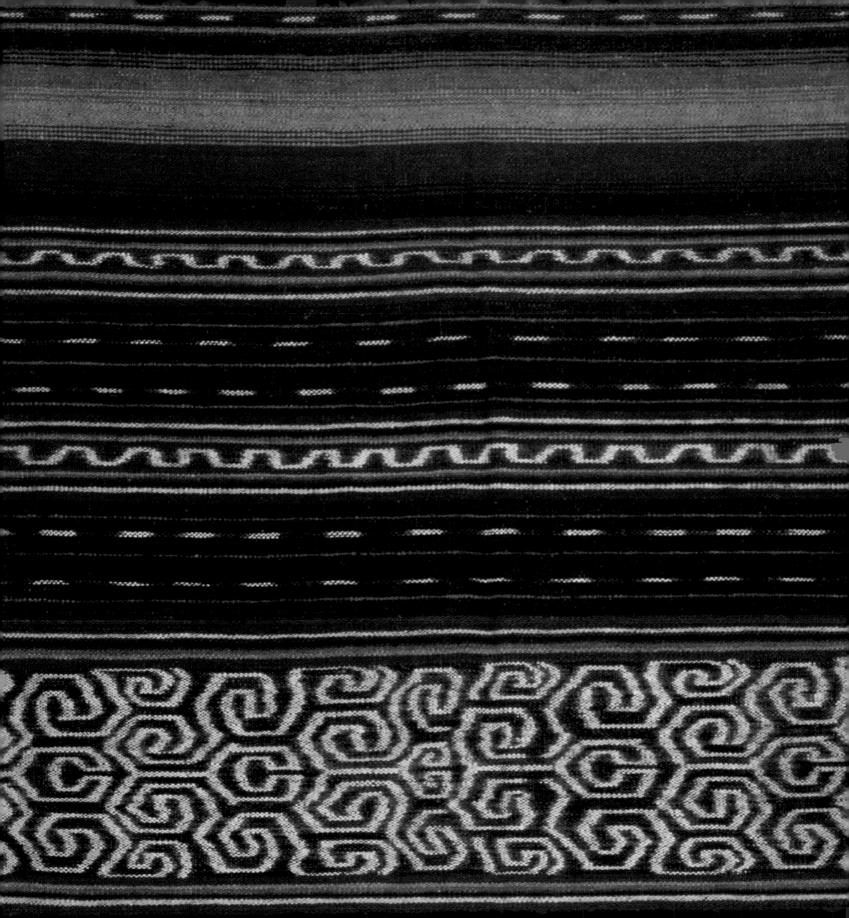

b)

Most Iban textiles challenge the eye. Kaleidoscopic patterns hover just at the edge of comprehension. Crocodile, snake, and anthropomorphic forms may emerge from the welter of patterning, but just as often there is a structured tangle of hooks and coils that defies labeling. This is a language of design unique to the Iban of Sarawak and the Iban-related peoples of Kalimantan—the Kantu' and Mualang.[1] It is a vocabulary to delight the gods and to invite them and their blessings into this world.

These are societies that revel in complexity as expressed in elaborate ritual and oral traditions replete with metaphor and allusion. It is no wonder that their textile arts share in this richness of intellectual play. Patterned textiles are the field on which women enter into the socially applauded fray. A woman's technical excellence and design agility in the face of spiritual and physical danger earn for her the prestige similarly awarded to great warriors.

Yet there are no myths or legends that speak to the origins of weaving or patterning in these societies. What myth exists relates the use of a type of patterned blanket to a ritual associated with head-hunting but not to the beginning of weaving skills.[2] The use of these textiles reveals singular customs: patterned cloth is not meant for everyday use. Rather it is an element of ceremony and may be critical to the efficacy of ritual. Skirts, jackets, loincloths, and, most importantly, large, blanketlike hangings known as *pua* are central to the cloth repertoire. These may be patterned with wrapped supplementary wefts (*pua sungkit*) (Figs. 7.7, 7.8) but more commonly show warp ikat patterns in deep earthen red, beige, and blue-black colors (*pua kombu*) (Figs. 7.3–7.6). The *pua* in particular communicate with the spirit world and protect individuals in times of crisis.[3]

This chapter concerns primarily the textiles of the Iban of Sarawak, where most recent fieldwork has been concentrated. It also includes a few examples of *pua* and skirts (*kain keban* or *kain kebat*) made by the Ibanic peoples living in Indonesia, primarily the Kantu' and the Mualang (Figs. 7.9–7.11).[4] Drake, working among the Mualang in 1978–79, reported on their textiles only briefly and some of that material is included here.[5] It is, unfortunately, not comprehensive enough to allow a comparison of these peoples and the Iban or to gain an understanding of the evolution of their textile arts. The Iban moved from the Kapuas River area in a series of migrations into Sarawak, probably leaving behind elements we know today as the Kantu' and the Mualang. The Iban are now found in every division of Sarawak.

The ritual life of these Ibanic people is largely manifested in gatherings known as *gawai*. These may be structured about the agricultural calendar or important death rituals, but rites connected to warfare, now adjusted to acknowledge prestige as reflected in riches, remain most important. Current worldly prestige forms now replace once-required trophy heads.[6] These affairs involve hosts of people who gather at a longhouse for several days to feast and witness the calling of the gods from their heavenly abode. Bards relate this long journey through the mythical realms and eventually guide the gods up the longhouse steps where they are greeted by large displays of *pua*, which line the ceremonial scene. Pleasure at such displays brings forth godly blessings on the longhouse and the festival givers.[7]

Pua are critical for *gawai* and a variety of other occasions. Temporary shrines are created by enclosing ritual objects with a *pua* (Fig. 7.1). A *pua* may be hoisted as a warning sign to signal a longhouse is in mourning, or may be used in healing rites to

Detail from Figure 7.14

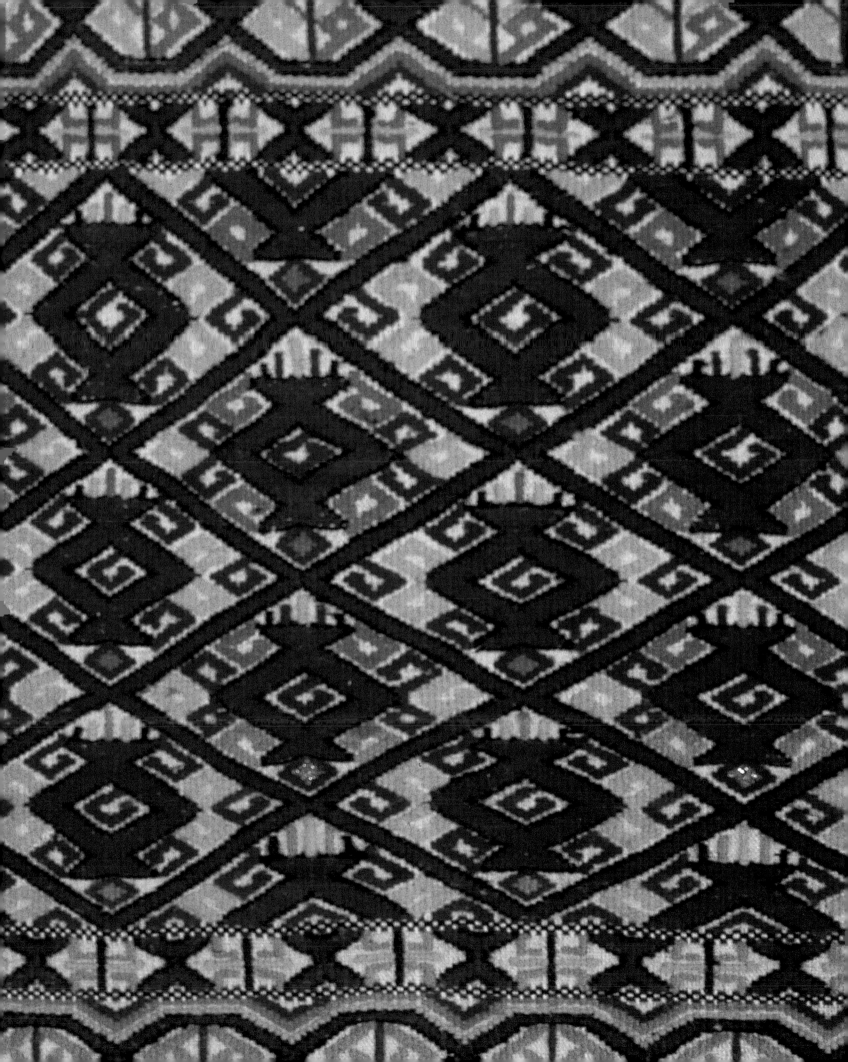

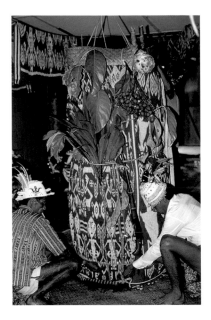

Figure 7.1
Pua are used to form a shrine enclosing sacred objects during certain rituals. Other *pua* line the walls to encourage the gods to bless the ceremony. Baleh area, 1986

act as a barrier to evil spirits. A shaman in trance is covered by a *pua* while another *pua* helps the shaman to snare lost souls. Whenever there is potential danger or need to call forth divine assistance, *pua* will have a role.

Pua are not of equal ritual use. The oldest cloth in a family's possession is often considered the most powerful.[8] Also, design and quality of the dye enter into assessing the power of a cloth. However, the main differences among the *pua* are based largely on the significance of the patterns. Original patterns and patterns that invoke powerful concepts command great respect. Once complete, *pua* with original designs are presented to the longhouse community and may include a name or title. In other instances patterns receive titles only after being accepted and found efficacious. These may be short terms or complex phrases cloaked in Iban-specific concepts. Such oblique references convey the respect paid to pattern and the rank of the cloth. However, these titles or names are not written down, so once a *pua* is removed from the embrace of oral legend and family tradition, little of the deeper significance of a *pua* can be known. The dreams that might have inspired the work, the original name that might have accompanied its initial presentation, and the significance of the entire composition no longer enrich the viewer and enhance the cultural dimension these *pua* represent. Thus to survive, patterns must be replicated and their oral traditions repeated through time.

Titles of *pua* bear no relation to the depictions in the patterns. They are distillations from the Iban heritage of chants, myths, or legends that make use of indirect language to express powerful concepts. One legend relates that the god of war taught his grandson that trophy heads taken in war must be received ceremonially on a powerful *pua* known as *lebur api*.[9] In historical times, the title *lebur api*, recognized as a term by all Iban, has come to signify *pua* of complex design and superior rank. It does not, however, designate a particular pattern. [10]

The most powerful patterns in the upriver region known as the Baleh are constructed from small or large coil motifs. The titles of the most important *pua* had referents to head-hunting, making the cloths powerful instruments created by women to encourage men to war. *Remaung*, the mythical flying tiger (Fig. 7.6) is one of these powerful *pua*. This feared creature may become a warrior's spirit helper; at other times he guards the rice bin with its crop of trophy heads. This is a pattern known in upriver areas from the Baleh to Kalimantan.[11] Other patterns carry titles with referents to scenes the gods pass along on their descent to earth to attend *gawai*—"ladder of clouds" and "ripples of waters."

In more recent times patterns and their titles have become more realistic. However, certain realistic patterns are very ancient and still carry great importance and earn prestige for the weaver. The crocodile and the snake are two of these (Figs. 7.4, 7.3).[12]

Not all of the *pua* carried titles. Those that are copied from existing textiles or that carry generic patterns are considered less powerful, and while the component parts may have names, inherently they do not have content. Textiles other than *pua* are not seen as being powerfully endowed, although war jackets featuring ogre figures such as Figure 7.13 would have endowed their wearers with added bravery and instilled fear in the enemy. Women's patterned skirts, *kain kebat* or *kain keban* (Figs. 7.9a–e), carry no connotation of power, although they, too, are used only at specific times within a cere-

monial context: when washing the ritual rice, when laying out the plates for offerings, when receiving the liver of the ritually slaughter pig and so forth. These skirts may carry patterns labeled as deer, hawk, or leech, but these are in no way figural portrayals or even abstract images of the object named. Nor does the making of women's skirts involve danger for the weaver, even though these employ some of the Ibanic people's most complex patterning. Weaving is not in itself a dangerous undertaking, and a weaver completes less prestigious objects such as skirts and jackets and textiles during *pua* in the beginning stages of learning to weave.

Figure 7.2
Women wear their ikat-patterned skirts at only specific times in ceremonies. Here a woman washes the rice to be used for offerings to welcome the gods.

The task of weaving enters into perilous realms as women become more adept and thus attract the attention of the spirit world. This interfacing with supernatural powers at once endangers the weaver and empowers her patterns. A woman may receive inspiration for a *pua* pattern in a dream with spirit commands to do the work. On penalty of severe physical and mental malaise, she must follow such commands. The tensions on the weaver are multiple because she must follow the commands and execute the pattern correctly. To fail in the proper execution would also result in spirit displeasure and reprisal. Certain periods of the undertaking are particularly fraught with peril, such as preparation for the mordanting process, a necessary precursor to dyeing red. The weaver makes special offerings to protect herself from evil and invokes the help of special charms she has acquired over the years. Less experienced women will take their warp yarns to a senior woman when it is known she will conduct a mordanting ritual. This is known as the "war path of the women" and exists as a direct parallel to men's custom of head-hunting. Other perilous times include the starting of the tying of the main design, and the tying of particularly dangerous patterns that must be completed at one sitting.

The complexity of the patterns testifies to the weaver's maturity, strength, and her obvious communication with the spirit world. Society recognizes such skill in honoring these women with the highest social standing. The parallel prestige the Iban project upon the acts of creating original patterns, dyeing, and weaving and those of head-hunting derives from the perilous nature of each and the importance each holds for the well-being of the community.

7.3
RITUAL CLOTH (*pua kumbu*)

Malaysia, Sarawak, Baleh area
Iban people
Cotton
Warp ikat, weft twining
Warp 270 cm x weft 127 cm
The Textile Museum 2000.22.8
Gift of The Christensen Fund

Serpent patterns (*buah nabau*) such as
this from the nineteenth century are some
of the most powerful and ancient images
found in the Ibanic people's *pua*. The
serpent occurs in Iban origin myths and
guards the door to the land of the dead.
The weaver recognizes the fearsome
aspect of the serpent by placing a small
offering in the mouth of the image on
the cloth.

 Pua have a beginning and an end in
the Iban conception, which they term
"downriver" or "upriver." When the
patterns are planned and as the cloths are
used they, too, follow such an orientation.
In this instance the head of the snake is
the "start," or *pun,* end of the cloth and
must be oriented downstream, while the
tail is the *ujong,* or "end," of the pattern.
As the cloths are used the designs are
properly oriented with the river in a
downstream/upstream manner.

 This *pua* is unusual in not having
lateral borders. It may be that they were
separately woven pieces that have become
separated from the body of the cloth. The
pua shown in Figure 7.6 has such borders.
Many *pua* designs were potentially
dangerous, and borders were necessary
to contain their power. Patterns that are
considered dangerous have usually
brought the weaver into contact with a
deity or spirit helper who originally
commanded the weaver to execute the
pattern. Special charms—such as an
unusual stone—are needed while tying
certain parts of the pattern and later
are tied to the warp beam of the loom
during the weaving of these patterns. On
extremely dangerous patterns, offerings
were presented to the warp when the first
border was woven.

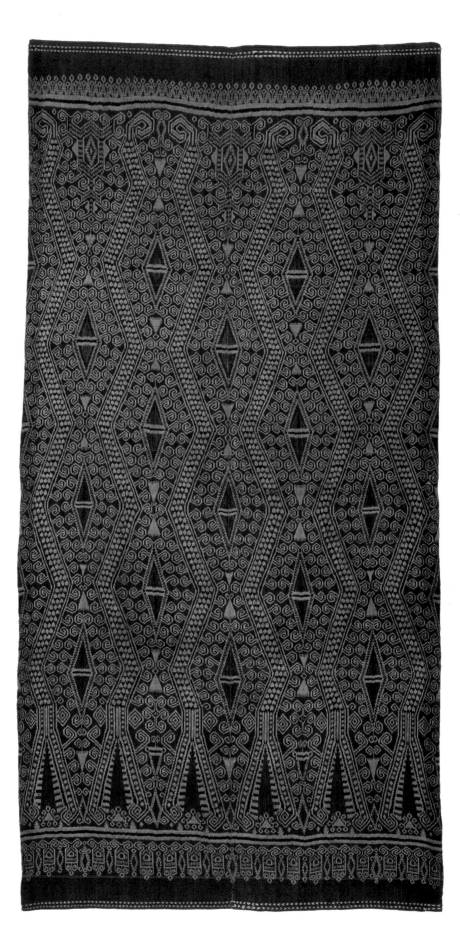

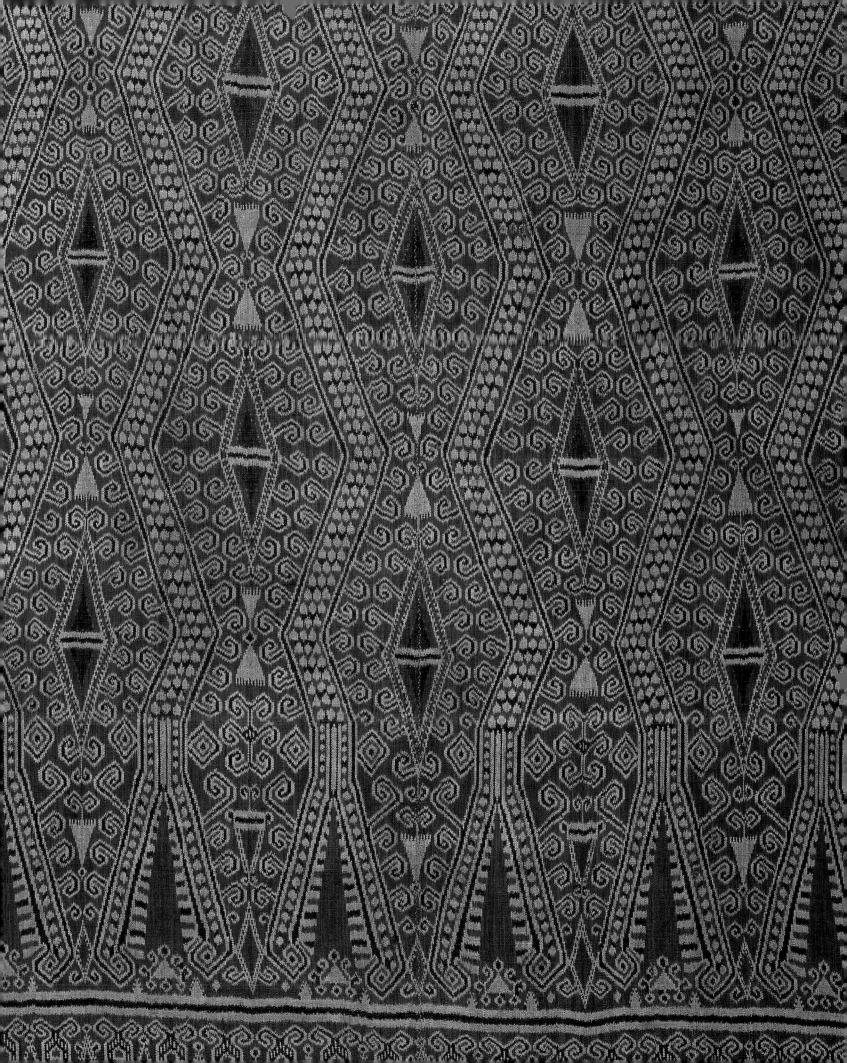

7.4
RITUAL CLOTH (*pua kumbu*)

Malaya, Sarawak, Saribas area
Iban people
Cotton
Warp ikat
Warp 229 cm x weft 112 cm
The Textile Museum 2000.22.4
Gift of The Christensen Fund

The crocodile, once readily found in the rivers of Sarawak, enters into Iban concepts of fertility but is feared as well. Myths relate an agreement struck between humankind and the crocodile to avoid conflict, and when the crocodile transgresses this pledge by killing a human, the Iban will kill the crocodile. Otherwise Iban and reptile exist in a modified totemic relationship, and the king of the crocodiles is viewed as a relative of the Iban. He is invoked in chants, and small crocodile images are set out to guard the rice fields. The motif is one of the Iban's oldest figurative patterns together with the serpent and an image of a demon spirit (*Nising*) (Gavin 2003, 97–103).

In this *pua*, the motifs show a relationship between the crocodile and head-hunting. Here humanoid figures carry trophy heads while other figures seem to become food for the crocodiles. The weaver has also made a distinction in the rendering of the reptiles in the facing rows.

This cloth was probably made in the Saribas River area where the use of plain stripes in the lateral borders, as in this example, was the privilege only of the highest-ranking weavers.

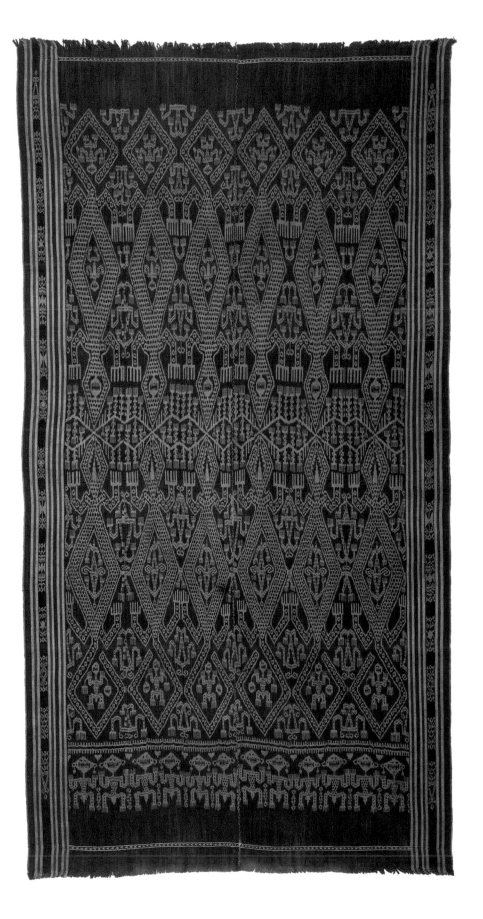

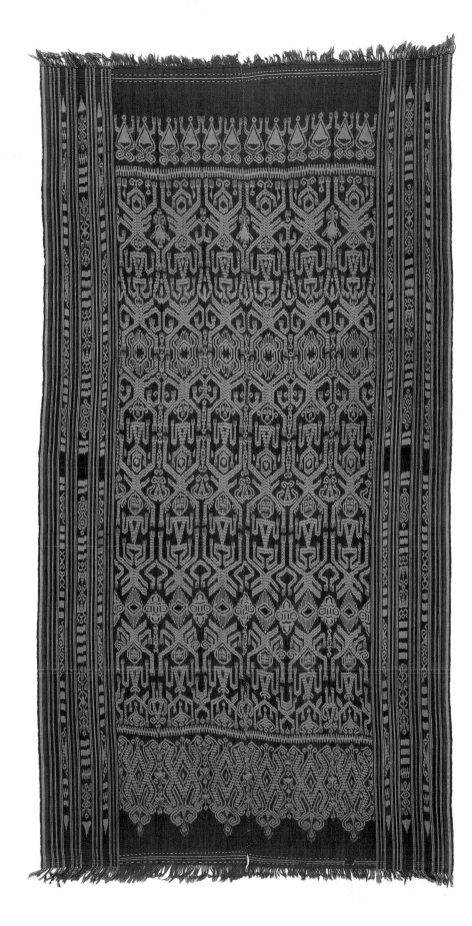

7.5
RITUAL CLOTH (*pua kumbu*)

Malaysia, Sarawak, Saribas area
Iban people
Cotton
Warp ikat, weft twining
Warp 216 cm x weft 107 cm
The Textile Museum 2000.22.3
Gift of The Christensen Fund

The anthropomorphic figures on this cloth, a design called *buah engkeramba*, were once thought to be some of the most powerful motifs among the Iban. However, more recent research suggests they are just anthropomorphic figures of no special importance. As one Iban explained the pattern, "Weavers only made the pattern to take a break from producing powerful patterns" (cited in Gavin 2003, 282). The abstract "forked" pattern that encloses the figures is known as *buah gajai*, whose interpretation is open to debate, possibly that of a bird (ibid., 290–91).

The Iban revel in complexity of pattern, and the most honored weavers create patterns having one hundred or more tied pattern units. Because this is a small pattern that is bilaterally symmetrical, the tying of the pattern would have involved few pattern units. It would not have pleased the Iban desire for allusion and indirect communication, which they value so highly.

For those of other cultures, however, the care with which the figures are rendered, revealing both male and female forms, tends to beguile the imagination.

7.6
RITUAL CLOTH (*pua kumbu*)

Malaysia, Sarawak, Baleh region
Iban people
Cotton
Warp ikat
Warp 246 cm x weft 140 cm
The Textile Museum 2000.22.7
Gift of The Christensen Fund

The design of this cloth represents the mythical tiger spirit known as *buah remaung,* one of the most powerful and feared members of the spirit world. Offerings to this spirit were placed on the longhouse roof so as not to invite this fearsome presence into the house, where normally offerings were made. Warriors invoked his aid as a spirit helper on head-hunting expeditions. The motif is known through all of the upriver areas of Sarawak.

The lateral margins of the *pua* are supplementary pieces sewn to the body, which carries the main design. This varia-tion was known in the Baleh region. The double row of patterning in the margins suggests the cloth was made in the early nineteenth century; more recent pieces tend to have a single row (Gavin, personal communication, February 25, 2004).

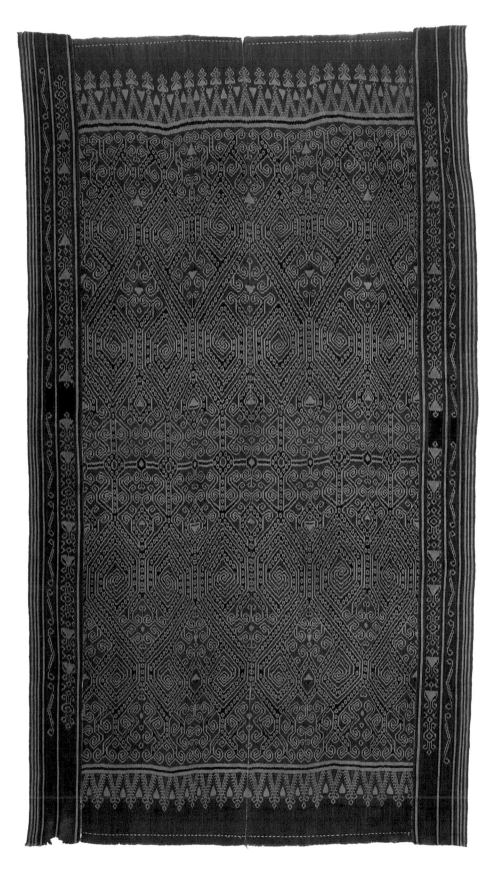

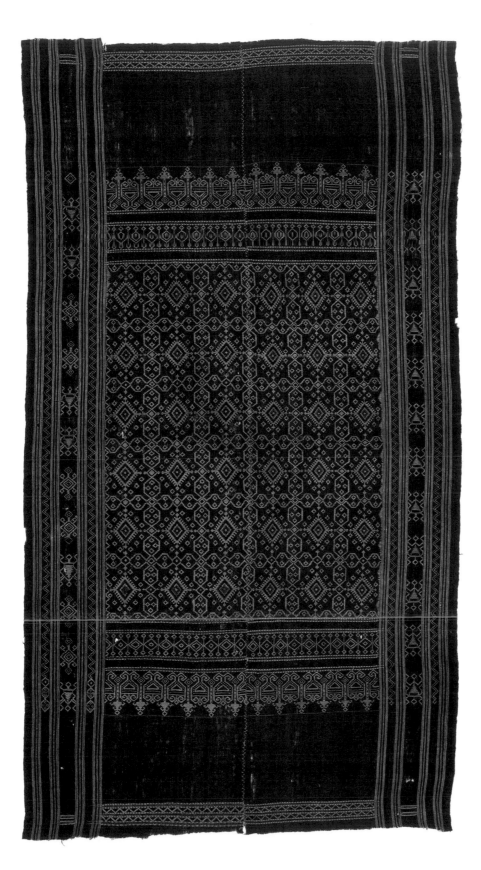

7.7
RITUAL CLOTH (*pua sungkit*)

Malaysia, Sarawak, Ulu Ai area
Iban people
Cotton
Warp ikat, supplementary weft (*sungkit*),
weft twining
Warp 179 cm x weft 100 cm
The Textile Museum 2000.25.17
Gift of The Christensen Fund

The pattern of this textile directly imitates that of an Indian-made patola cloth. These remarkable double ikat textiles made in western India were once the most prized trade cloth in insular Southeast Asia. Both in format and particular design motifs they influenced many locally woven textiles throughout the area (Bühler 1959,1–43).

While a majority of the locally made textiles showing patola-inspired motifs were worked in warp ikat, in this example supplementary colored weft yarns inserted between the regular wefts wrap around several warp yarns. It is thought these textiles, known as *pua sungkit*, are some of the oldest Iban textiles in existence, certainly dating back to the nineteenth century (Gavin 1999, 81). These cloths were used in the same manner as older *pua kumbu*, and one myth suggests they may be some of the very oldest to function in head-hunting rituals. Probably all come from the Ulu Ai region. The technique does not seem to have been used in the early twentieth century, but was revived with more modern designs in midcentury.

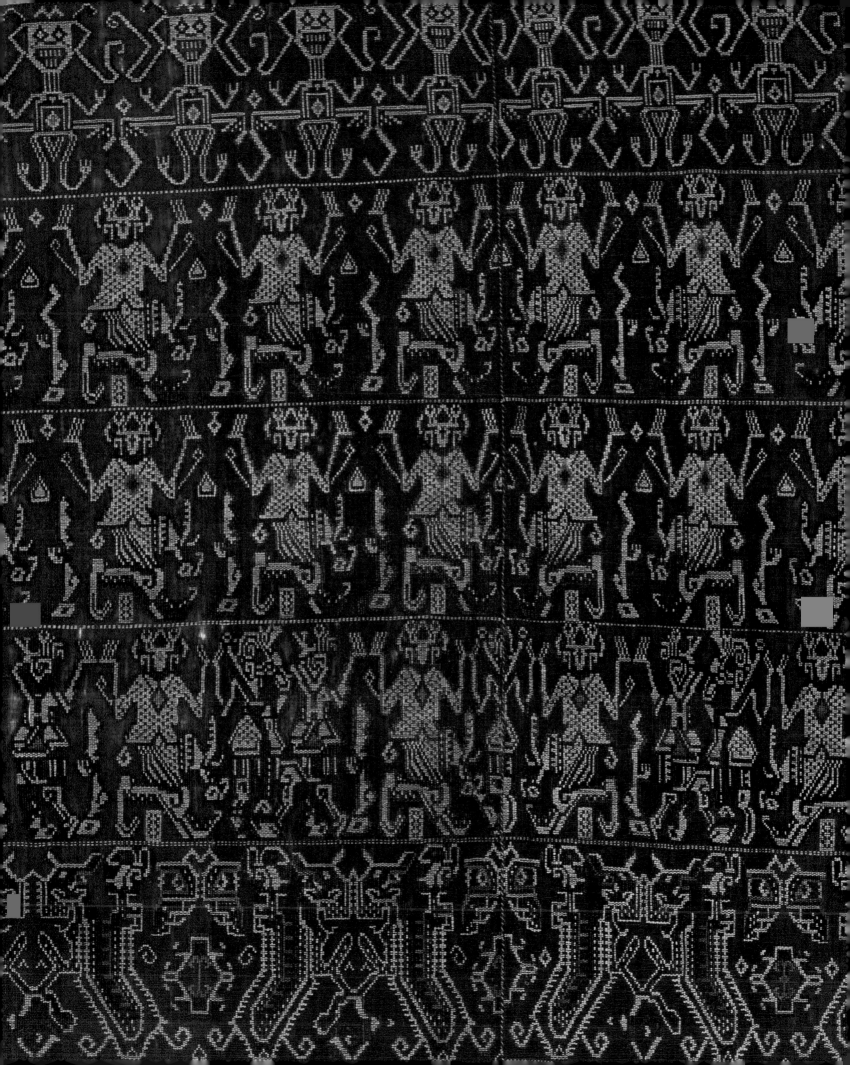

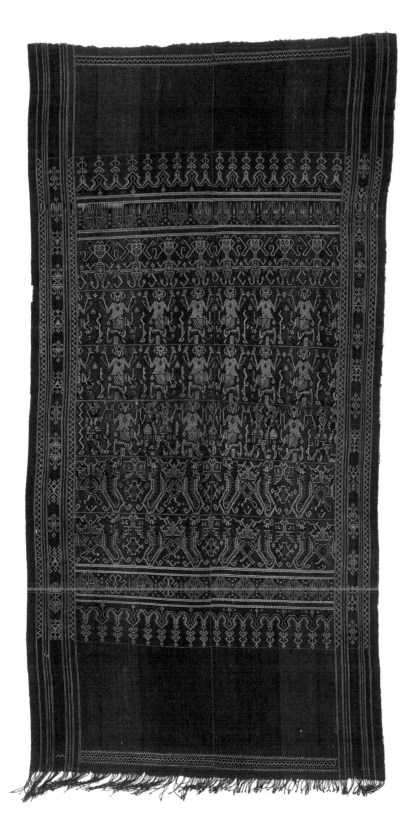

7.8
RITUAL CLOTH (*pua sungkit*)

Malaya, Sarawak, Ulu Ai area
Iban people
Cotton
Supplementary weft (*sungkit*), weft twining
Warp 216 cm x weft 104 cm
The Textile Museum 2000.25.18
Gift of The Christensen Fund

Indian-made textiles were historically the primary currency of exchange in the trade for spices in most of insular Southeast Asia. While Iban had the impact of the patola, details reveal other textiles had influence as well. A spectacular group of Indian textiles featuring a line of dancing ladies has become known in recent years coming from treasure holdings in Sulawesi and Timor. The manufacture of this type of cloth seems to have continued over a period from 1400 to 1600. Research proposes that the figures in this *pua sungkit,* dating to the nineteenth century, derive from those printed textiles. The pendant on the Iban rendering, as well as the white-spotted blouse, compares to exact details in the Indian textile (Gavin and Barnes 1999).

The row of figures linked across the top of the main design panel has been termed *bong midang,* meaning "warboat on a journey." Such *sungkit*-worked *pua* are very rare, numbering approximately two dozen.

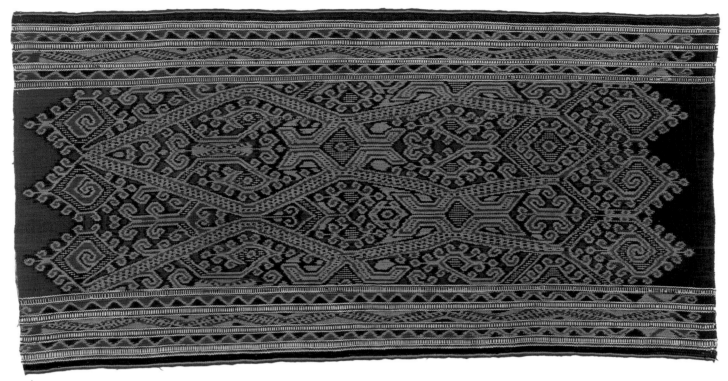

a)

7.9a–e
SKIRTS (*Kain keban*)

Indonesia, West Kalimantan
Kantu' people
Cotton
Warp ikat
a. Warp 102 cm x weft 48 cm
The Textile Museum 2000.25.8
b. Warp 119 cm x weft 56 cm
The Textile Museum 2000.25.11
c. Warp 104 cm x weft 53 cm
The Textile Museum 2000.25.12
d. Warp 112 cm x weft 56 cm
The Textile Museum 2000.25.14
e. Warp 114 cm x weft 51 cm
The Textile Museum 2000.25.1
Gifts of The Christensen Fund

These women's skirts, known as *kain keban*, come to the Museum as originating among the Kantu', an Ibanic people of West Kalimantan. Yet only an experienced eye would unhesitatingly label them Iban. The similarities in skirt patterns through all Ibanic peoples speak to their longevity as a textile form. While there is little specific information concerning these Kantu' skirts, the Iban information in general probably is true for these textiles as well.

Women's patterned skirts are not sacred to the same degree as the *pua*, yet the skirts are worn only at specific times in ceremonies. Women don the skirts to wash the ritual rice, prepare and set out the ritual offering plates, groom the sacrificial pigs, and at other critical times. Skirts also enter into creation myths and are requisite ritual items at some ceremonies, such as that to atone for incest.

Not being inherently dangerous, skirts are made as an alternate exercise in the weaving sequence to relieve the weaver of the perils associated with weaving *pua*. Less experienced weavers also weave skirts, even though skirt patterns may be very complex.

Design elements in the skirts may be named but do not pretend to represent an image of the object named. The large hooked forms in Figures 7.9a–b are named "leech," and the elongated lozenge in Figure 7.9d is called *aji* variously translated as "moon rat," "shrew," "bat," or "king" (Gavin 2003, 173). The Kantu' call their skirts *kain keban*, and the Iban, *kain kebat*. Both indicate a cloth patterned by ikat.

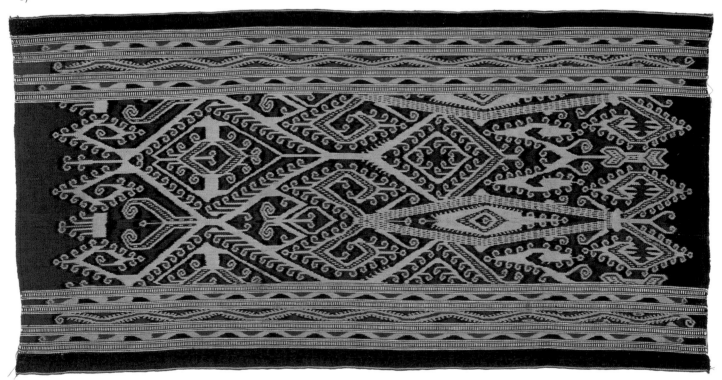

b)

c)

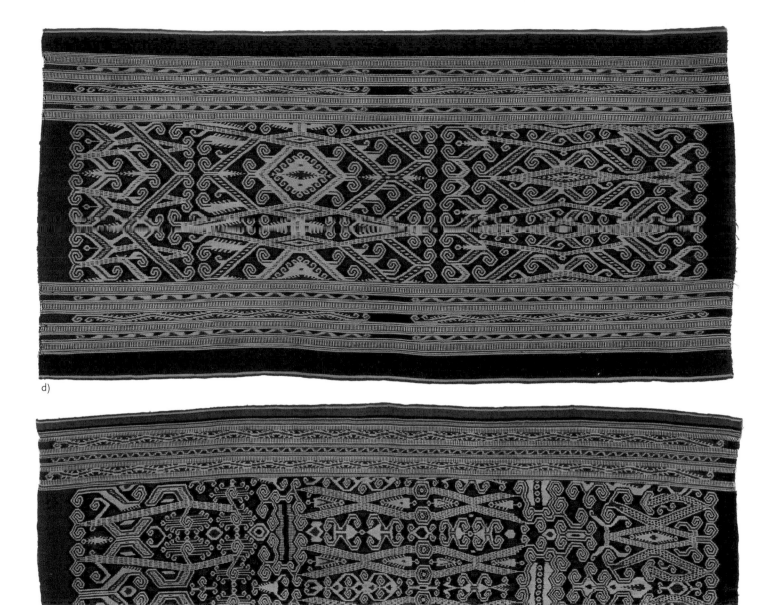

d)

e)

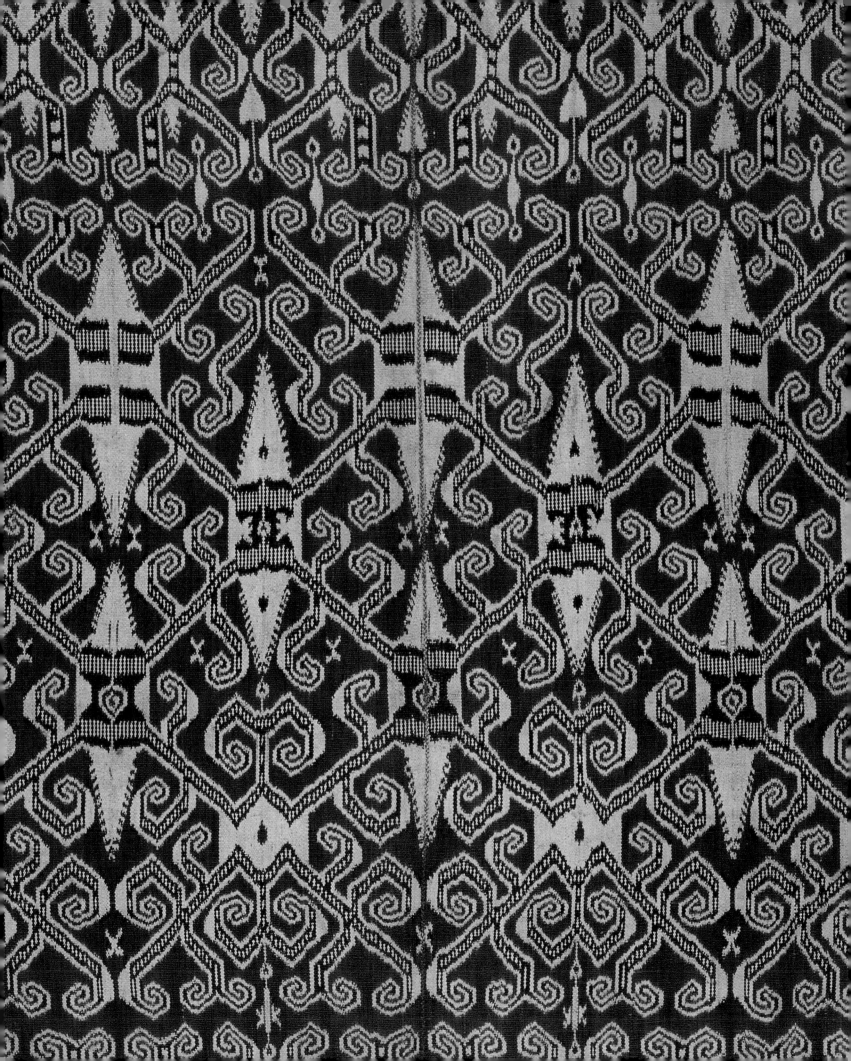

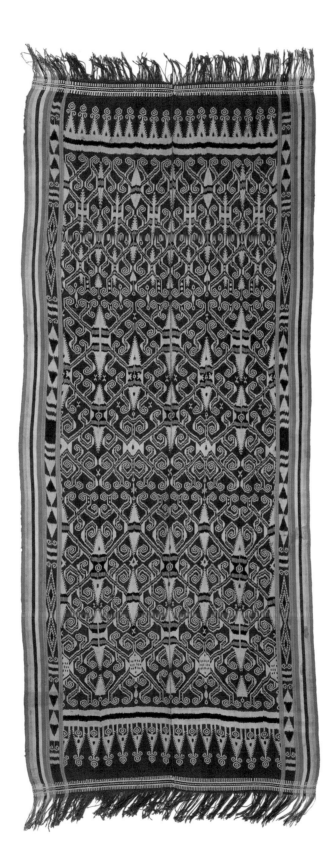

7.10
RITUAL CLOTH (*pua kumbu*)

Indonesia, West Kalimantan
Kantu' people
Cotton
Warp ikat, weft twining
Warp 206 cm x weft 79 cm
The Textile Museum 2000.22.6
Gift of the Christensen Fund

Until recently *pua* from the Ibanic people living in Kalimantan, Indonesia, have been rare in museum collections. In the last ten years small numbers have appeared, but they included little or no field information. At present, scholars are compelled to assume these textiles functioned much as the better-documented Iban cloths. This might be hard irony for the Kantu', who were bitter enemies of the Iban and who engaged them in frequent head-hunting raids.

The size of the Kantu' *pua* is more modest, and the patterns seemingly less complex. Often the borders carry simple triangular shapes in red, beige, and blue-black series. The main design field often includes large, white unpatterned areas.

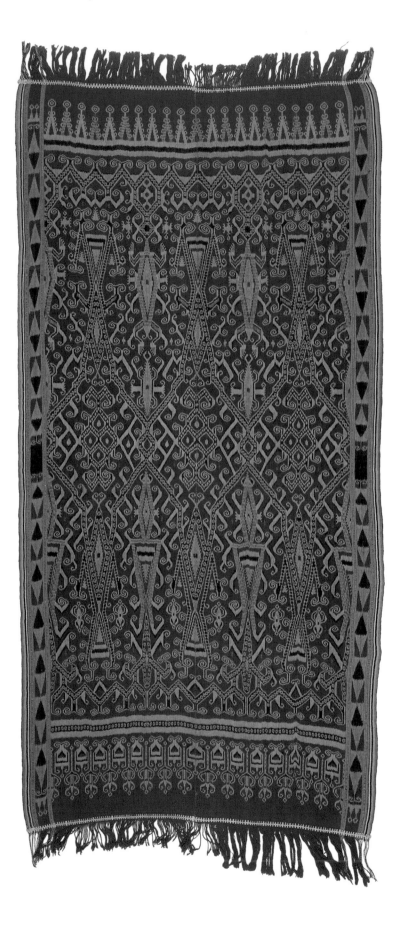

7.11
RITUAL CLOTH (*pua kumbu*)

Indonesia, West Kalimantan
Kantu' or Mualang people
Cotton
Warp ikat, 2-strand twining
Warp 216 cm x weft 94 cm
The Textile Museum 66.13
Acquired by George Hewitt Myers

This *pua kumbu* was made by people
related to the Iban—the Kantu' or
Mualang. They remain along the Kapuas
River system in the Indonesian part of
Borneo known as West Kalimantan. It was
along this river system that the Iban are
thought to have traveled to their initial
locations in Sarawak between 175 and
400 years ago.

The Kalimantan *pua* tend to be
smaller in size and some have less
complex patterning than those of the
Iban of Sarawak. However, their common
heritage is readily discernible. Similar
environments fostered common design
elements. The crocodile pattern is one of
the oldest representational figures and
is found among all Ibanic people.
Drake (1988, 32) reports that among the
Mualang to use any animal motif was an
extremely dangerous undertaking and
only older experienced women would
make such designs.

The Kantu' and Mualang, much like
the Iban, used their *pua* only for ritual and
ceremonial purposes.

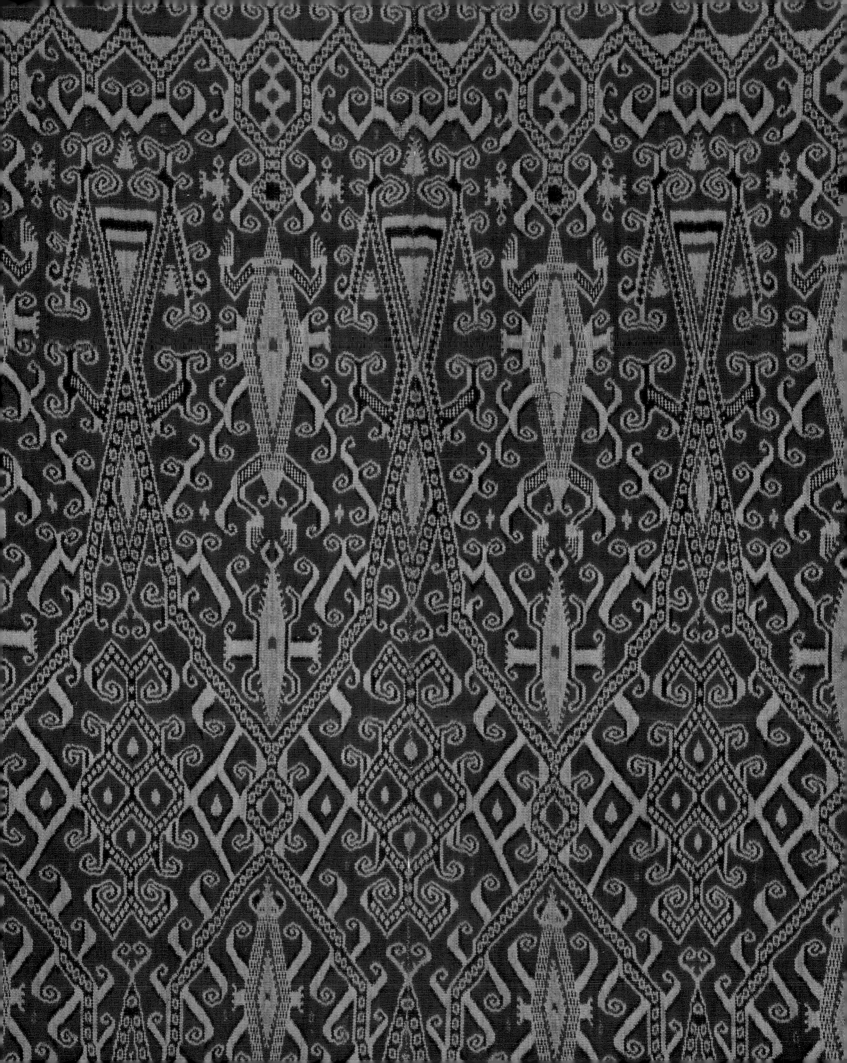

7.12
JACKET (*kelambi*)

Indonesia, East Kalimantan
Kayan people
Bark cloth
Embroidery, appliqué, paint
Height 58 cm x width 43 cm
The Textile Museum 66.7
Acquired by George Hewitt Myers in 1956

While the Austronesian peoples of the
archipelago have known of weaving for
centuries, bark-cloth garments continued
to be made in Borneo and elsewhere in
the archipelago through the nineteenth
century. Utilitarian garments such as this
were made from a loosely matted fabric,
probably from an *Autocarpus* or *Antiaris*
tree bark. Transverse darning helped to
strengthen as well as decorate the
garment. Stencils were probably used
to trace the broad curvilinear designs,
known as *aso*, a dragonlike creature,
in the lower section.

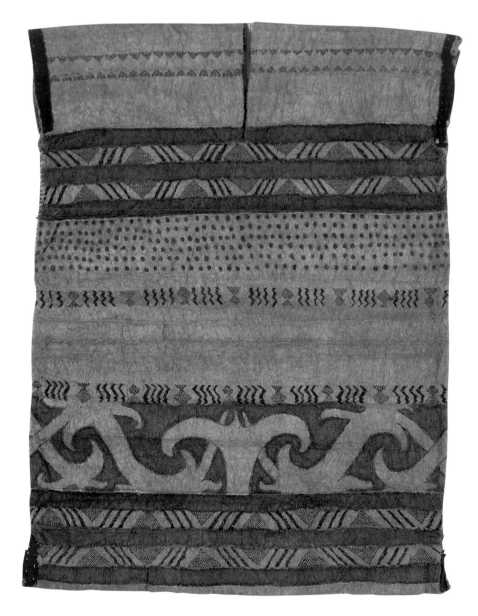

JACKET (*kelambi*)

Malaysia, Sarawak
Iban people
Cotton
Supplementary weft wrapping, countered
2-strand twining, tapestry
Height 61 cm x width 48 cm
The Textile Museum 1996.4.1
Gift of David and Barbara Fraser

Sleeveless jackets such as this were central to men's costume in times of warfare. The stark ogre figures would have intimidated the enemy, thus providing extra protection to the wearer.

It is unusual to find twining in the images in the body of a jacket. More common is the twined and tapestry-worked lower border showing a gyronny pattern. This pattern is associated with protection in many areas of the archipelago, appearing on warriors' shields and in the costume of Javanese palace guards. It appears on the lower edge of most Iban jackets as in this example, which was probably made in the late nineteenth century.

7.14
LOINCLOTH (*sirat*)

Malaysia, Sarawak, Skrang area
Iban people
Cotton
Supplementary wefts (*sungkit* and *pilih*),
embroidery
Warp 125 cm x weft 24 cm
The Textile Museum 66.10
Acquired by George Hewitt Mayers

Loincloths were men's essential garment
throughout Southeast Asia until relatively
recent times. Even today, in some regions,
they continue to serve as a practical
costume for arduous labor such as
agricultural tasks and as appropriate
costume in certain ceremonies. "The
color and decoration of the *sirat*, together
with the method of tying, is a mark of
distinction for each different regional
group" (Ong 1991, 111).

The decorative ends of this man's
loincloth show off the virtuosity of the
weaver. In the decorative end on the right,
supplementary wefts, inserted after paired
foundation wefts, wrap around warps to
form an identical design on each side of
the cloth. The technique is known as
sungkit. On the opposite end, shown in
the panel to the left, colored supplemen-
tary weft yarns extend across the entire
width of the cloth, forming a pattern on
one face and the reciprocal of that pattern
on the reverse. These alternate with the
foundation weft. This technique is locally
known as *pilih*. Finally, loose warp ends
were wrapped with colored yarns that
also secured the cotton balls creating
colorful tassels.

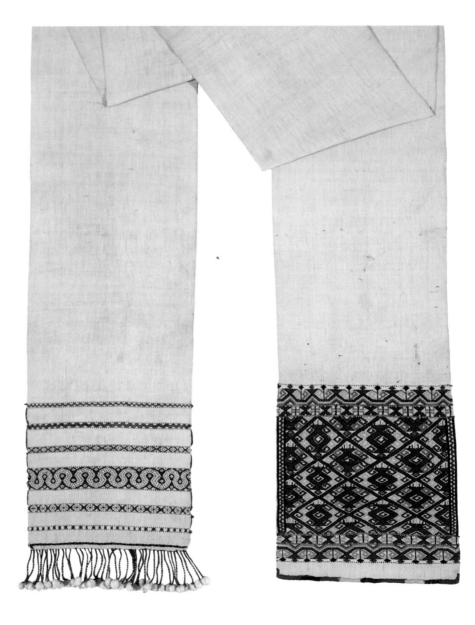

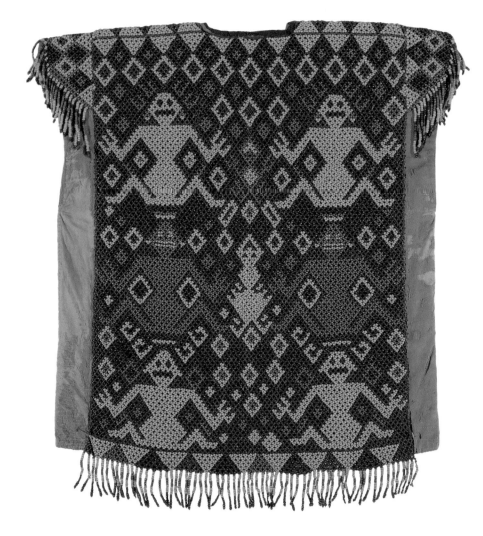

7.15
BEADED JACKET (*sapé manik*)

Indonesia, West Kalimantan
Maloh people
Commercial cotton, beads
Height 60 cm x width 58 cm
The Textile Museum 1963.19.4
Acquired by George Hewitt Myers

Beaded jackets such as this were worn
by the Maloh women on ceremonial
occasions. The squatting human figures,
representing slaves, was a motif reserved
for aristocrats in this hierarchal society.
The motif is often employed in a funerary
context because formerly slaves were
sacrificed at funerals to act as servants
for aristocrats in the hereafter (King 1985,
139–40).

7.16
SKIRT (*kain lekok*)

Indonesia, West Kalimantan
Maloh people
Commercial cotton, beads, shells, buttons,
sequins
Embroidery
Warp 81 cm x weft 53 cm
The Textile Museum 66.8
Acquired by George Hewitt Myers

The design worked in beads on this skirt
probably owes its inspiration to the
dragon images on Chinese jars traded to
the interior of Borneo. Locally it is identi-
fied as an *aso*, meaning "dog." Such skirts
would have been worn only on important
ceremonial occasions, which included
marriage, death, and a successful harvest.
The Maloh believed displaying their most
prized beaded textiles would ensure
abundant harvest in the following year.

The Maloh prized beads, and their
myths and legends speak of hazardous
voyages in search of such treasures. Over
time certain beads acquired magical
qualities. In addition to embellishing
clothing, beads entered into ceremony,
being placed in holes prepared for the
main posts of a new building. It is inter-
esting to note how hard, glossy traditional
emblems of treasures from far away have
been supplemented by more recent
items, such as buttons and sequins,
from abroad.

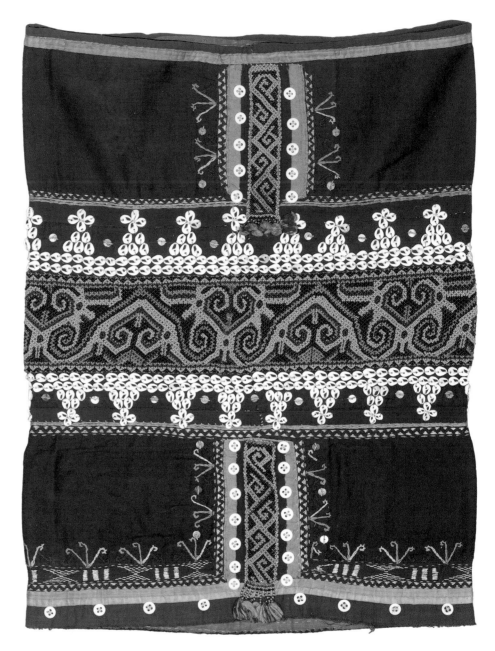

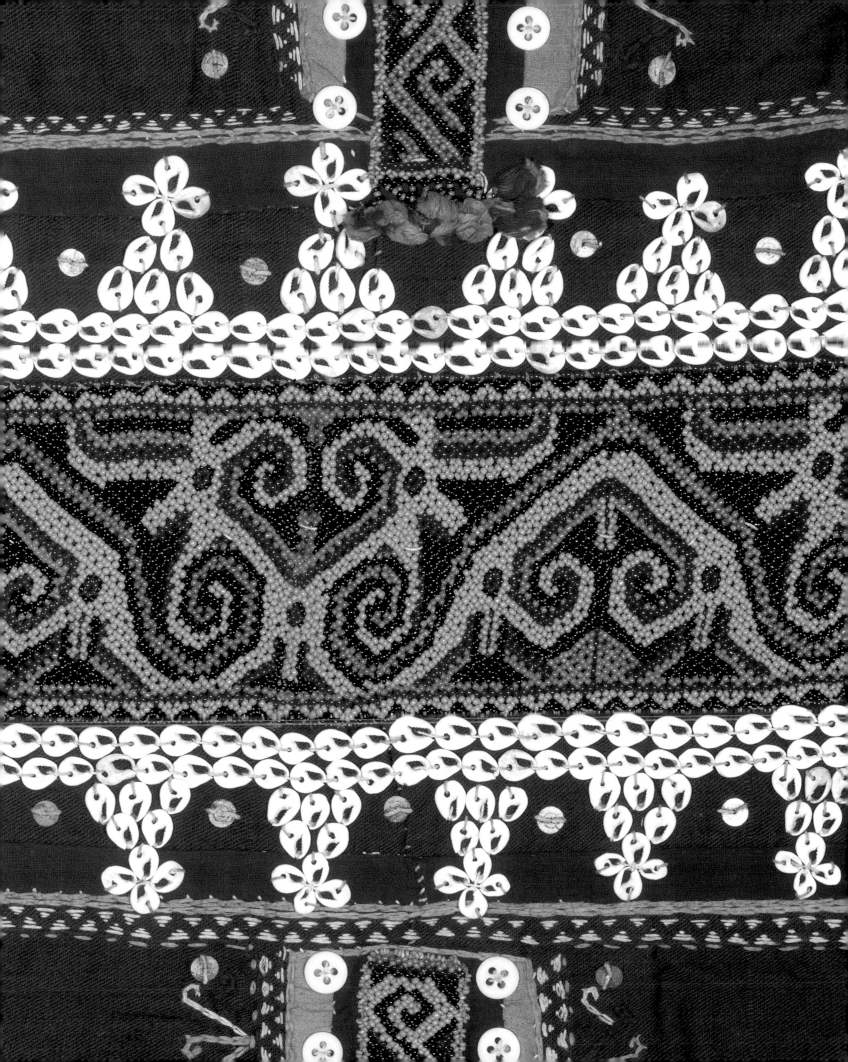

Introduction

1. Tryon 1995, 35.
2. Work in this field of linguistics is summarized in Bellwood et al. 1995.
3. Zorc 1994, 557.
4. For a survey of looms in Southeast Asia, see Gittinger 1979c.
5. Geirnaert (1991) presents a case example of these ideas in a Sumba environment.
6. This pattern of gift exchange may be found in varying degrees in insular Southeast Asia but was early reported among the Batak by Vergouwen (1964 [1933]). Neissen (1985) has done more recent work. Other examples of this system of exchange may be found in Gittinger 1979b; Barnes 1989b, 88; and Lewis 1994, 153.
7. Jensen 1974, 74–75.
8. Ibid., 84–85.
9. Christie 1993, 11.
10. Adams 1980, 211.
11. Heringa 1993, 1996.
12. Heringa 1996, 179.
13. Heringa 1993, 157.
14. Hamilton 1994a, 44.
15. Lewis 1994, 160.
16. Maxwell 1990, 82, fig, 114.
17. Nooy-Palm 1980, 81.
18. Adams 1969, 66.
19. Ramseyer 1985, 192.
20. Ibid., 203.
21. Hauser-Schäublin et al., 1991.
22. Wessing 2004, 178.
23. Ras 1968, 442–43; Hall 1996, 95.
24. Brown 1952, 46–47.
25. Gittinger 1979a, 25 ; Tirta 1996, 144.
26. Pigeaud 1962, 4:289.

The Messages of Color, Pattern, and Technique

1. The Savu information here and in association with the textiles illustrated utilizes the impressive work of Duggan (1997, 2001).
2. Gavin 1996, 21.
3. Boow 1988, 95.
4. Ibid., 156.
5. Hardjonagoro 1980, 229–30
6. Pigeaud 1962, 4:48, 57, 58.
7. Heringa 1989, 1993.

8. Heringa 1989, 127–28. This is a simplistic recounting of a highly complex interpretation of dyes developed by Heringa.
9. Hoskins 1989, 148.
10. Christie 1993, 12–13.
11. Adams 1969, 157–58.
12. Yeager and Jacobson 1998, 55.
13. Barnes 1989a, 49.
14. Vogelsanger 1980, 117; Linggi in Sutlive 2001, vol. 3.
15. Gavin (1991) and Linggi (in Sutlive 2001, vol. 2) discuss and illustrate stages of the *ngar* ceremony.
16. Beaten bark cloth has continued to be important in funeral rites for certain groups in the archipelago and used as clothing until recently in parts of Sulawesi,
17. Christie 1993, 13.
18. Ibid., 16.
19. Forge 1989.
20. Rouffaer and Juynboll 1914.
21. See Gittinger 1979b, 182, fig. 141.
22. Duggan 2001, 28–29.
23. Hamilton 1994, 106.
24. Bolland (1956) explains how this was done on Sumba.
25. Fraser 1989, 11–12.
26. Geirnaert 1989, 61.

Sumatra and the Malay World

1. Gittinger (1989) explores this relationship.
2. Gittinger (1979b) illustrates these types.
3. Gittinger 1976, 211–16.
4. Selvanayagam 1989, xviii.
5. Fraser-Lu 1988, 143.
6. Selvanayagam 1990, xxi.
7. Selvanayagam 1990, xx.
8. There are occurrences of weft ikat on cotton such as the *cepuk* of Bali, but this is an exception.

Batik in This World

1. A simple form of resist patterning was used in Sulawesi by the Toraja to create some of their most sacred cloths, the *sarita*. Also, batik was known in the Jambi region of Sumatra, but it is not thought to

have been very old in that area.
2. The Textile Museum appreciates the contribution of many who have shared their knowledge of batik for this exhibition, including Rens Heringa, Iwan Tirtaamidjaja, K. R. T. Hardjonagoro, Asmoro Damais, and Judi Achjadi.
3. Christie 1993, 16.
4. There are good explanations of the batik process in Tirtaamidjaja 1966 and Heringa 1996.
5. Mordants are substances, usually metallic salts, that allow the dye to bind to the fiber. In building a pattern with mordants the artist may use them in a positive sense, applying where color is wanted or in a negative sense by leaving an area untouched by the mordant. This retains the foundation color.
6. Heringa 1996, 34–35.
7. Geirnaert 1989, 10.

The Lesser Sunda Islands

1. This term is applied to the islands from Bali to Timor. While technically Bali belongs to this group, its Hindu heritage and close historical relations with Java make its association with Java and Sumatra more logical. The textiles of Bali are given full exposure in Hauser-Schäublin, Nabholz-Kartaschoff, and Ramseyer 1991. Included here, also, is an example from Kisar. While not strictly included in this geographical alignment, its textiles are closely associated.
2. Hamilton 1994, 23.
3. Bühler 1959.
4. Christie 1993, 13.
5. Bellwood 1985, 141.
6. Fox 1980, 39–55.
7. Ibid., 43.
8. Duggan 2001, 54–55.
9. Jong 1994, 219.
10. Moreland 1975, 56.

The Toraja of Sulawesi

1. Nooy-Palm 1979, 136.
2. Nooy-Palm 1989, 164.

3. Ibid., 171.

4. Nooy-Palm (1980, 88–90) describes these and other uses of these sacred cloths.

5. Ibid., 90–91. Legends relate that the highest deity of the Toraja resides in heaven in an enclosure made of sacred *mawa'*.

6. Wellenkamp 1988, 312.

7. Volkman 1985, 47; Nooy-Palm 1989, 169.

8. Kruyt 1920, 394.

9. These beaters are presumably those made for pounding bark cloth. The Toraja of this area are not known to have made bark cloth, although some in Central Sulawesi were once famous for their bark-cloth costumes.

10. Kruyt 1920, 388.

11. Gerlings 1952, 40; Aragon 1991, 191.

The Iban, Iban-Related Peoples, and Their Neighbors

1. Only in the last quarter of the twentieth century did reliable information about Iban textiles become available. The following material based on field research began to correct some of the earlier misconceptions: Vogelsanger 1980, Ong 1982, Heppel and Usin 1988, Jabu 1991, Linggi, 1998, and most importantly the thorough investigations by Gavin (1993, 1995, 1996, 1997, 2003). Gavin corrects many previous misconceptions and brings new insights to the field. This chapter draws heavily on her work.

2. Jabu 1991, 76.

3. Gavin 1993, 191.

4. Other Ibanic groups in Kalimantan, Indonesia, include the Seberuang, Bugau, and Desa. Little is known regarding their weaving. King (1978, 58) discusses the distribution of the Ibanic groups.

5. Drake 1988, 32.

6. Gavin 2003, 12.

7. Vogelsanger 1980, 118–19.

8. Gavin 1996, 29.

9. Jabu 1991, 76.

10. Gavin (2003, 86) discusses this title and the similar term *menyeti*.

11. Ibid.,143.

12. In the Saribas area, a downstream region long subjected to outside influences, a weaver indicates her relative prestige in a series of border stripes. These are red, yellow, black, and white; normally the red faces outward, but the highest-ranked weavers have the privilege of placing the white on the outer edge (Gavin 2003, 155).

adat Custom or tradition that governs much religious and social life.

alas-alasan Javanese motif depicting a forest environment with wild animals. Strong connotation of fertility and the cosmos.

badan Body. Main design field of a *kain*.

batik Resist process that involves applying wax to the surface of a cloth to create patterns. After dyeing, patterns are reserved in the color of the foundation. For additional colors sequences of waxing and dyeing are used.

batik *cap* Stamped batik in which wax is applied by metal stamps.

batik *tulis* Written batik so called after freehand application of the wax resist with a *canting*.

canting A tool consisting of a small copper cup having a spout and a bamboo handle. When filled with molten wax it allows precise drawing of patterns on the cloth surface. Unique to Java, the tool permitted the development of the art of batik.

ceplok A classification of geometric designs found in Javanese batik.

ei Savu woman's skirt.

ei raja A type of Savu woman's skirt having narrow supplementary warp stripes. Worn by members of the Greater Blossom group.

ei worapi A type of Savu woman's skirt having no Blossom alignment. It may be worn by women of either Blossom group and is the most popular type skirt made today because there are a broad number of situations where this skirt is considered appropriate to wear and few rituals are connected to the weaving.

geringsing Double ikat textiles woven only in the Balinese village of Tenganan Pageringsingan. These were sacred in Tenganan

and critical in ceremonies to maintain the ritual purity of the village. Elsewhere in Bali, they entered into ceremonies and were used in curing rites.

gringsing, grinsing Illness-averting. A type of cloth mentioned in fourteenth-century records. Also, a scalelike motif used in batik patterning.

hi'i A Savu man's hip wrapper usually patterned with warp ikat.

hinggi Man's warp ikat wrapper in eastern Sumba. Usually made and worn in pairs.

ikat A term applied to a resist-dye process in which designs are reserved in warp or weft yarns before weaving by tying off small bundles of yarns with palm leaf or plastic strips that resist the penetration of the dye. Some resists are cut away and others added for each new dye bath. After dyeing the resists are cut away, leaving patterned yarns ready for weaving. *Ikat* means "string" or "band" and in its verb form "to tie" or "to bind." The patterning process may be applied to the warp yarns, the weft yarns, or, as on Bali, to both, yielding "double ikat."

ireng Dark or black. Used to describe the background color of a batik.

kain Term used to denote a piece of cloth. Most often used in conjunction with type of cloth. Thus, *kain songket*, *kain panjang*, and so forth.

kain cap An alternative term for *batik cap*.

kain kebat and **kain keban** Iban woman's ikat-patterned skirt. *Keban* is the term used by the Ibanic-related peoples of West Kalimantan.

kain panjang Long cloth. Refers to a rectangular batik cloth that is wrapped about the hips. Length is approximately two and a half times the width.

kain porselen Type of batik pattern having motifs dyed in several shades of blue in imitation of porcelain.

kain sisihan Type of batik patterned with dissimilar halves. *Kepala* at either end has different colors and design details.

kain tulis An alternative name for *batik tulis*.

kandaure A cone-shaped beaded ornament hung from tall poles during Toraja ceremonies or worn as an ornament by Toraja women on ceremonial occasions.

kawung, kawong A geometric motif found in old batik patterns. Originally reserved for use in the Central Javanese courts.

kemben Breast cloth for women.

kebaya Woman's blouse.

kepala Head. Refers to the rectangular design panel that crosses a sarong from selvedge to selvedge. This may be in the center of the cloth or at one end. When the cloth is sewn into a tube, this panel may be worn at the back or front or folded to reveal only one half. The term is used in reference to the design panel on batiks and woven cloths through much of Southeast Asia.

khombu (kombu) Term used on Sumba for a red or rust dye made from *Morinda citrifolia*.

lau Sumbanese woman's tubular garment.

lurik A striped cotton fabric woven on Java.

mawa' Cloths considered sacred to the Toraja of Sulawesi. These may include textiles originally made in India, China, or Java. They are considered critical to a family's well-being.

naga Serpent, snake, or dragon of supernatural character.

nitik Term for batik designs built of dots and dashes in imitation of designs in woven textiles.

palepai A long narrow cloth, often carrying a ship motif, hung behind the principal of a ceremony among the Paminggir people of South Sumatra. Originally they were the prerogative of lineage nobles.

papan Board. Rectangular section that, together with the *tumpals,* forms the *kepala* of a *kain* batik.

parang Knife, dagger. Traditional batik motif arranged in slanting bands.

parang rusak Broken knife. One of the most-renowned batik patterns. Once restricted to rulers in Central Java.

patola (plural), **patolu** (singular) Indian double ikat textiles. The plural form has become so generally used whether singular or plural, that this catalogue has retained this term for both. These textiles were traded through most of insular Southeast Asia and affected local textile patterns in varying degrees.

pilih To choose. Decorative technique using a continuous supplementary weft that is inserted between regular foundation wefts to create a design.

plangi Rainbow. Resist-dye process in which small areas of a woven textile are bound off by a cord or similar material that reserves the area from the dye. Large areas may be reserved or small circles organized to create larger patterns. The name for the technique probably originates in the colorful nature of these textiles.

poleng Checkered pattern imbued with protective capabilities.

pua Term for a ritual blanket found among the Iban of Sarawak and Ibanic peoples of Kalimantan.

putih White.

sarita Ceremonial cloths sacred to the Toraja of Sulawesi. Some were patterned with a resist process similar to batik. Others were painted or stamped.

sarong, sarung Tubular garment worn around the lower body.

sawat Motif depicting two bird wings flanking an outspread tail. A motif associated with Javanese rulers and fertility.

selimut Large mantles and wrappers worn about the hips and over the shoulders.

semen Traditional Javanese pattern showing tendrils and sprouts, all associated with fertility.

slendang Usually narrow rectangular cloth worn over the shoulder.

songket Supplementary weft patterning. When used as *kain songket* it denotes silk and metallic textiles from Palembang and Bali.

sungkit Needle. Patterning technique in which supplementary wefts are worked with needle on passive warp between the regular wefts.

supplementary warp or weft Patterning technique in weaving in which pattern yarn is added between two regular foundation yarns.

tampan Small square ceremonial cloth once woven in South Sumatra.

tapis Woman's sarong. In this work it refers to skirts in South Sumatra.

tritik Resist-dye process in which designs are worked by stitching patterns on a woven cloth. When the stitches are drawn up tightly, the area is gathered and thus reserved from the dye bath. When the stitches are removed, a pattern remains on the woven cloth. Used particularly for breast and shoulder cloths.

tumpal Triangle motif usually arranged in confronting rows in the *kepala* of a sarong, or in a single row at the ends of cloth.

warp Parallel yarns that run longitudinally in loom or fabric.

warp-faced Textile structure in which warp yarns conceal the weft. Warp ikat fabrics usually have a warp-faced weave to allow the design to ride clearly on the surface.

weft Reverse elements in a fabric that cross and interwork with the warp.

Adams, M. J. 1969. *System and Meaning in East Sumba Textile Design—A Study in Traditional Indonesian Art.* New Haven. Yale University, Southeast Asian Studies.

—. 1971. "Work Patterns and Symbolic Structures in a Village Culture, East Sumba, Indonesia." *Southeast Asia, an International Quarterly* 1(4):321–34.

—. 1980. "Structural Aspects of East Sumbanese Art." In *The Flow of Life,* ed. James J. Fox, pp. 208–20. Cambridge, Massachusetts: Harvard University Press.

Aragon, Lorraine. 1991. "Sulawesi." In *Beyond the Java Sea,* by Paul Michael Taylor and Lorraine V. Aragon, pp.173–99. Washington, DC: The Smithsonian Institution, and Harry N. Abrams.

Barnes, Ruth. 1989a. "The Bridewealth Cloth of Lamalera, Lembata." In *To Speak with Cloth,* ed. Mattiebelle Gittinger, pp. 43–55. Los Angeles: UCLA Museum of Cultural History.

—. 1989b. *The Ikat Textiles of Lamalera— A Study of an Eastern Indonesian Weaving Tradition.* Leiden: E. J. Brill.

Bellwood, Peter, James J. Fox, and Darrell Tryon, eds. 1995. *The Austronesian— Historical and Comparative Perspectives.* Canberra: The Australian National University.

Bolland, Rita. 1956. "Weaving a Sumba Woman's Skirt." In *Lamak and Malat in Bali and a Sumba Loom,* ed. P. Galestin, L. Langewis, and Rita Bolland, pp. 49–56. Amsterdam: Royal Tropical Institute.

Boow, Justine. 1988. *Symbol and Status in Javanese Batik.* Perth: University of Western Australia.

Brown, C. C. 1952. "Sejarah Melayu or 'Malay Annals'—A Translation of Raffles Ms. 18." *Journal of the Malay Branch of the Royal Asiatic Society* 25:2–3.

Bühler, Alfred. 1959. "Patola Influences in Southeast Asia." *Journal of Indian Textile History* 4:4–46.

—. 1972. *Ikat Batik Plangi.* 3 vols. Basel: Pharos-Verlag Hansrudolf Schwabe AG.

Bühler, Alfred, and Eberhard Fischer. 1979. *The Patola of Gujarat.* 2 vols. Basel: Krebs AG.

Christie, Jan Wisseman. 1993. "Ikat to Batik? Epigraphic Data on Textiles in Java from the Ninth to the Fifteenth Centuries." In *Weaving Patterns of Life— Indonesian Textile Symposium 1991,* ed. Marie-Louise Nabholz-Kartaschoff, Ruth Barnes, and David J. Stuart-Fox, pp. 11–29. Basel: Museum of Ethnography.

Drake, Richard Allen. 1988. "Ibanic Textile Weaving." *Expedition* 3(1):29–36.

Duggan, Geneviève. 1997. "Matrilineal Descent Groups and Weavings on the Island of Savu." *The Textile Museum Journal* 34 and 35:55–73.

—. 2001. *Ikats of Savu—Women Weaving History in Eastern Indonesia.* Bangkok: White Lotus Press.

Forge, Anthony. 1989. "Batik Patterns of the Early Nineteenth Century." In *To Speak with Cloth,* ed. Mattiebelle Gittinger, pp. 91–105. Los Angeles: UCLA Museum of Cultural History.

Fox, James J. 1980. "Figure Shark and Pattern Crocodile—The Foundation of the Textile Traditions of Roti and Ndao." In *Indonesian Textiles—Irene Emery Round-table on Museum Textiles 1979 Proceedings,* ed. Mattiebelle Gittinger, pp. 39–55. Washington, DC: The Textile Museum.

Fraser, David W. 1989. *A Guide to Weft Twining.* Philadelphia: University of Pennsylvania Press.

Fraser-Lu, Sylvia. 1988. *Handwoven Textiles of South-East Asia.* Singapore: Oxford University Press.

Gavin, Traude. 1991. "Kayau Indu, the Warpath of Women." *Sarawak Museum Journal* 42(63):1–41.

—. 1993. "The Patterns of *Pua Kumbu* in an Iban Cultural Context." In *Weaving Patterns of Life —Indonesian Textile Symposium 1991,* ed. Marie-Louise Nabholz-Kartaschoff, Ruth Barnes, and David J. Stuart-Fox, pp. 191–228. Basel: Museum of Ethnography.

—. 1995. *Iban Ritual Fabrics; Their Patterns and Names.* PhD thesis, University of Hull.

—. 1996. *The Women's Warpath— Iban Ritual Fabrics from Borneo.* Los Angeles: UCLA Fowler Museum of Cultural History.

—. 1997. "Naming and meaning; ritual textiles of the Iban of Sarawak." In *Sacred and Ceremonial Textiles,* Proceedings of the Fifth Biennial Symposium of the Textile Society of America, 1996, pp. 280–87. Chicago: Textile Society of America.

—. 2003. *Iban Ritual Textiles.* Leiden: Koninklijk Instituut voor Taal-, Land- en Volkenkunde Press.

Gavin, Traude, and Ruth Barnes. 1999. "Iban Prestige Textiles and the Trade in Indian Cloth—Inspiration and Perception." *Textile History* 30(1): 81–97.

Geirnaert, Danielle C. (Geirnaert-Martin). 1983. "Ask Lurik Why Batik—A Structural Analysis of Textiles and Classifications in Central Java." In *The Future of Structuralism,* ed. Jarich Oosten and Arie de Ruijter, pp. 156–99. Papers of the IUAES–Intercongress, Amsterdam, 1981. Güttingen: Edition Herodot.

—. 1989. "From Technique to Symbolism in Javanese Batik." In *The A.E.D.T.A. Batik Collection,* ed. Danielle Geirnaert and Rens Heringa, pp. 4–13. Paris: Association Pour l'Étude et la Documentation des Textiles d'Asie.

—. 1991. "The Snake's Skin." In *Indonesian Textiles Symposium 1985,* ed. Gisela Völger

and Karen V. Welck, pp. 34–42. Cologne: Rautenstrauch-Joest Museum.

—. 1998. "Textiles of West Sumba." In *To Speak with Cloth*, ed. Mattiebelle Gittinger, pp. 57–79. Los Angeles: UCLA Fowler Museum of Cultural History.

Gerlings, J. H. Jager. 1952. *Sprekende Weefsels*. Amsterdam: Koninklijk Instituut voor de Tropen.

Gittinger, Mattiebelle. 1976. "The Ship Textiles of South Sumatra: Functions and Design System." *Bijdragen tot de Taal-, Land- en Volkenkunde* 132(2, 3):207–27.

—. 1979a. "Conversations with a Batik Master." *The Textile Museum Journal* 18:25–32.

—. 1979b. *Splendid Symbols—Textiles and Tradition in Indonesia*. Washington, DC: The Textile Museum.

—. 1979c. "An Introduction to the Body-Tension Looms of Southeast Asia." In *Looms and their Products—Irene Emery Roundtable on Museum Textiles 1977 Proceedings*, ed. Irene Emery and Patricia Fiske, pp. 54–68. Washington, DC: The Textile Museum.

—. 1989. "A Reassessment of the *Tampan* of South Sumatra." In *To Speak with Cloth*, ed. Mattiebelle Gittinger, pp. 225–39. Los Angeles: UCLA Museum of Cultural History.

—. 2000. "Extraterrestrial Inspiration A Remarkable Batik from The Textile Museum Collection." In *Building on Batik—The Globalization of a Craft Community*, ed. Michael Hitchcock and Wiendu Nuryanti, pp. 227–35. Dunia Batik Conference, Yogyakarta, Indonesia, November 5, 1997. Hants, England: Ashgate Publishing.

Hall, Kenneth R. 1992. "Economic History of Early Southeast Asia." In *Cambridge History of Southeast Asia*, ed. Nicolas Tarling, vol. 1, pp. 183–275. Cambridge: University of Cambridge.

—. 1996. "The Textile Industry in Southeast Asia, 1400–1800." *Journal of the Economic and Social History of the Orient*, 39:87–135.

Hamilton, Roy W. 1994a. "Introduction." In *Gift of the Cotton Maiden—Textiles of Flores and the Solor Islands*, ed. Roy W. Hamilton, pp. 18–77. Los Angeles: UCLA Fowler Museum of Cultural History.

—. 1994b. "Ngada Regency." In *Gift of the Cotton Maiden—Textiles of Flores and the Solor Islands*, ed. Roy W. Hamilton, pp. 98–121. Los Angeles: UCLA Fowler Museum of Cultural History.

Hardjonagoro, K. R. T. 1980. "The Place of Batik in the History and Philosophy of Javanese Textiles: A Personal View." In *Indonesian Textiles—Irene Emery Roundtable on Museum Textiles 1979 Proceedings*, ed. Mattiebelle Gittinger, pp. 223–34. Washington, DC: The Textile Museum.

Hauser-Schäublin, Brigitta, Marie-Louise Nabholz-Kartaschoff, and Urs Ramseyer. 1991. *Textiles in Bali*. Basel: Periplus Editions.

Heringa, Rens. 1989. "Dye Process and Life Sequence. The Coloring of Textiles in an East Javanese Village." In *To Speak with Cloth*, ed. Mattiebelle Gittinger, pp. 107–30. Los Angeles: UCLA Museum of Cultural History.

—. 1993. "Tilling the Cloth and Weaving the Land—Textiles, Land and Regeneration in an East Javanese Area." In *Weaving Patterns of Life—Indonesian Textile Symposium 1991*, ed. Marie-Louise Nabholz-Kartaschoff, Ruth Barnes, and David J. Stuart-Fox, pp. 11–29. Basel: Museum of Ethnography.

Heringa, Rens, and Harmen C. Veldhuisen. 1996. *Fabrics of Enchantment—Batik from the North Coast of Java*. Los Angeles and New York: Los Angeles County Museum and Wetherhill.

Holmgren, Robert J., and Anita E. Spertus. 1980. "Tampan Pasisir—Pictorial Docu-

ments of an Ancient Indonesian Coastal Culture." In *Indonesian Textiles—Irene Emery Roundtable on Museum Textiles 1979 Proceedings*, ed. Mattiebelle Gittinger, pp. 157–85. The Textile Museum. Washington, DC.

Hoskins, Janet. 1989. "Why Do Ladies Sing the Blues? Indigo Dyeing, Cloth Production and Gender Symbolism in Kodi." In *Cloth and Human Experience*, ed. Annette B. Weiner and Jane Schneider, pp. 141–73. Washington, DC: Smithsonian Institution Press.

Jabu, Empiang. 1991. "Pua Kumbu; The Pride of the Iban Cultural Heritage." In *Sarawak Cultural Legacy; A Living Tradition*. ed. Lucas Chin and Valerie Mashman, pp. 75–89. Kuching: Society Atelier Sarawak.

Jensen, Erik. 1974. *The Iban and their Religion*. London: Oxford University Press.

King, Victor T. 1978. "The Mualang of Indonesian Borneo: Neglected Sources for Iban Studies." *Borneo Research Bulletin* 10:57–73.

—. 1985. "Symbols of Social Differentiation—A Comparative Investigation of Signs, the Signified and Symbolic Meanings in Borneo." *Anthropos* 80:125–52.

—. 1993. *The Peoples of Borneo*. Oxford: Blackwell.

Kruyt, Albertus C. 1920. "De To Rongkong in Midden-Celebes." *Bijdragen tot de Taal-, Land- en Volkenkunde van Nederlandse-Indie* 76:366–430.

Lewis, E. D. 1994. "Sikka Regency." In *Gift of the Cotton Maiden—Textiles of Flores and the Solor Islands*, ed. Roy W. Hamilton, pp.148–69. Los Angeles: UCLA Fowler Museum of Cultural History.

Linggi, Margaret. 2001 (citations). In *The Encyclopaedia of Ibanic Studies—Iban History, Society and Culture*. 4 vols., ed. Vinson Sutlive and Joanne Sutlive. Kuching: Tun Jugah Foundation.

Majlis, Brigitte Khan. 1984 *Indonesische Textilien Wege zu Göttern und Ahnen*. Cologne: Rautenstrauch-Joest Museum.

Masing, James Jemut. 1981. *The Coming of the Gods—An Iban Invocatory Chant (Timung Gawai Amat) of the Baleh Region, Sarawak*. 2 vols. Canberra: Australian National University.

Maxwell, Robyn. 1990. *Textiles of Southeast Asia—Tradition, Trade and Transformation*. Melbourne: Oxford University Press.

Niessen, Sandra A. 1985. *Motifs of Life in Toba Batak Texts and Textiles*. Dordrecht, Holland: Foris Publications.

Nooy-Palm, Hetty. 1979. *The Sa'dan Toraja*. Vol.1. The Hague: Martinus Nijhoff.

—. 1980. "The Role of the Sacred Cloths in the Mythology and Ritual of the Sa'dan-Toraja." In *Indonesian Textiles—Irene Emery Roundtable on Museum Textiles 1979 Proceedings*, ed. Mattiebelle Gittinger, pp. 81–95. Washington, DC: The Textile Museum.

—. 1986. *Rituals of the East and West*. Vol. 2 of *The Sa'dan-Toraja—A Study of their Social Life and Religion*. Dordrecht, Holland: Foris Publications.

—. 1989. "The Sacred Cloths of the Toraja—Unanswered Questions." In *To Speak with Cloth*, ed. Mattiebelle Gittinger, pp. 163–80. Los Angeles: UCLA Museum of Cultural History.

Ong, Edric. 1991. "Sarawak Costume." In *Sarawak Cultural Legacy; A Living Tradition*, ed. Lucas Chin and Valerie Mashman, pp. 107–17. Kuching: Society Atelier Sarawak.

—. 2000. *Woven Dreams: Ikat Textiles of Sarawak*. Kuching: Society Atelier Sarawak.

Ong, Walter J. 1982. *Orality and Literacy: the Technologizing of the Word*. London: Methuen.

Pigeaud, Theodore G. Th. 1962. *Java in the 14th Century*. 4 vols. The Hague: Martinus Nijhoff.

Ramseyer, Urs. 1985. "Clothing, Ritual and Society in Tenganan Pegeringsingan (Bali)." *Verhandlungen der Natur-forschenden Gesellschaft Basel* 95:191–241.

Ras, J. J. 1968. *Hikayat Bandjar—A Study in Malay Historiography*. The Hague: Martinus Nijhoff.

Rouffaer, G. P., and H. H. Juynboll. 1914. *De Batikkunst van Nederlandsch-Indie*. Utrecht: A. Oosthoek.

Schuster, Carl. 1968. "Remarks on the Design of an Early Ikat Textile in Japan." In *Festschrift Alfred Bühler*, ed. Carl August Schmitz, pp. 339–68. Basel: Pharos-Verlag Hansrudolf Schwabe AG.

Selvanayagam, Grace Impam. 1990. *Songket—Malaysia's Woven Treasure*. Singapore: Oxford University Press.

Sutlive, Vinson, and Joanne Sutlive, eds. 2001. *The Encyclopaedia of Ibanic Studies—Iban History, Society and Culture*. 4 vols. Kuching: Tun Jugah Foundation. (This work has numerous, well-illustrated entries pertaining to the textiles of the Iban. The textile entries seem to have been written by Traude Gavin and Datin Amar Margarat Linggi. It is not always clear which is the work of whom.)

Taylor, Paul Michael, and Lorraine V. Aragon. 1991. *Beyond the Java Sea*. Washington, DC, and New York: The National Museum of Natural History, Smithsonian Institution and Harry N. Abrams.

Tirta, Iwan. 1996. *Batik—A Play of Light and Shades*. 2 vols. Jakarta: Gaya Favorit Press.

Tirtaamidjaja, N. (English text by B. R. O. G. Anderson). 1966. *Batik Pola & Tjorak* (Pattern & Motif). Jakarta: Djambatan.

Tyron, Darrell. 1995. "Proto-Austronesian and the Major Austronesian Subgroups." In *The Austronesians—Historical and Comparative Perspectives*, ed. Peter Bellwood, James J. Fox and Darrell Tryon, pp. 17–18. Canberra: Australian National University.

Vergouwen, J. C. 1964. *The Social Organi-sation and Customary Law of the Toba-Batak of Northern Sumatra*. The Hague: Martinus Nijhoff. (Orig. pub. 1933.)

Vogelsanger, Cornelia. 1980. "A Sight for the Gods: Notes on the Social and Religious Meaning of Iban Ritual Fabrics." In *Indonesian Textiles—Irene Emery Round-table on Museum Textiles 1979 Proceedings*, ed. Mattiebelle Gittinger, pp. 115–26. Washington, DC: The Textile Museum.

Volkman, Toby Alice. 1985. *Feasts of Honor: Ritual and Change in the Toraja Highlands*. Urbana: University of Illinois Press.

Wellenkamp, Jane C. 1988. "Order and disorder in Toraja thought and ritual," *Ethnology* 27 (3):311–26.

Wessing, Robert. 2004. "The Power of the Dead in Southeast Asia." *Bijdragen tot de Taal-, Land- en Volkenkunde* 160(1):176–88.

Yaeger, Ruth Marie, and Mark Ivan Jacobson. 1998. *Traditional Textiles of West Timor —Regional Variations in Historical Perspective*. Jacksonville, Illinois: Bantuan Biru Productions.

Zorc, R. David Paul. 1994. "Austronesian Culture History through Reconstructed Vocabulary—An Overview." In *Austrone-sian Terminologies—Continuity and Change*, ed. A. K. Pawley and M. D. Ross, pp. 541–94. Canberra: Australian National University.